The Jewish Identity Project
New American Photography

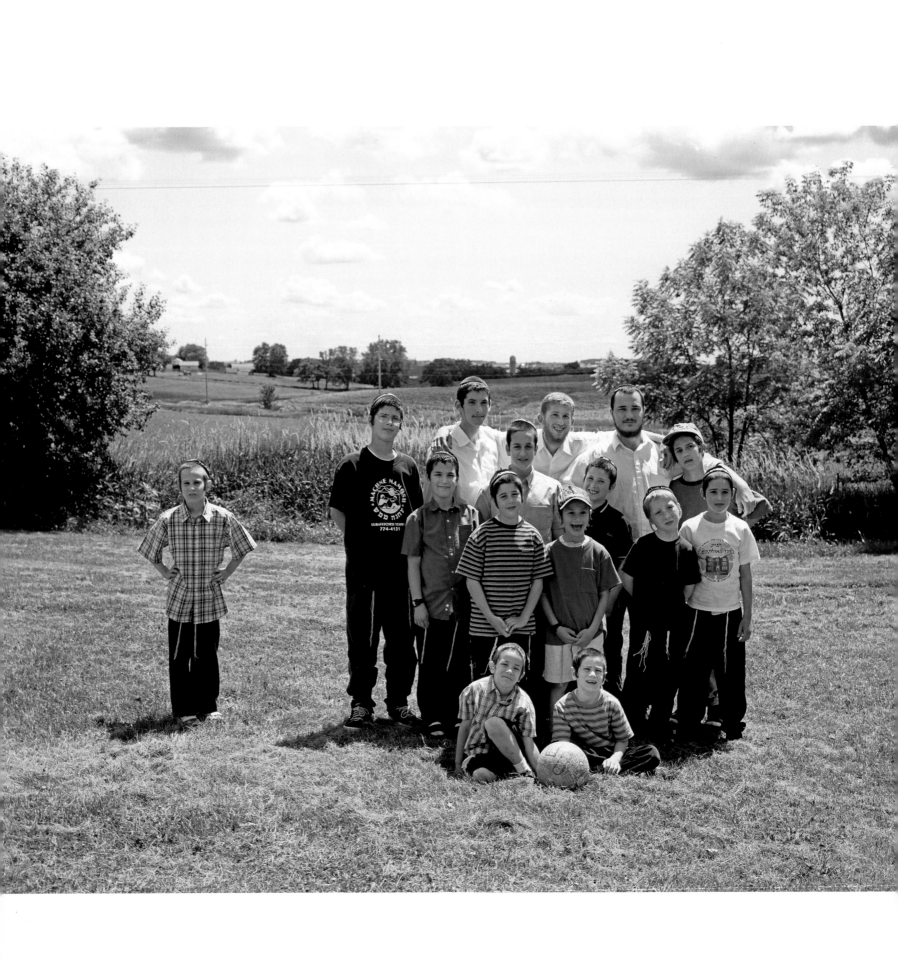

The Jewish Identity Project
New American Photography

Susan Chevlowe

With Essays by
Joanna Lindenbaum and Ilan Stavans

The Jewish Museum, New York
Under the auspices of the Jewish Theological Seminary of America

Yale University Press
New Haven and London

This book has been published in conjunction with the exhibition
The Jewish Identity Project: New American Photography, organized by The Jewish Museum.

The Jewish Museum, New York
September 23, 2005–January 29, 2006

Skirball Cultural Center, Los Angeles
March 24–August 27, 2006

Contemporary Jewish Museum, San Francisco
October 2006–January 2007

Exhibition Curator: Susan Chevlowe
Manager of Curatorial Publications: Michael Sittenfeld
Exhibition Assistant Curator: Joanna Lindenbaum
Curatorial Assistant: Ali Gass
Manuscript Editor: Joseph Newland
Publications Assistant: Beth Turk
Exhibition Design: Barbara Suhr
Exhibition Graphic Design: Miko McGinty

Yale University Press
Publisher, Art & Architecture: Patricia Fidler
Associate Editor, Art & Architecture: Michelle Komie
Senior Production Editor, Art Books: Kate Zanzucchi
Production Manager: Mary Mayer
Photo Editor: John Long

Designed by Katy Homans, New York
Set in Clarendon and Franklin Gothic by Katy Homans
Color separations by Professional Graphics, Rockford, Illinois
Printed and bound by CS Graphics

Cover illustrations: (front) Nikki S. Lee, *The Wedding (8)* (detail), 2005;
(back) Dawoud Bey, *Sahai,* 2005
Frontispiece: Andrea Robbins and Max Becher, *Boy's Camp,* 2004
Pages 46–47: Andrea Robbins and Max Becher, *Boy Biking* (detail), 2004

The Jewish Museum
1109 Fifth Avenue
New York, New York 10128
www.thejewishmuseum.org

Yale University Press
P.O. Box 209040
New Haven, Connecticut 06520-9040
www.yalebooks.com

Library of Congress Cataloging-in-Publication Data
Chevlowe, Susan.
The Jewish identity project : new American photography / Susan Chevlowe ;
with essays by Joanna Lindenbaum and Ilan Stavans.
p. cm.
Published in conjunction with the exhibition The Jewish identity project: new
American photography, organized by the Jewish Museum and held at the Jewish
Museum Sept. 23, 2005–Jan. 29, 2006, and at other U.S. museums.
Includes bibliographical references and index.
ISBN 0-300-10916-4 (pbk.)
1. Photography, Artistic—Exhibitions. 2. Video art—United States—Exhibitions. 3.
Installations (Art)—United States—Exhibitions. 4. Jews—United States—Identity—
Pictorial works—Exhibitions. I. Jewish Museum (New York, N.Y.) II. Title.
TR645.N72J483 2005
779'.9973'04924—dc22 2005011803

A catalogue record for this book is available from the British Library.
The paper in this book meets the guidelines for permanence and durability
of the Committee on Production Guidelines for Book Longevity of the Council on
Library Resources.
10 9 8 7 6 5 4 3 2 1

Contents

Donors to the Exhibition

This catalogue was funded by The Allan Morrow Foundation.

Major support for *The Jewish Identity Project: New American Photography* was provided by

The Allan Morrow Foundation

Henry Nias Foundation

National Endowment for the Arts

NATIONAL
ENDOWMENT
FOR THE ARTS

UJA-Federation of New York

and the estate of Matilda Orlik.

Generous support was also provided by

The Appleman Foundation

Goldie and David Blanksteen

Jerry and Emily Spiegel Foundation

and other donors.

Foreword

The Jewish Museum explores the nexus of art and Jewish culture, creating
exhibitions that range in subject from artifacts of the ancient Near East to con-
temporary videos. The nature of Jewish identity is a subject that has been
explored widely by artists in the last quarter of the twentieth century and in
these early years of the twenty-first. Who is Jewish? And what is a Jew? These
are questions that pervade artworks by Jews or about Jews, and have naturally
been essential to a number of exhibitions at The Jewish Museum. One notable
example is the 1996 exhibition *Too Jewish? Challenging Traditional Identities*—
organized by Norman L. Kleeblatt, Susan and Elihu Rose Curator of Fine Arts
at The Jewish Museum—which opened new lines of inquiry for the public as
well as for artists and art historians. Nearly a decade later, *The Jewish Identity
Project: New American Photography* takes a different approach by exploring
photography and video rather than painting, sculpture, and drawing, and by
focusing more on the identity of the subjects of the works than on the identity
of the artists themselves.

Our goal in *The Jewish Identity Project* was to explore and even celebrate
the heterogeneous nature of Jews in America. The strategy for creating a com-
pelling exhibition was to commission a group of works by contemporary artists
who have a history of exploring identity issues. Obviously we had to limit our
reach in terms of the numbers of families, individuals, or communities that could
be presented in these commissions. Thus we needed to find a group of artists
that would, in their own diversity of vision, offer a collective new reflection of
American Jewish life. We were looking for a cumulative picture that might
challenge the usual notion of American Jews as a homogeneous group—white,
middle-class, and of European origin. We also wanted to present a variety of
means by which artists use the medium of photography to see the world, to
reveal themselves, and to inspire viewers to question their own vision.

This is not a documentary study, or the work of a group of photojournal-
ists. In this project, the artistry of the works and the subject of identity are
equal in weight. One viewing these works is experiencing simultaneously the
wide range of lifestyles and ethnicities of the subjects and the varied visions
and strategies of the artists. Within the diversity that emerges are two common
threads: the possibility of continuity and change embraced by the idea of
Jewishness, and the breadth of creativity available in American society in shap-
ing one's identity.

The Jewish Museum is indebted to Vivian Shapiro for bringing the idea
of photographing American Jews to the attention of the staff. We are also

immensely grateful to the exhibition curator, Susan Chevlowe. She began her work on this project as an Associate Curator on the staff of The Jewish Museum and, after completing her Ph.D. in art history and becoming an Adjunct Assistant Professor at the Jewish Theological Seminary, completed her work on the project as a guest curator.

I wish to extend my profound thanks to the donors whose support made *The Jewish Identity Project* possible. Major support for the exhibition was provided by The Allan Morrow Foundation, which also funded this catalogue; Altria Group, Inc.; the Henry Nias Foundation; the National Endowment for the Arts; UJA-Federation of New York; and the estate of Matilda Orlik. In addition, generous support was provided by The Appleman Foundation, Goldie and David Blanksteen, the Jerry and Emily Spiegel Foundation, and other donors. Finally, we are indebted beyond measure to The Jewish Museum Board of Trustees for its unwavering support of this exhibition and catalogue.

Joan Rosenbaum
Helen Goldsmith Menschel Director
The Jewish Museum

Acknowledgments

SUSAN CHEVLOWE

I am indebted to the quotidian yet extraordinary contributions of the many people whose work and lives have helped to shape the content and interpretation of this exhibition. At that elusive boundary between art and everyday experience, the distinctive visions of thirteen artists have resulted in art at once pleasing to the eye and demanding—obliging us to think about our place in the world and our relationship to one another. For their advocacy and support of this project, I am indebted to Joan Rosenbaum, Helen Goldsmith Menschel Director, and Ruth Beesch, deputy director for program.

The process leading to this exhibition began in 1999 when Vivian Shapiro, mother of an adopted Chinese daughter, Cece, came to The Jewish Museum with a proposal for "a photographic exhibit of Jews in America today." Vivian and her partner, Mary Nealon, have since adopted a second daughter, Gabi. What was then called "Common Ground" would capture the remarkably diverse face of Jewish life in the United States. Watching Cece in synagogue with other multiracial Jewish children motivated Vivian to explore the impact of intermarriage, adoption, and extended families on the American Jewish population. She gathered a group of parents and art-world insiders to develop the project. In addition to Vivian, I must acknowledge the original members of the group for their initial efforts and heartfelt commitment to the project: Irwin Feld, Marcy Feld, Edwynn Houk, Robert Morrow, Deborah Roberts, Patrice Samuels, and Barbara Schwartz.

Subsequent meetings brought together scholars, educators, filmmakers, interviewers, community activists, clerics, and other individuals. Their personal experiences and professional work, scholarly insights and personal anecdotes all helped us to construct a framework for photography's inquiry into what it means to be Jewish in America today and to create an exhibition that would explore how a matrix of ethnic, racial, cultural, and religious attributes shapes individual and collective Jewish identities. These key figures included: Katya Gibel Azoulay, Maurice Berger, Irene Bowers, Rabbi Daniel Brenner, Marla Brettschneider, Karen Brodkin, Rabbi Angela Warnick Buchdahl, Adele Burke, Jen Chau, Jordan Elgrably, Rabbi Capers C. Funnye Jr., David Theo Goldberg, Matthew Frye Jacobson, Loolwa Khazzoom, Josh Kun, Patricia Lin, Lane Mashal, Shahanna McKinney-Baldon, Karen Michel, Nicholas Mirzoeff, Peter Nelson, Steven Nelson, Rabbi Hailu Paris, Amy Posner, Riv-Ellen Prell, Mojgan Moghadam Rahbar, Joanna Rizzi, Robin Roberts, Homa Sarshar, Yolanda Thomas, Gary Tobin, Rabbi Rigoberto Emmanuel Viñas, Rabbi Yhoshua B. Yahonatan, and Rabbinit Yahonatan.

Either on my own or with Joanna Lindenbaum, assistant curator for the exhibition, or with other Jewish Museum staff, I met numerous individuals who shared their overlapping life- and professional experiences with us. Their examples and advice have served as underlying refrains and created the momentum to move this project forward: Yosef I. Abramowitz and Rabbi Susan Silverman, Reena Bernards, Nadav Davis, Rachel Factor, Cass Fey, Coco Fusco, Martha Gray, Lauren Greenfield, Chester Higgins Jr., Marianne Hirsch, Clare Kinberg, Jane Lazarre, Yavilah McCoy, France Morin, Gail Quets, Demetria Royals, Valerie Smith, Jon Stratton, Elinor Tatum, Jean Weinberg, and Abbie Yamamoto. I would also like to thank Rabbi Sholomo Ben Levy of Beth Elohim Hebrew Congregation and the members of his synagogue for their hospitality when Marcy Feld, Vivian Shapiro, Patrice Samuels, and I attended Shabbat services there in 2000. I also especially want to acknowledge the openness with which Linda Jum welcomed my family to the Jewish Multiracial Network Retreat in 2001, and to thank the individuals and families that I met there that year and in 2002.

We are grateful to Ilan Stavans, whose literary life—especially as he describes it in the allusive and beautiful *On Borrowed Words: A Memoir of Language,* which says so much about the richness and complexity of being Jewish and the constant reinvention of who we are—exemplifies art's evocation of life. We thank him for his wonderful contribution to this volume.

Above all I want to thank the artists—Dawoud Bey, Tirtza Even and Brian Karl, Rainer Ganahl, Nikki S. Lee, Shari Rothfarb Mekonen and Avishai Mekonen, Yoshua Okon, Jaime Permuth, Andrea Robbins and Max Becher, Jessica Shokrian, and Chris Verene—for their dedication to this project, which I believe many of them saw as more than a commissioned opportunity to add to or create a new project or body of work, which ultimately also expanded and enriched their own lives, as their final projects will in turn expand and enrich the lives of the museum's visitors. Special thanks also go to Dan Collison and Elizabeth Meister for their audio interviews in conjunction with Dawoud Bey's project (in production as this catalogue goes to press); for their work on Tirtza Even and Brian Karl's installation, to Melinda Ring, choreographer, Todd Holoubek and Scott Fitzgerald, programmers, and the numerous talented performers who donated their time to the project; to Leslie Tonkonow of Leslie Tonkonow Artworks + Projects; to the Sonnabend Gallery; and to Jay Gorney, Karen Bravin, and John Lee.

Of course, the work of the artists would not have been possible without the cooperation of the dozens of people with whom they collaborated: the subjects of their artworks, who are sharing themselves with us, not as paradigmatic representatives of the American Jewish experience but as unique individuals with unique experiences, which give us insight into and optimism about the future of Jews in this country we call home.

As with many of the exhibitions at The Jewish Museum, the dedication of staff at all levels has been crucial to the completion of our task. I would like to thank the following: Al Lazarte, director of operations; Anne Scher, director of communications; Aviva Weintraub, director of media and public programs, and Andrew Ingall, assistant curator, National Jewish Archive of Broadcasting and Media; Alessandro Cavadini, audio-visual coordinator; Jane Rubin, director of collections and exhibitions, Dolores Pukki, coordinator of exhibitions, and

Lauren Smith Breyer, assistant registrar; Sarah Himmelfarb, former associate director of development, Elyse Buxbaum, senior manager, corporate and government relations, and Susan Wyatt, senior grants writer, as well as to my former colleague in program funding, Elana Yerushalmi; Nelly Silagy Benedek, director of education, Jane Fragner, assistant director of education, and Greer Silverman Kudon, manager of school programs and outreach; and, especially, Emily Hartzell, assistant curator for web projects. For his critical insights and help in shaping this exhibition in a myriad of ways, I am grateful to Norman L. Kleeblatt, Susan and Elihu Rose Curator of Fine Arts. I also want to thank Fred Wasserman, Henry J. Leir Curator, for his ongoing interest in the show, his keen eye, and his helping me to keep it all in perspective. I also extend my gratitude to current and former staff members and interns in the fine arts department who have worked on this project: Johanna Goldfeld, Orit Darwish, Susanna Abramowicz, Gabriel de Guzman, Lisa Mahoney; and finally, Ali Gass, who came aboard at a difficult and crucial moment in the production of the catalogue, and who was able to take things competently in hand and see to the implementation of this project and its success.

We are pleased that the efforts of the many individuals involved will be brought to a wide audience, and for this we thank Lori Starr, senior vice president for the Skirball Cultural Center and director of the Skirball Museum, and Sarah Vure, consulting curator, Skirball Cultural Center and Museum, Los Angeles; and Connie Wolf, director and CEO, and Barbara Levine, deputy director, The Contemporary Jewish Museum, San Francisco.

The creation of this book has been a challenge that required both creativity and logistical skills to realize. This was not least because of the fact that this work was commissioned (although coincidentally the Mekonens were already at work on their film when we asked them to edit a segment for inclusion in the exhibition) and that it came into being through a complex collaborative process in which the reality of deadlines often threatened to become the Achilles' heel of the creative process. The professionalism, support, and patience of the staff at Yale University Press must also be acknowledged, as well as the talents of the book designer Katy Homans and editor Joseph N. Newland, with whom it has been a pleasure to work. At the museum, this project could not have been accomplished without the guidance and leadership of Michael Sittenfeld, manager of curatorial publications, and the resourcefulness, calm, and initiative of Beth Turk, publications assistant. Barbara Suhr has imaginatively and handsomely designed this large and technically complex installation of the exhibition, which is enhanced by Miko McGinty's graphics.

A final word of gratitude to Carole Zawatsky, former director of education at The Jewish Museum, and Joanna Lindenbaum, who have devoted much emotional, intellectual, and creative effort to the planning process for this show, although both have since moved on from this museum. I am especially indebted to Joanna for her interviews with the artists that appear in this volume and her ability to clarify the relationship between the aesthetic and social issues embodied in the exhibition. I also deeply appreciate her personal support and seemingly infinite capacity to come up with innovative ideas that have strengthened the presentation of these works of art, as well as have informed the process of their creation.

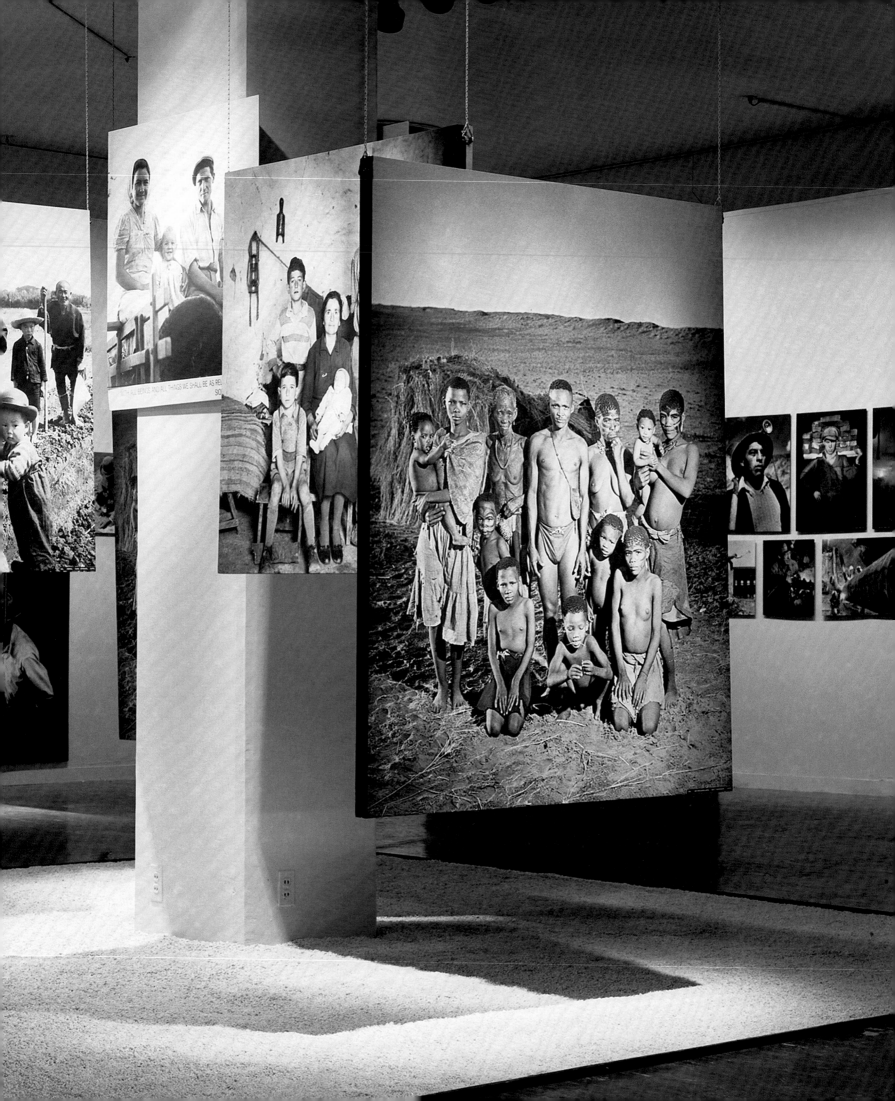

PHOTOGRAPHY AND

THE BOUNDARIES OF COMMUNITY

Framing Jewishness

SUSAN CHEVLOWE

Jewishness, like most—perhaps all—
other identities, is imagined; it has no empirical,
objective, verifiable reality to which we can point and
over which we can exclaim, "This is it!"
Jewishness is in the mind. In the felicitous phrase of
Benedict Anderson, we are
speaking of an "imagined community."

—Shaye Cohen

Who belonged? What were the qualifications?
Were there certain exclusive benefits or practices;
a certain number of ancestors defined as Jewish;
a certain size nose; a certain look in the eyes;
a certain smell; a certain relation to language;
dirt; morality; community; culture?
Could one choose to be Jewish?
Is a Jew white? If a Jew converted was she still a Jew?
If a Jew became an American was he still a Jew?

—Daniel Itzkovitz

Detail of fig. 1

The ten photographic, video, and multimedia installation projects commissioned for this exhibition bring to light the complexity of ethnic and racial Jewish identities in the context of multiculturalism in the United States. By collaborating with their subjects and using a variety of aesthetic strategies, the artists in *The Jewish Identity Project* bring to our attention how photography participates in the construction of individual and communal identities. Rather than offer stereotypes reflecting a singular and familiar image of Jewishness, they raise questions about how *we* picture *us,* when for so long so many of *us* have been invisible in the picture. Collectively, these works ask: How can we frame Jewishness in an increasingly multicultural society when old stereotypes about American Jews no longer hold? Today Jews in the United States come from many backgrounds: They are people of color, immigrants, Jews by choice, and adoptees. They follow a wide range of customs, and although many are secular, even observant Jews follow increasingly idiosyncratic practices. Not only is it futile to attempt to categorize "the heterogeneous world Jewish population" as a "religious group, race, nation, transnational people, or ethnic group . . . such efforts have the effect of excluding some Jews."[1] The same holds true when trying to define any Jewish population as "native" to a particular country or more narrow geographic locale.

American Jews have been considered a highly assimilated religio-ethnic group that participates fully in society while maintaining ancient traditions and observances, as well as, for some, a commitment to a historical homeland that unites them as "a people." However, this image of unity comes at the price of the erasure of differences, including "racial" and class distinctions, personal histories, points of origin, and multiple ways of experiencing Jewishness. Jews are both the same as and different from the people among whom they live as well as the same as and different from one another. As individuals with different geographic and ethnic roots, they "bear the marks of the particular cultures, languages, histories and traditions which 'formed' them, but they do not occupy these as if they were pure, untouched by other influences, or provide a source of fixed identities to which they could ever fully 'return.'"[2] Neither side of the hyphen of Jewish-American identity is pure.

Rabbi and historian Shaye Cohen sees Jewishness as a "social construction—a variable, not a constant."[3] Its meaning changes throughout history, according to the conditions of different times and places. Cohen argues that contemporary questions about Jewishness and Judaism have their roots in

antiquity, before the boundaries of religion, ethnicity, and nationality were "fixed" by rabbinic law. Today's question "Who is a Jew?" is thus an echo from the past. "Jewishness," writes Cohen, "was a subjective identity, constructed by the individual him/herself, other Jews, other gentiles, and the state."[4]

Most Jews in America—whatever their racial, ethnic, or national origins—seemingly "blend in" with the rest of the multiethnic population of this country. And again, in keeping with ancient practice, it is evident that non-Jews, too, live in Jewish families (whether traditional or otherwise), attend synagogue, raise Jewish children, light Hanukkah candles, even have Jewish funerals. Even in ancient times, the identity of the first cultural Jews, the Judaeans, incorporated both an ethnic and a religious component. Religion allowed the community to incorporate new members—gentiles who chose to follow Jewish religious observances.[5] In later days, the conviction that Judaism was solely a religion had an inverse effect, allowing Jews to be incorporated into non-Jewish nations. Enlightened Jews felt assimilated into European culture in the nineteenth century because their religion was a private matter. To paraphrase Moses Mendelssohn, they were Jews at home, but Germans, Frenchmen, or Britains in the street. By the early twentieth century, "American accounts of Jewish difference" continued to slip "within and among the categories of race, nation, religion, and culture, and the criteria for affiliation and disaffiliation (notwithstanding the religious law that defines as Jewish those individuals whose mother is Jewish) were very vulnerable to contestation."[6]

Definitions remain in flux and no longer adhere to the simplistic models of "religion" as in 1950s discourse or 1970s "ethnicity."[7] Nevertheless, an understanding of what may constitute ethnicity and the instability of its components is relevant to the present discussion about photography and the construction of Jewish identity. An ethnic group shares a common culture, whether or not there is a strict definition of what constitutes that culture. In this sense, ethnicity is imagined, and photography plays a crucial role in reinforcing awareness of how the group imagines itself to be bound together through what its members have in common: the kinds of foods they eat, their physical characteristics, the way they practice their religion, their history, their shared language and belief in a common origin. Photography is not simply a mirror held up to reality. It shows us what we want to see, framing and shaping the world and the values and history of a particular community.

Increasingly since the 1970s, photography books have appealed to mainstream American Jews, in fact have constituted that mainstream, in bulky tomes like *The American Jewish Album, 1654 to the Present* (1983), by Allon Schoener, and others about which Jack Kugelmass has written, such as Franz Hubman's *The Jewish Family Album: The Life of a People in Photographs* (1975), which set the boundaries of Jewishness by presenting a story of Jewish continuity and collective progress. For Kugelmass, Hubman's "ethnic panopticism, its controlling gaze," presents history "as a dramatic sequence, building from destitution to social elevation, destruction to redemption." The past or its representation is shown as a way "to reconstitute group unity in the face of an overabundance of heterogeneity."[8]

During the dislocating upheavals that have faced Jews over the millennia, the Bible (Torah) has been regarded as a visual and textual symbol of Jewish

continuity, binding the heterogeneous global Jewish population as "a people." As such it figures in photographs such as those described by Chaim Potok in his introduction to David Cohen's *The Jews in America* (1989): "Long threads bind these images to the past. The young men who hold *Torah* scrolls and read from them; the scribe and his family gathered around a large scroll of parchment; the child with a *Simhat Torah* flag; the men who joyously carry their new *Torah* beneath a *hupah*—all have their origins in the Jewish people's passion for the Covenant. Embodied by the sacred scrolls, this Covenant is the central concept that has propelled the Jewish people through history."[9] For Potok, "multigenerational images" of Jewish *men* observing such rituals as the laying on of *tefillin* depict the "links between man and man," that is, the covenant of family.[10] Aside from the gender bias in Potok's description, in an increasingly secular and humanistic community where many Jews are unaffiliated, is this really true? How are Jews pictured without the accoutrements of their religious practice?[11] And, what, if anything, binds them together without these attributes?

Yet another book, *Behold a Great Image: The Contemporary Jewish Experience in Photographs* (1978), claimed "to hold up a mirror to a vibrant Jewish actuality," while dispensing with narrative and focusing instead on the ostensibly universal experience of Jews everywhere at all times.[12] With history and geography collapsed, non-Western Jews and traditional Jewish observance stand for ancient and timeless practices that connect the Jewish people eternally. Among the many such books on the extended Jewish family, this one most resembles the catalogue of the famous Museum of Modern Art exhibition *The Family of Man,* organized by Edward Steichen in 1955 (fig. 1) and baldly criticized by Roland Barthes for its universalizing, and, indeed, essentializing message.[13] What Barthes loathed was the exhibition's "ambiguous myth of the human 'community.'" In aiming "to show the universality of human actions in the daily life of all the countries of the world: birth, death, work, knowledge, play," the exhibition imposed the same types of behavior onto humans in order to prove in fact that "there is a family of Man." In *Behold a Great Image*, images of the Jewish rituals, holidays, and life-cycle events were intended to offer analogous "proof": There is a Jewish "Family of Man."

For Barthes, the myth of *The Family of Man* subverted history to nature by insisting on the exoticism of its non-Western subjects as it projected diversity all over the globe. It covered up the truths and injustices of history and proclaimed that the relativity of human institutions and the diversity of human types are only superficial; underneath one finds "the solid rock of a universal human nature." Of course, *The Family of Man,* held a decade after World War II, inevitably sought healing and wholeness for a dehumanized and fragmented world community. Producers of Jewish family albums in the decades after the Holocaust similarly sought to emphasize the common ground of Jewish history, religion, and culture despite a plurality of Jewish faces, customs, dress, and ethnic and national origins, in an effort to perpetuate group survival.

Rather than the mirror of actuality it aimed to be, *Behold a Great Image,* its title taken from the Book of Daniel (2:31), constructed a "cultural imaginary" for liberal and observant Jews, particularly in New York.[14] Its view of Jewish culture reinscribed a narrative of destruction, authority, and renascence (a refiguring of the traditional cycle of exile and redemption) onto contemporary

Fig. 1
Installation of the 1955 Museum of Modern Art exhibition, *The Family of Man,* organized by Edward Steichen

Fig. 2
Bill Aron
Simchat Torah, New York Havurah Shabbat School,
1977. Gelatin silver print, 10 x 8 in. (25.4 x 20.3 cm)

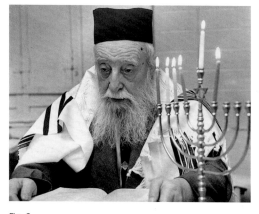

Fig. 3
Irving I. Herzberg
Lighting the Chanukah Menorah, 1977. Gelatin silver
print, 8 x 10 in. (20.3 x 25.4 cm). Brooklyn Public
Library, Brooklyn Collection, Herzberg Collection Folder
56, HERZ 0687

Jewish experience. The winners of the first and second prizes, Suellen Snyder's
Zitomer Yeshiva, New York City, Stripped Interior, and Bill Aron's *Simchat
Torah, New York Havurah Shabbat School* (fig. 2), respectively, reinforced this
message. Part of a multigenerational triad, the third-prize photograph by Irving
I. Herzberg was of an elderly man wearing a prayer shawl (*tallit*) who regards
an open prayer book (fig. 3), during the fifth night of Hanukkah. Such repre-
sentations of pious Jews have traditionally conveyed a vision of Judaism as an
ancient faith transmitted unchanged from generation to generation.[15]

Aron's photograph is distinctive for another reason—it includes an inter-
racial child in the background on the left—and is thus a rare occurrence of
racial difference in the American Jewish community being made visible. Of
course, what Aron's *New York Havurah School* photograph acknowledges for
those who really look are also the facts of history: that by the 1970s intermar-
riage of blacks and Jews had made an impact on the Jewish community,
although it may have been accompanied by a general anxiety as the product of
both simple racism and the fear that exogamy was a threat to Jewish survival.[16]
Interfaith families and proactive conversion were not yet seen as possible path-
ways to Jewish continuity.[17] Interracial identities have been represented as the
least stable and socially viable Jewish identities and are still highly contested
today.[18] Though updated in this image, the white male teacher nevertheless
takes the place of older, patriarchal figures in more traditional images who pass
on Jewish learning from generation to generation. And Judaism, like the liberal
Jews of this period and of earlier generations, is assumed to be color blind.

Today we are aware of the limitations of this philosophy as well as the
necessity to overcome the system of racial classification based not in biology
but in social construction. As Jane Lazarre, a white Jewish mother of African
American sons, reminds us in *Beyond the Whiteness of Whiteness* (1996), "the
whiteness of whiteness is the blindness of willful innocence."[19] The story of the
Jewish people is the story of a collectivity that has left little space for including
the story of those marginalized at its borders, including converts and people
of color. "It is too late for clichés about all of us being the same," Lazarre has
written.[20] Katya Azoulay, the daughter of a European Jewish refugee mother
and a Jamaican father, maintains an equally complicated view of whiteness
given the place of Jews in the racial discourse of the United States. She writes,
"From a Jewish perspective, given the racial and ethnic diversity of the Jewish
people produced in the Diaspora, when Jewish parents in the U.S. identify them-
selves as 'White,' they reproduce race thinking in their children which, in turn,
reinforces, rather than undermines racial hierarchies."[21]

Having understood for so long a narrative of Jewish Diaspora where Jews
come to look like those in the dominant culture in which they live, we see para-
doxically how geography tends to reinscribe anti-miscegenation, close the bor-
ders, and reinforce an ethnic and racial hierarchy among Jews. For example,
with its very different "south of the Rio Grande" context, Ilan Stavans's memoir
On Borrowed Words (2001) disrupts the naturalization of Jewish assimilation
when he recalls, "MÉXICO LINDO. What makes me Mexican? White-skinned, blond,
brown-eyed, with a name like Ilan, which in Hebrew means 'palm tree,' and a
surname like Stavans. What makes me Mexican?"[22] Born into a bilingual (Yiddish
and Spanish) Ashkenazi family in Mexico City, Stavans's memoir exposes the

Fig. 4
Frédéric Brenner
Perry Green, Fur Trader, Son of David Green (1904–1971)
with Inuit, Saint Lawrence Island, Alaska, 1994. Gelatin silver
print. Courtesy of the Howard Greenberg Gallery, New York

deception in the model of United States Jewish acculturation, where success
may be measured by how blond one becomes over the generations.[23] There is a
subtle message here that even Jewish Diasporans cannot mix.[24] We are con-
tained in the racial and national borders of liberal pluralism as Indian Jews,
Yemenite Jews, American Jews, Russian Jews, Ethiopian Jews. That there are
Asian American Jews and African American Jews appears anomalous. In the
United States this plays right into the hands of racism.

In 2003–4, Jewish visitors to Frédéric Brenner's exhibition at the Brooklyn
Museum, *The Jewish Journey: Frédéric Brenner's Photographic Odyssey,* found
themselves pictured in all their great diversity, spread throughout the world.
The pictures validated the upwardly mobile middle-class Jew's self-perception,
and with it the vision of the fathers of the Enlightenment. Here every Jew,
everywhere, successfully assimilated into the dominant culture in which he
lived and became "native." Even with a nod to multiple migrations, written onto
especially the Soviet Jews who have emigrated to the United States since the late
1970s, Brenner's work upheld the ideology of Enlightenment. As Laura Levitt
has written of the photographer's earlier work focusing on the American Jewish
Diaspora, Brenner's project faces a serious pitfall in not offering "a critical re-
evaluation of the stereotypes he reproduces."[25] According to Levitt, "the multi-
plicity of separate images . . . presents American Jewishness as a form of liberal
pluralism. . . . Brenner's text 'produces a version of diversity which is made
up of multiple "units" of differences.'"[26] As a text panel at the beginning of the
Brooklyn exhibition explained, what Brenner sought in each of his spectacu-
larly staged photographs was the "iconic moment" that represented his subjects'
essential Jewishness and their relationship to their host cultures. In other
words, he constructed a fixed identity, within a specific geographic locale,
rather than exposing the contingency of Jewishness and its intersection with
a constellation of impure and multiple sites of identity. A work such as *Perry
Green, Fur Trader, Son of David Green (1904–1971) with Inuit, Saint Lawrence
Island, Alaska* is a prime example (fig. 4). Here the Jew stands out because he
has not lost his "ethnic" North American–European Jewish features—his "essen-
tial" Jewishness. He merely wears the clothes of the group, but has not become
like them. The ethnic dress, on the other hand, stands for the whole of Inuit
identity. Thus, while playing on ethnographic modes, Brenner does not get
beyond the meeting of two seemingly "pure" ethnic groups.

How are Jews (or some Jews) identified and identifiable? How do they (or
some of them) identify themselves in different contexts? Specifically, how are
African Americans identified as Jews? In photographer Chester Higgins Jr.'s
Feeling the Spirit: Searching the World for the People of Africa (1994), Hebrew

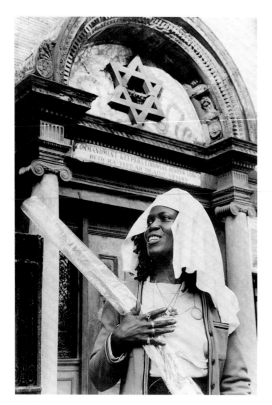

Fig. 5
Chester Higgins Jr.
Untitled *(Woman with Lulav, Commandment Keepers*
Ethiopian Hebrew Congregation, Harlem, New York),
1992. Gelatin silver print, 20 x 16 in. (50.8 x 40.6 cm).
The Jewish Museum, New York, Purchase: Gift of Mr. and
Mrs. Kurt Olden, by exchange, 1995-30

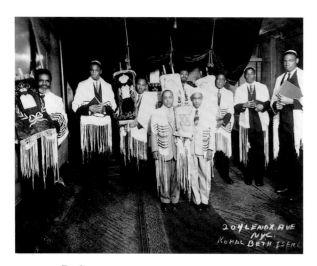

Fig. 6
James Van Der Zee
Kohal Beth Israel, New York City, 1958. Gelatin silver print,
8 x 10 in. (20.3 x 25.4 cm). The Jewish Museum, New York,
Purchase: Judith and Jack Stern Gift, 1994-600

Israelites, a sect on the margins of the American Jewish mainstream, are one group in a "collective portrait" of people of African descent. Members of the African diaspora share a common geographic origin and "empowering spirituality."[27] In *Feeling the Spirit,* several photographs, including *New York City, 1989, Commandment Keepers Synagogue,* which features leaders of the congregation blowing the shofar, represent the diversity of religious practice in the African diaspora; in different contexts another of Higgins's photographs featuring a member of this group, *Woman with Lulav* (fig. 5)—specifically, as reproduced in The Jewish Museum children's book *L'Chaim! To Jewish Life in America!* (2004) and when on view in the museum's permanent exhibition *Culture and Continuity: The Jewish Journey*—represents the racial diversity of American Jews. Whereas in the first the African American Jews' "difference" was located in their Jewishness, although elided through the common bond of African spirituality, in the other, the woman's difference was located in her presumed origins, once again elided with her Jewishness. In both, the ritual implements in use mark both the intersections and boundaries of multiple identities. Similarly, James Van Der Zee's photographs of black Jews on the one hand celebrate the diversity of African American life in the Harlem Renaissance and on the other have appeared in specifically Jewish contexts (fig. 6).

Photographs by Bill Aron in *A Portion of the People: 300 Years of Southern Jewish Life,* an exhibition on the Jews of South Carolina, included photographs of Reuben Greenberg, Charleston's police chief, shown dressed in his uniform at his office, and, in other photographs, wearing a *tallit* in the sanctuary at the Conservative synagogue he attends, or in costume participating in a Civil War reenactment (fig. 7).[28] In each we are clued into Greenberg's multiple identities as represented by the different hats he wears (both literally and figuratively) and the locations he inhabits. Nevertheless, we have no inkling where he fits into the larger story of Jews of the South, their origins and processes of acculturation. In the context of the show, Greenberg's presence as an African American is enigmatic. He is not fully integrated into the family album of Southern Jewish life. The text panel hanging near these three photographs—a general overview narrating the historical progression of this section of the exhibition—was thus disturbing. It stated: "With the rest of the white American mainstream, urban Jews abandoned downtown for the suburbs." Like colonial subjects theorized by Homi Babha, Southern Jews, we are told, shaped their identity by mimicking white Christian society. We are informed that Southern Jews are white, integrated into their host culture, unified, and therefore able to thrive; their differences—places of birth, ethnicities, races, and national origins—are underplayed. Ashkenazi American Jewishness has the ability to absorb occasional "anomalies" such as Reuben Greenberg and the young boy in the picture with Aron's Havurah group, without articulating the complexity of multiracial identities.[29] It is as if, given a homogenizing set of ritual tasks and attributes—as in ethnographic photographs that detail ritual observances—"everyday practices . . . extend a line of continuity from us to them" (fig. 8), as Kugelmass has observed.[30]

Recently, monographs in the form of "personal" photographic albums have also been mass marketed to targeted audiences. Take Lenny Kravitz's published album of photographs by Mark Seliger, which erases the boundaries between

the musician's private and public personas.[31] Kravitz happens to be Jewish, but this book shares little in common with the extended Jewish family albums discussed above. He is "post-ethnic," seeming to transcend racial or ethnic categorization, while asserting a multiplicity of identifications as he performs to Seliger's lens. There is no disruption in this aestheticization of multiple consciousness—thanks to the privilege of a Hollywood background.[32]

That Kravitz grew up finding solace in music, "which he felt embraced all ethnicities,"[33] is evident in the photographs. In one of two photographs captioned *Crosseyed Studio, New York City, 2000,* Kravitz has his arm around his dad's neck, and their faces are close together. Both men are serious. They have the same nose and chin, high foreheads; the patterns of their eyebrows are the same. But the gray-white thinning hair and pale skin of the father contrast with the son's light brown skin and Afro. "My dad is half of what makes me interesting," Kravitz's text states. "The half that makes me different."[34]

Elsewhere Kravitz smiles, sticks out his tongue, looks serious and severe, silly and confused; he slides his glasses on and off, down his nose, so that he is looking over the wire rims. He clowns for the camera, echoing famous stills of the Marx brothers or even Jerry Lewis. Through these self-representations Kravitz claims a visual bond and thus a shared cultural identity with these classic Jewish comedians, as if in response to the theoretical writings of Paul Gilroy: "To share an identity is apparently to be bonded on the most fundamental levels: national, 'racial,' ethnic, regional, local. And yet identity is always particular, as much about difference as about shared belonging."[35] Where is Lenny Kravitz in the larger American Jewish family album? Where does his "difference" locate him?

In a sense Chabad, the Lubavitch Hasidim, have proposed one answer. Their aggressive outreach to unaffiliated Jews and adept marketing strategy are apparent in an almost intuitive grasp of the potential for a policy of inclusiveness. This is suggested by a photograph by Mel Weinstein entitled *One People* that appeared in *Farbrengen* in 2000 (fig. 9). A paean to the Messianic vision of the movement, here the multiracial, multicultural children of Israel are ingathered and redeemed—a theme also plumbed by the Museum of the Diaspora in Tel Aviv (fig. 10).

The representations of Jewishness discussed thus far establish the context for the photography, video, and multimedia installations in *The Jewish Identity Project* exhibition, which may be understood in relation to how images reinforce or challenge stereotypes about Jews and Jewish ethnicity. Photography is an exemplary medium for laying bare the process of identity as "a matter of 'becoming' rather than of being." Following Stuart Hall, scholars of Jewish culture, such as Laurence J. Silberstein, think of identity, "as a 'production' . . . constituted within . . . representation."[36] For Silberstein "identity is seen as produced through the discourses we use . . . [including] ethnicity, religion, gender, sexual orientation, race, nationality, socioeconomic position, intellectual perspective, and geographic location. Rather than unified or singular, identities are considered to be 'multiply constructed across difference, often intersecting and antagonistic, discourses, practices, and positions.'"[37] Because the projects in this exhibition are by a number of artists with varying points of view, they avoid the kind of "coherent units of difference" that Levitt found to be

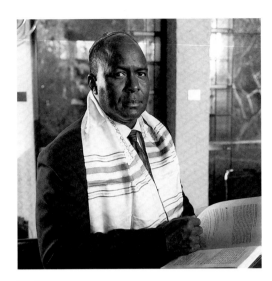

Fig. 7
Bill Aron
Reuben Greenberg, Emanu-El Synagogue, Charleston, South Carolina, 2000

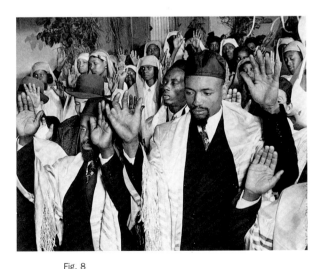

Fig. 8
Alexander Alland
Untitled *(Commandment Keepers Congregation, Harlem, New York),* c. 1940. Gelatin silver Gavelux print, 8 x 10 in. (20.3 x 25.4 cm). The Jewish Museum, New York, Purchase: Judith and Jack Stern Fund, 1994-602

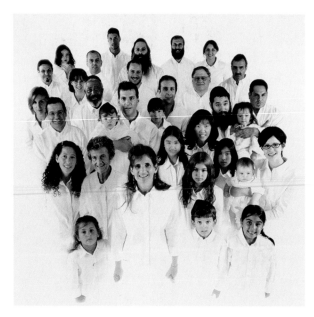

Fig. 9
Mel Weinstein
One People, from the cover of the fall 2000 issue of
Farbrengen Magazine, published by Chabad of California

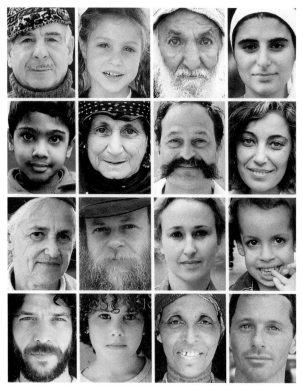

Fig. 10
Ronit Baratz
Portraits of Jews from the Permanent Exhibition, illustration
from the cover of *Beth Hatefusoth, the First Ten Years*
(1988), designed by Hayim Shtayer. Courtesy Beth
Hatefusoth, The Nahum Goldmann Museum of the Jewish
Diaspora, Tel Aviv

neutralized in Brenner's project. They are not intended to be read together, as "horizontal lists, producing clear boundaries," or to offer a single, coherent representation of American Jewishness, but rather to consider individual subjectivities and the shifting and dependent experiences of American Jews. The projects, by both Jewish and non-Jewish artists, look at American Jewishness across "racial," ethnic—Latino, Middle Eastern, black, Asian, Native American, and white—cultural, geographic, gender, and class borders. They explore hierarchies of difference in the construction of American Jewish identity as well as the role of power relationships in the control of communal boundaries. They communicate the experiences of Jewish ethnic and racial identities, how they are constituted visually, and how images both reflect and shape individual and collective Jewish identities. They question ideas about: What is Jewish? What is multiculturalism? What is photography?[38] The Jewish Museum is attempting here something quite different from the extended family albums of the past.

ARE JEWS WHITE FOLKS?

The first section of the exhibition interrogates the question: "Are Jews White Folks?" It focuses on the ways the discourse of race constructs Jewish identity in the United States and the limitations of understanding Jewish identity in terms of "white" ethnic minority status or any assumed "racial" category. In the United States, social constructions of race have made Jews of color virtually invisible in the Jewish community.[39] Here four projects by Dawoud Bey, Nikki S. Lee, Chris Verene, and Shari Rothfarb Mekonen and Avishai Mekonen both question assumptions about Jews as "white folks" and explore the complexity of "whiteness" itself.[40] These projects ask: If a Jew is not defined by what he or she looks like, how are Jews identifiable, and how do they identify themselves in different contexts? How do individuals navigate simultaneous sites of identity (geographic, ethnic, racial, gender, economic), and how can the intersections of these multiple sites be represented visually? These projects critically reflect on the notion of Jews as a white ethnic minority group, bringing issues of Jews and race into sharper focus. In all of them, identification is important. Viewers might ask: Who am I looking at? What do I assume about the individuals I see? Is this person Jewish? How do I know?

Pseudoscientific ideas that constructed Jews as a separate race were products of nineteenth-century European anti-Semitism. Almost simultaneously, these "racial" characteristics developed into lingering modern stereotypes of Jews, which have also been internalized as Jewish "difference."[41] In the twentieth century, as European Jews in the United States became more firmly identified as an ethnic group (or sometimes a religio-ethnic group), racial characteristics became ethnic characteristics. What has happened since the closing decades of the twentieth century is that, within the framework of multiculturalism, stereotypes of Jewish ethnicity have become entrenched. Jews are all-too-commonly represented as East European, white ethnics, with Yiddish-speaking backgrounds and a certain self-deprecating style of humor, partial to certain ethnic foods, and rooted in certain neighborhoods of America's large cities. Even when Jews are dispersed from these centers, it is still food and a particular

East European nostalgia that lets them remember they are Jewish. Such a view, though it may still be true for the majority of American Jews, who are nonetheless rich in diversity, has come to exclude the reality of Jewish heterogeneity. In other words, when Jewishness is represented in the multicultural mix of American culture generally, it seems to fall back on particular stereotypes—think Jerry Seinfeld or Jackie Mason, for example. The nuances of the "microdiversity" of the American Jewish experience are often absent.[42]

In the early 1990s Dawoud Bey turned to issues of identity and representation among adolescents from minority communities through large-scale Polaroid photographs meant to disrupt stereotypes of young people that appear in the media—whether negative images or unrealistically idealized ones. Eventually, Bey moved away from the Polaroids to crisp, monumental chromogenic color prints. In 2002, he worked with Chicago high school students to create a collaborative photographic, audio, and text project addressing the questions, "Is it possible for a photographic portrait to reveal anything 'real' about you to someone else? What aspects of yourself are you willing to share with the world, and how do others respond to those self-representations?"

Bey's setting in his ongoing series *Class Pictures* has been the high school classroom—the one place that dominates students' social interactions, where they struggle to define themselves against and within the larger group. These works reflect Bey's interest in describing experience: How does a pose convey individuality? How is the subject revealed through facial expressions and body language? While the photographer's posing of figures places boundaries on self-expression, the sitter's personality is not necessarily neutralized. Bey's project for The Jewish Museum continues these strategies, though the setting has been moved to the subject's own home. In these domestic interiors, Bey's images mark the tensions of adolescence and project a dual sense of defiance and vulnerability; in their monumentality and directness they also straddle the boundaries between public and private personas—what we keep to ourselves and what we show to others. Bey has posed his subjects with arms or elbows propped on tables or, in one case, the pillows of a couch. These gestures are at once protective and expressive. Much of the impact of these photographs is achieved through one of Bey's key aesthetic strategies: a narrow depth of field, in which he presents the sitter's face and body in sharp, yet ambivalent relief. Here and there within a single photograph the body meets the blurred background with a knifelike edge or in soft focus. Audio interviews by Dan Collison and Elizabeth Meister complement the images and allow the young people to literally speak for themselves about being young and having a Jewish background while simultaneously negotiating issues of race and ethnicity. In the context of this exhibition, Bey's work undermines easy assumptions about how Jewishness is marked in visual representations and intersects with his belief that young people "are arbiters of style in the community; their appearance speaks most strongly of how a community of people defines themselves at a particular historical moment."[43]

A second artist in this section is Nikki S. Lee, an émigré from South Korea. Lee is the subject of her own work, enlarged snapshotlike photographs staged to interrogate specific issues regarding the performance of female and ethnic identities. In the *Projects* series (1997–2001), Lee staged and put herself in the scene while someone else snapped the picture, to create seemingly informal

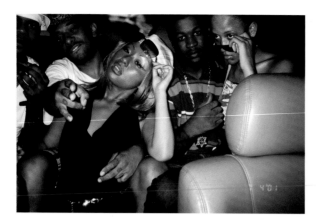

Fig. 11
Nikki S. Lee
The Hip Hop Project (1), 2001. Fujiflex print, 21½ x 28¼ in.
(54.6 x 71.8 cm). Courtesy of Leslie Tonkonow Artworks +
Projects, New York

group portraits depicting hip-hop culture, seniors, yuppies, Japanese schoolgirls, exotic dancers, skateboarders, and more (fig. 11). Paying particular attention to the matrix of social, ethnic, and cultural differences among groups, Lee uses makeup, hairstyle, gesture, and dress to pass into other cultures and races and to call into question how fixed or homogeneous the identities of those groups, or the individuals within those groups, really are. In a more recent series, *Parts,* begun in 2002, Lee uses male friends or hired actors in carefully staged narratives that she then has photographed, but she carefully slices most of the man out of the picture in the enlarged final prints. The viewer gets only hints of a story and must confront what is missing. By cropping the figure of the man, Lee draws attention to the fact that it is the masculine figure's privilege that she seemingly borrows for her access into the particular situation.

The settings for these works have been wide-ranging: the back seat of a London taxi, a Home Depot store in Queens, and the delivery room of a Memphis hospital. Who is Lee playing in each of these scenarios? Is this the real Nikki Lee? The answer is intentionally ambiguous, to be determined by what the viewer brings to the encounter. Such questions are central to the work she has created for The Jewish Museum. Using the strategies from the *Parts* series, Lee has herself photographed as the bride in a Jewish wedding ceremony, literally cutting most of the white groom out of the picture. The final work incorporates the ambivalence of the question as to whether the missing man is the one who has provided her access into Judaism, thus interrogating the suspicion that Asian women sometimes find accompanies their presence in the Jewish community—the assumption that they are there because of a man. For Lee, the work also sets up the question as to how far she can successfully integrate herself into a group that is intrinsically different from the one she comes from—is there a common ground between her and her partner? Can she be Jewish? And can viewers of her work see her as such?

The third project in this group is Chris Verene's *Prairie Jews,* shot in Galesburg, Illinois, the small town where he was born, and where most of his photographic work has been based. Verene now lives in Brooklyn, but continues to travel frequently to Galesburg. Thus he is simultaneously insider and outsider to this community—an overwhelmingly Protestant manufacturing town and rail crossroads with a population of just under thirty-four thousand people. Verene himself has observed the liminal visibility of the Jews of Galesburg: "There is a small synagogue and an old Jewish cemetery there and yet one would not know who is Jewish in the community without asking."[44] The local Temple Sholom's Reform congregation is made up of thirty-five families. Too small to afford a permanent rabbi, it is served by a student rabbi from Hebrew Union College–Jewish Institute of Religion in Cincinnati.

Representations of regional Jews tend to essentialize or stereotype both the "people of the dominant culture" ("the people of the Prairie" in Verene's case) and the Jews who assimilate into that culture. But Verene's pictures and the stories he tells through his handwritten texts on the edges of the paper challenge and complicate the idea of the prairie and the prairie Jews. The first Jewish settlers came to Galesburg in 1855, less than twenty years after the city's founding in 1837. Conspicuously different from their coreligionists on the East and West Coasts despite their ethnic ties, do Galesburg's Jews blend into Midwestern

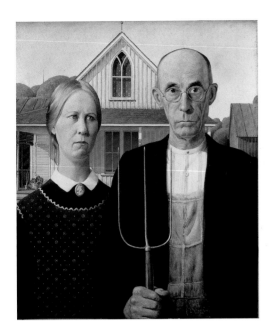

Fig. 12
Grant Wood
American Gothic, 1930. Oil on beaver board, 30¹¹⁄₁₆ x 25¹¹⁄₁₆
in. (78 x 65.3 cm). The Art Institute of Chicago, Friends of
American Art Collection, 1930.934

culture or are they integral to its formation? Though few in number, they are not just immigrants to this Midwest town but settlers as well.

We see Donny, Verene's father, and one of his two best friends in *Donny and Barry on the Porch* (2001). Both of Donny's best friends from childhood, Barry and Harry, happen to be Jewish. Verene's composition in *Donny and Barry on the Porch* echoes Grant Wood's famous painting *American Gothic,* in the collection of The Art Institute of Chicago, which depicts a farmer and his spinster daughter in front of their house (fig. 12). Wood—who was from Iowa—was accused of creating a satire on the intolerance and rigidity that the insular nature of rural life can produce. He denied the accusation, claiming that *American Gothic* epitomized "the Puritan ethic and virtues that he believed dignified the Midwestern character."[45] With a nod to Wood, Verene seems to offer us these Jewish and gentile Midwesterners as embodiments of similar virtues as well as to show us the fluidity of boundaries in both their relations to the seeming insularity of that locale.

The caption accompanying each of Verene's photographs does not try to give us the complete story of its subject or to seamlessly narrate a complex life as a journalist might. We get the "most whole truth."[46] We glean from the artist's texts that "barry and donny and harry have been best friends since cubscouts" and that "my father, donny, says they almost made eagle scout together" and that "harry founded the galesburg model train show." We see Brenda, who is originally from Peoria and works at a liquor store and as a maître d' at a local restaurant, in a jungle-print shirt in a garden, holding a glass of wine: "Our friend brenda drinking a toast to the flowers!" Verene's work in Galesburg has the effect of creating an extended family album, a chronicle of the town. In getting to know the town's Jews and adding their representations to his ongoing narrative of small-town life, he develops a reformed history. In Max Wineman ("our friend max is 93. he was close to my father's father" and "max escaped from the camps and came alone to galesburg. his wife passed away in 1972"), the photographer sees "a fascinating hybrid identity" where the "work in the end seeks to complicate any stereotype of Jewishness—yet relies on it as well." Max's life and Verene's visualization of it may make us think about how Jewishness is constituted not only through communal institutions or familial rituals but also individually and alone.

This section also includes a specially edited excerpt from Shari Rothfarb Mekonen and Avishai Mekonen's *Judaism and Race in America,* a documentary presenting the stories of Jews of color living in the United States. This film follows Mekonen's search for his identity as a Jew of color new to America. An Ethiopian Israeli married to his co-documentarian, Rothfarb Mekonen, of European descent, Mekonen emigrated to Israel during Operation Moses at the age of ten, in 1984—his first pivotal journey. On September 11, 2001, Mekonen had an appointment for an INS-required blood test in Lower Manhattan and was carrying his Israeli passport. When the catastrophe struck at the World Trade Center he made his way to the site and began working with uniformed police and other rescue workers. After three hours, the FBI began to take greater notice of this dark-skinned man with a foreign accent and less-than-fluent command of English. "Who are you?" they asked. He wanted to explain that he had served in the Israel Defense Forces and was trained in emergency response. He showed them his

passport. They looked in disbelief. "You can't be a Jew," they said. "You're black." They refused to believe him and became suspicious of his presence at the scene.

In New York City Mekonen was confronted by the question "Are you Jewish?" for the first time. In response he asks, "Who is a Jew?" Mekonen's journey intersects with the stories of other American Jews of color. Stylistically, the film layers Mekonen's past and present lives and uses vérité footage to reveal and integrate the central themes of visibility, acceptance, diaspora, and community. This message of the film is underscored by commentary by such figures as Ephraim Isaac, professor of African history, language, and religion at Princeton University, who is of Yemenite and Ethiopian descent and discusses the historical diversity—both ethnically and racially—of the Jewish people.[47] Rothfarb Mekonen and Mekonen have said that the people in their film "confront tough questions: How to resolve their own conflicting multiple identities? What does it mean to gain 'acceptance' into the majority Jewish society? What needs to be changed? But most of all, What does it mean to be a Jew?"[48]

By making Mekonen's story the centerpiece of their narrative, Rothfarb Mekonen and Mekonen destabilize the authority of the white, male Ashkenazi Jewish protagonist. Mekonen's multiple migrations also complicate our sense of American-Jewish identity and the story of the Jews in America as a singular grand narrative of immigration, acculturation, progress, and economic success. His story reminds us that, as in the United States population generally, more Jews in America are foreign born today than ever before. Other questions raised by the film—such as "How do the multiple identities of Jews of color speak to and illuminate the issues of intermarriage and interracial unions of all kinds in America today?"—are also relevant to the larger culture.[49]

WHERE IS HOME?

The second section of the exhibition explores issues of emigration and exile and asks the question: "Where Is Home?" This section includes videos by Jessica Shokrian, installations combining videos and photographs by Rainer Ganahl, and photographs by Andrea Robbins and Max Becher that in their different ways explore to what extent America is "home" to Jews from different places of origin and what role Jewishness plays in creating a sense of home. Do individuals live in perpetual exile from a homeland, real or imagined, religious or national— whether it is Israel, Iran, Austria, Mexico, or elsewhere? One of the questions that Laurence J. Silberstein has asked in his research on Jewish identity is, "How do contemporary Jews position themselves within, and/or how are they positioned by, the narratives of the past?"[50] While this question is relevant to most projects in the exhibition, here key narratives are immigration to America and diaspora in relationship to a spiritual homeland or place of origin. While traditionally Jews have thought of themselves as being "at home" in America, still there are many comings and goings, and immigrants, whether recent or more settled, continue to live between cultures. Ongoing migrations of Jews and other immigrant groups perpetually reshape both the self-image of Americans and of American Jews.

The word "Diaspora" (capitalized) represents the historic dispersion of the Jewish people in the first century of the Common Era. But as David Biale, Michael Galchinsky, and Susannah Heschel point out:

[Jewish] history and religion have required a constant dialectic between "homeland" and "exile." In the contemporary world more and more people are said to live in diaspora and the creation of a true multiculture requires devising ways of negotiating between one's home and one's homeland. For Jews, this is an old problem and a new one. On the one hand, the Holocaust has destroyed what was the ancestral homeland for most American Jews. On the other, the state of Israel has provided a new homeland, although a paradoxical one since most American Jews neither come from there nor intend to live there. The complex ways in which collective identities are formed in the tensions between homeland and diaspora are common to Jews as well as other migrant groups (contrary to the assumptions of many American Jews).[51]

America is perceived as an "exceptional diaspora" outside the framework of exile and redemption.[52] And American Jews have a complex relationship to the rest of the Jewish Diaspora. Jews have understood themselves as having a common origin but as being a diverse people with hybrid identities in relationship to the dominant cultures in which they live. The consequences of this paradigm have been to create a hierarchy among Jews of European descent and others, and in this country, in particular, a hegemony among Jews of Ashkenazi descent. Non-Western Jews are often exoticized, commonly represented as ethnographic subjects fixed in the "timeless" and "eternal" cultures from which they have been wrenched by the upheaval of modern society.[53] While recognition of the multicultural beginnings of Jewishness are crucial for undoing this stereotype, the diaspora concept becomes the framework through which some white Jews try to integrate their understanding of the Jews of color they meet today, thus re-exoticizing them.[54] For example, the contemporary black Jew of European and Afro-Caribbean heritage is seen through the lens of the "exotic" Ethiopian Jew. As shown above, in the case of Avishai Mekonen, Jewish identity is overdetermined by geography; the Ethiopian Jew in New York is suspect from the point of view of others unlike himself, whether Jewish or not; there appears to be no place for him in the episteme of American Jewish identity. The obsession with what Jews look like intersects with geography in this discourse. The diasporic model of Jewish history in which Jews are seen as coming to look like the people among whom they live continues to marginalize Sephardi, Mizrahi, and other Jews of color in the United States.[55] The discourse of whiteness—even in such groundbreaking studies as Karen Brodkin's *How Jews Became White Folks and What That Says about Race in America* (1998)—reproduces the same effect of marginalizing Jews of color and other non-European Jews in the United States.

The Jewish framework of Diaspora seems to be fixed with historic territorial borders. In a global world, however, we understand the fluidity of borders and see that Jews, like other peoples, are still on the move.[56] A Jew born to a European émigré to South Africa may settle in California for a generation, while his brother emigrates to Israel. How can our old notions of Diaspora say much about contemporary Jewish identity? As Jewish community centers and synagogues learn to celebrate Jewish difference in America—for example, through multicultural Shabbat dinners or Hanukkah observances that feature the customs, foods, songs, and dress particular to various Jewish ethnic and national groups—the community is made aware of its heterogeneity. At the same time, the presumed

essential nature of these ethnic or national groups is in danger of being repro-
duced in a new, and overarching, way. Their essential and exotic foreignness
comes to be seen as both a reflection of their fundamental nature as Jews and of
their basic character as, for example, Iraqis, Indians, Poles, or Italians. As new
boundaries are erected around those identities, geography becomes the deter-
mining factor of Jewish identity. We lack the ability to pierce the borders, to
find, as Amiel Alcalay has put it, what we "might again become."[57]

Rainer Ganahl, who was born in Austria but lives and works in New York
City, actively engages his subjects to create works that investigate identity, dis-
location, culture, and politics. Beginning in 1999 he has worked on a series of
installations called *Language of Emigration* that comprise video interviews and
photographs of German and Austrian refugees and survivors of the Holocaust
who came to New York immediately prior to, during, or shortly after World
War II. At first glance, Ganahl's project seems to share much with the ground-
breaking work by historians and others to gather Holocaust testimony (the
Yale Fortunoff Video Archives for Holocaust Testimony and, perhaps best
known, Steven Spielberg's Survivors of the Shoah Visual History Foundation
now housed at the United States Holocaust Memorial Museum) before the last
remaining witnesses are gone.[58] In Ganahl's work the interview process is a
self-conscious enterprise in which the subject's story reveals much about the dis-
location, rejection, and preservation of the past. The point, too, is to understand
a person in process, how not only one particular experience, but all memories
and experiences constitute an individual.[59] In the stories they tell the artist,
prompted by his questions, these people retell their lives, thereby revealing the
continuities and disruptions in their personal and cultural identities. All born
Jewish, they have lived various Jewish lives. And who they have become, rather
than who they are, can only be communicated in the telling.

Beginning in 2003 in response to this commission from The Jewish
Museum, Ganahl decided to also interview the children and grandchildren
of a German and two Austrian émigrés. The émigré families include Gerda
Lederer and her daughter, Catherine L. Lederer-Plaskett, and son-in-law, Rodney
Lederer-Plaskett, and their children, Aliza and Lucas; Gisa Indenbaum and
her daughter, Miriam Indenbaum, and son-in-law, Wilfredo Rodriguez, and their
son, Michael; and Lizza Schlanger and her husband, Sam, and their daughter,
Debby Schlanger. In many cases members of these extended families have relo-
cated and intermarried, creating new families, which include members who are
not Jewish, who are African American and Latino—as well as families with
same-sex parents and adopted children. As the interviews bring out, the ties of
the younger generations both to Jewishness and to their parents' and grandpar-
ents' traumatic European heritage mean different things. What it means to be
an American and a Jew is transformed from generation to generation. Ganahl's
project maps these lines of migration and change.

In the installations, portrait snapshots of the subjects and of the interiors
of their homes hang on the gallery walls while a monitor plays the lengthy,
unedited video interviews. The photographs and interviews relate intimate sto-
ries, sometimes painful and sometimes banal, as the subjects narrate their own
histories. Their homes offer clues to the past, the presence of objects that func-
tion as souvenirs of earlier periods in their lives. Such fragments transgress

the boundaries of past and present as time intersects with issues of identity, raising questions about who these subjects were, who they are, and who they might have become if history had not intervened. On desks, coffee tables, and bookshelves, objects out of time occupy the physical space alongside newly published books, today's newspaper, or a current calendar. In the context of the dislocation of diasporic identities, Freud's term *unheimlich* is all the more apt as such objects constitute the uncanny, the "unhomely" seemingly "at home." Language also functions in the same way. Ganahl's original subjects were all in their eighties. Having come here as teenagers, they have lost most of their German accents, but the repressed accent and the language itself "returns" depending on the conversation, and German words sometimes come easier when describing a historical situation. As Ganahl has noted, the German is sometimes anachronistic, using idioms frozen in the mid-1930s; no one has spoken exactly this way in seventy years.

Ganahl is more than a generation younger than his initial émigré subjects, so they automatically have more authority than he does. He is the naïf. Though born decades after the end of World War II in a country of the perpetrators, there is surprisingly little tension between interviewer and subject. We never see Ganahl directly in his work, although he is ambivalent about trying to neutralize his own presence as an interviewer. He cannot resist asking Miriam Indenbaum, "When you meet an Austrian like me you would not automatically think or ask the questions: what did his grandparents, what did his parents do?" Her answer must be comforting: "It would never occur to me," she says.

Ganahl's subjects also provide their audience with alternative narratives of Jewish immigration to America. Not all those interviewed are completely comfortable as Americans whether they are immigrants or first-generation Americans. Like earlier East European immigrants, the children may feel the most at home, although not in every case, settled in the different cities and communities in which they live, in the kinds of work they have taken up, optimistic about the future. Gisa Indenbaum's family's traumatic story of running from the Nazis and subsequent struggles in the United States is particularly poignant as it presents a narrative counter to the conventional immigrant success story. As an American she is a failure. Neither she nor her sister or parents "became American" she tells Ganahl.

Ganahl's photographs show the things with which she surrounds herself, a "symbolic ecology" that structures her individuality to herself and reveals it to outsiders.[60] Indenbaum's refrigerator door is a memo board holding her Red Cross volunteer ID and credentials to enter the World Trade Center site. There are snapshots of family and friends, a political button; black-and-white photographs, mostly landscapes, and stark graphic works in simple frames adorn the walls. Her shelves include such Jewish books as *Masada, Pathways through the Bible, Tales of Elijah the Prophet, Jewish Stories One Generation Tells Another,* and I. J. Singer's *Ashkenazi;* professional and reference books; and books on feminism, gender, and motherhood, all ordered on separate shelves. There are many non-Western decorative artifacts, masks, and statuettes, symbols of a common and global humanity—of an archaeology of knowledge. Indenbaum's hybrid surroundings and her story as the visualization of her émigré identity situate her between what Israeli-born Irit Rogoff has called the two inevitable

and mutually interdependent sites of belonging and displacement.[61] For many of Ganahl's interviewees, as well as for other Jews living in America who have lived other lives, whether in Europe, the Near East, or Africa, Rogoff's concept of the "diaspora's diaspora" holds true.[62] Indenbaum's discomfiture as an American reflects her exile from the prewar European Jewish world of her childhood. This kind of exile experience has a particular resonance for Jews who emigrated to the United States owing to the turmoil of the twentieth century. For Gisa Indenbaum, there is no home to which to return. "Those places don't exist anymore," she tells Ganahl.

For Americans, the diaspora's diaspora may undermine the possibility of feeling completely at home. Jews are becoming more and more a transnational minority with connections to their actual or imagined homelands. Even with varying degrees of traumatic rupture from a faraway place, one can maintain a connection to it. There are songs and languages, foods and customs, carried not only in memories but purveyed locally in neighborhood specialty food stores catering to émigré populations. This is evident in Jessica Shokrian's project and in some of the voices in Tirtza Even and Brian Karl's, which is in the final section of the exhibition, and in Miriam Indenbaum's feelings for Israel. Perhaps temporal distance is one of the biggest factors in how much an identity is implicit in a place imbued with nostalgia and longing. One cannot ignore either the fact that Israel is for many Jews who live in the United States, and who may even have dual citizenship, a place of origin—mythic or national—rather than a place of return.

The culture created and sustained by Iranian immigrants in Southern California seems significantly more insular than life for Ganahl's Austrian and German Jewish families on the East Coast. The relationship of artist to subjects is also very different in the case of Ganahl and Jessica Shokrian; Shokrian was born and raised in California and began taking pictures as a way to connect with her extended Iranian Jewish family, Persian Jews whose language of Farsi she did not speak. This longing for connection with a mysterious origin (exacerbated by the fact that Shokrian's mother was not born in Iran and was a convert to Judaism) and a quest for personal identity drew her to photography, writing, and videography. In 1998, Shokrian began documenting the life of her Aunt Aziz, then seventy years old, who had come to California to visit family twenty years before and due to the deteriorating political situation never returned to Iran. In the eleven-minute video *Ameh Jhan (Dear Aunt)* from 2001, a slow pace and the visual details poetically transform a bus ride to the ethnic food markets before Shabbat into a metaphor of the displacement and longing experienced by an immigrant living between cultures. Her routine journey marks the separation between her extended family, and their success, and the Fairfax neighborhood where she shops—with its imported foods, newspapers, culinary smells, and common language that maintain the flow of contact between America and home.

Ameh Jhan has become the centerpiece for a longer work composed of five additional self-contained video pieces with different styles and emotional pitches. Through the lens of ritual and life-cycle events, these look at other family members, her relationship to them, and to the demands of Iranian Jewish American society. The sequence opens with *Simchah Torah* (2004), which introduces the extended family and marks an important communal event in which Shokrian's father, Nasir, donates a Torah to his synagogue. It also signals

Shokrian's efforts to bridge the distance from her own increasingly religious father, who came to the United States as a student in the 1950s, through her art. The group parades with the Torah through Beverly Hills to arrive in the lobby of a grand hotel where they will install the Torah in the ark of their temporary sanctuary, a ballroom. But before they do so, the women take the Torah and pass it around, kissing it, which is shown in slow motion. They spontaneously begin to trill, a traditional expression of emotional and religious rapture. Afterward, the image cuts to the final scene. Nasir emerges alone from down the street and walks toward his house. The sky is a dark but brilliant moonlit blue, and the road is aglow from the streetlights. Behind him another group of family members walks very slowly into the frame. They cross the street toward the house, too. It is not Iran, but it is home.

The videos also reveal the tension implicit in frameworks of cultural conformity—such as *Brit Milah* (2004), documenting her cousin Isaac's son's *bris,* the filming of which evoked memories from ten years earlier of the mixed emotions that almost led the artist herself to call off her own son Hunter's *bris*.[63] Next, *The Funeral* from 1999 shows the funeral of Aunt Aziz's husband. Shokrian's camera focuses not on the mass of mourners but more tightly on two figures who take an active role, Aunt Aziz's daughter-in-law, who is Polish, and Hunter, who looks visibly different from his relatives, who toss flowers onto the lowered coffin. *Ameh Jhan (Dear Aunt)* comes next, followed by *The Engagement* of 2003, the most abstract as well as briefest of the videos. A quick succession of somewhat grainy images and close-ups are suffused with a blue atmosphere as young people speak to each other and directly to Shokrian. On the sound track we hear, "She lives behind the camera," and "Face the reality of your life, Jessica." It is the most explicit acknowledgment that, as an observer, the artist is hiding behind the camera rather than participating in her family's life; yet at the same time filming is her way of coming to terms with her relationship to this larger world. The final shot is of Hunter, who in gesturing seems to signal to his mother in a reassuring way, while also somehow representing her unseen presence. Filmed at the engagement party of her cousin Rossana, the separation Shokrian feels from the events underscores her own distance—as a single mother—from the model of Iranian family life valued by the traditional community, despite such realities as an increasing divorce rate.[64]

In the last of the six videos, *Turning It Around* of 2005, Shokrian turns the camera on herself. At times sound track and image are out of sync. The artist exudes a painful self-consciousness as she confesses that she is "extremely concerned with how I look and how I look to other people." She moves in and out of focus, seemingly unable to control her own representation or artistic means. The repetition in the editing, an endless loop, underscores the failure to complete the circuit of communication and intensifies the emotional impact of this coda. Viewed in sequence, Shokrian's videos reveal moments of convergence and divergence in a group portrait that ranges across the multiple geographic, generational, economic, acculturational, and religious experiences of one family.

During the last twenty years Andrea Robbins and Max Becher, born in Boston and Düsseldorf, respectively, have created photographic projects encompassing portraits, landscapes, and architectural motifs centered on dislocated and reconstituted cultural experience. Each series of their photographs is accompanied

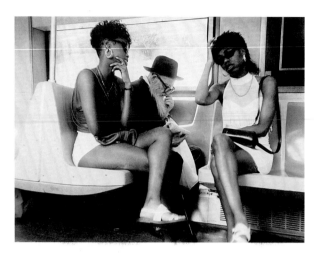

Fig. 13
Thomas Roma
Untitled *(Two Women and Elderly Jewish Man on N Train, Borough Park, Brooklyn)*, 1994. Gelatin silver print, 11 x 14 in. (27.9 x 35.6 cm). The Jewish Museum, New York, Purchase: Photography Acquisitions Committee Fund, 1999-116

Fig. 14
Cover of Stephen G. Bloom's book *Postville: A Clash of Cultures in Heartland America* (2000)

by a text that they have written to explain the ironies in their pictures. In *Postville*, one half of their two-part project for The Jewish Museum, entitled *Brooklyn Abroad*, they have photographed members of the Lubavitch community in Postville, Iowa, who moved there from Brooklyn in the mid-1980s, attracted by the opening of a Glatt kosher slaughterhouse and processing facility.[65] The irony uncovered by Robbins and Becher's project is that the Hasids now really are but "one facet of the family of American Jewry."[66] They can no longer legitimately be represented as the remnants of a dying culture, as ethnographic photographers have done before. Nor are they representations "of the essential Jewish self uncorrupted" whose "existence betokens continuity."[67] While there may be a somewhat "lyrical romanticism" in some of these pictures, such as *Fishing Scene* (2004), it is not tied to spiritual practice but rather embodied in the relationship between father and son and communion with nature. Mundane existence is everything in these photographs. Although these Hasidim have been almost demonized for their failure to attempt to blend into public life in northeastern Iowa, Robbins and Becher's photographs show that Postville's Orthodox Jews are not so different from their neighbors in their living relationship to a place where lawns must be mowed, houses painted, and nature and family can be enjoyed— except for the symbols of or some of the values ascribed to geography, such as the stereotypical overalls and farmers' caps worn by "the locals."

Robbins and Becher did not look for the encounters between those assumed to be native and the newcomers, the "foreigners" to this place. What would such encounters prove? Elsewhere, however, other photographers, such as Thomas Roma, have created images in a New York City locale that attest to the striking visual contrast of cultures between ultra-Orthodox Jews and other "locals" (fig. 13). In the case of Iowa, some of the most sensational representations have become iconic representations meant to stand for the entirety of the relationship between the Lubavitchers and those "already there," as if even the most native of the Iowans did not come from somewhere else, and perhaps displace someone else "already here." That encounter was staged dramatically in the cover image on Stephen G. Bloom's book *Postville: A Clash of Cultures* (fig. 14). Ironically, that representation is a pastiche, a composite of two stock photographs. While the figure of the Jew walking down the street with prayer book in hand may illustrate one of Bloom's contentions that the Hasidim were unfriendly to their gentile neighbors, more seriously, it has been criticized for not truthfully depicting a Lubavitcher Hasid, whose clothing is distinctively different from that pictured.

Robbins and Becher's representations of Postville's Jews are not circumscribed by the black-and-white *lieu de mémoire,* the urbanized shtetls of Brooklyn's Crown Heights, Borough Park, or Williamsburg neighborhoods fixed in a timeless eternity. While some viewers may associate the Hasidim with urban spaces, they rarely have been depicted outside (the exception may be Leon Levinstein's photograph of Hasidim in Prospect Park in the 1950s, fig. 15) or in color photographs—like Robbins and Becher's intensely hued examples, where they seem somewhat out of place in nature. How much the group reimagines itself in this setting is open to speculation. Are they trying to reconstruct the European shtetl, their imagined point of origin? The Lubavitchers are a massive organization that operates worldwide. Their portable culture extends beyond the Torah itself and is embodied in mass media communications and ubiquitous

Fig. 15
Leon Levinstein
Prospect Park, c. 1955. Gelatin silver print, 11 x 17 in.
(27 x 43.2 cm). The Jewish Museum, New York, Gift of
Howard Greenberg, 1998-15

images of the Rebbe, Menachem Schneerson, who died in 1994. Not only
does his representation freely circulate, but so, too, although at much greater
expense, does his home, the world Lubavitch headquarters at 770 Eastern
Parkway, which has been replicated in Jerusalem, Los Angeles, and elsewhere,
as shown in Robbins and Becher's *770* series. For the photographers, this home
is "a visible though not often seen sign of the distance between Hasidic identity
and the difficulties American Jews have in letting go of antiquated images of
idealized European Jewish identity." It represents multiple points of origin for
the Hasidic community.

Robbins and Becher's representations of the Postville Hasidim are uncan-
nily earthly. Their pictures incorporate the familiarity of the snapshot aesthetic
while undermining such key aspects of tourist photography as its homogeniza-
tion and mystification of regional groups. Despite their particular traditional
way of life, the ability of the Hasids to stand for "traditional" life in Iowa seems
implausible. It also signifies the ambivalent possibility of the region being repre-
sented by any single, "authentic" cultural group or by a particular way of life.[68]

WHAT IS JEWISH?

The third and final section of the exhibition is a further exploration of the
boundaries of Jewishness and takes up the question: "What Is Jewish?" Here
photographs by Jaime Permuth and video projections by Yoshua Okon are the
products of collaborations with two very different communities of Spanish-
speaking Jews, Permuth looking at one on the East Coast, and Okon on the
West Coast; while Tirtza Even and Brian Karl have created an interactive multi-
media installation around the question "What does Jewish mean?" based on
interviews with a variety of people living in the United States, mainly in New
York City.

"It is the myth of a common and unique origin in time and place that is
essential for the sense of ethnic community," according to Anthony D. Smith.[69]
But as Shaye Cohen points out, "Whether the group in fact shares a common
and unique origin does not much matter; what matters only is that the members
believe that the group shares a common and unique origin in a specific place at
a specific moment." For the ancient Judaeans, and for Jews today, Jewishness is
more than a religion. The ethnic group, nation, or people—the words can be
interchangeable—coheres because of its "common culture," its "collective will,"
even if it no longer shares a common territory or real point of origin.[70]

These three artists' projects address how individuals with common experi-
ences imagine Jewishness. How do individuals, alone or within groups, define
themselves through narratives of Jewish continuity? What is the role of ritual in
this process? How do different cultural and ethnic heritages shape community
and the institutional frameworks that support it? Ultimately, the projects in this
section underscore the larger question posed by this exhibition for Jews in par-
ticular, and for Americans generally: How do we see our (communal) future?

Jaime Permuth, who was born in Guatemala in 1968 and now lives in
Crown Heights, uses a traditional documentary approach. He develops ideas
through an investigative process, spending lengthy periods with his subjects.

In this case he maps the intersections of ethnic, national, linguistic, religious, and gender identities as he follows three narratives of the Spanish-speaking nondenominational congregation El Centro de Estudios Judíos Torat Emet (Torat Emet Center for Jewish Studies). Torat Emet was founded in Riverdale, in the Bronx, by a young Sephardi rabbi born in Miami of Cuban descent, Rigoberto Emmanuel Viñas, who, like many in his congregation, traces his roots to the Spanish Anusim (*conversos*). Through his activities both as a scribe and rabbi, Rabbi Manny, as he is affectionately known, has gained a reputation beyond the borders of the United States and has become a spiritual guide to individuals seeking to convert or return to Judaism.

Rites of passage bring newcomers into the community, but they also allow for individual new beginnings. Through Permuth's series of photographs, *La Conversión de Carmen (Carmen's Conversion)* of 2003, the viewer enters the privacy of a Beth Din (a judicial panel of three rabbis) under the supervision of an Ashkenazi rabbi in Borough Park, Brooklyn. For more than twenty years, Carmen, a single, professional woman born in Cuba, had gone through an intense spiritual questioning until she found Rabbi Manny and commenced a two-year program of learning and preparation to arrive at this point. Her moment of spiritual transformation and communal recognition takes place in the context of a very specific legal process maintained for centuries in and transplanted from Eastern Europe, and to which, in fact, she herself is a stranger.[71] The first photographs show Carmen waiting to begin the process. Then, overcome by emotions, she does her best to answer the rabbis' questions. Although the very private experience of the *mikveh* (ritual immersion in a bath of water) was not photographed, the ceremony's conclusion is shown as Carmen signs a contract, is blessed, and emerges into the daylight as Esther.

The second story, *Kashrut en la casa Liker (Kashrut in the Liker Home)* of 2003, follows the Liker family—Howard, who was raised Jewish, Vivian, who was born in Ecuador and raised Christian but has converted, and their son, Jeremy (Vivian also has an older daughter from a previous marriage)— as they make their kitchen kosher. With Rabbi Manny they examine various kitchen utensils to determine which can be "kashered," or ritually purified, and retained, and which must be discarded. The last photograph shows Vivian, exhausted, yet happy, collapsing into a chair, the task completed. The third story, *La Bat Mitzvah de Gila Viñas (Gila Viñas's Bat Mitzvah)* of 2003, takes place during the bat mitzvah of Rabbi Manny's daughter at his new synagogue, Lincoln Park Jewish Center in Yonkers. The photographs capture the cautious encounters between the two populations brought together for the celebration: the Torat Emet group, mostly young and Spanish speaking, and the Lincoln Park congregation, mostly elderly survivors of the *Shoah*.

Permuth's depictions of kashering and conversion disrupt the seamlessness of narratives of American Jewishness. In other visual records of Jewish life-cycle events Jews are "always already" Jewish. The exception of course is the *brit milah*, the point of origin and entry into the covenant for male Jews at the age of eight days old, which is frequently represented in visual art.[72] As a framework for interpreting Jewishness through time and across space, rituals, holiday, and life-cycle events have been used to establish a common ground among Jews in the Diaspora. By expanding the canonical framework

for interpreting Jewish life—by including that which has traditionally been excluded—Permuth challenges essentialist notions of tradition, of unbroken traces of Jewish history. In particular, by choosing the conversion and the kashering process, he introduces *becoming* into questions of Jewish identity. The canonical Jewish rituals and life-cycle events have functioned to limit definitions of Jewishness outside participation in those events. In other words, are you Jewish if you have not had a *bris,* not been bar mitzvahed, etc.? For Permuth to show these particular events, which are as firmly prescribed by Jewish law as any others, is to unveil the borders and boundaries of the supposedly homogeneous community. It allows other stories to be added to the collective history.

In a diverse array of projects, Yoshua Okon, a photographer and video artist born in Mexico City who resides in Los Angeles, has taken his camera to the streets, where he collaborates with strangers in order to capture unscripted exchanges that deal with racism, classism, and contemporary culture. His work for this exhibition is entitled *Casting: Prototype for a Stereotype* (2005). The project emerged from his engagement with the Ken community in San Diego.[73] This secular, Jewish communal organization comprises recent immigrants, mostly from Mexico but representing diverse economic, ethnic, and national backgrounds as well as levels of observance. As the group has worked to preserve both "Jewish values" as well as its particular "Mexican Jewish values," it has produced a hybrid collective Mexican–United States Jewish identity. The group's concern to safeguard and at the same time reinvent its communal identity led Okon to explore "this question of preservation and . . . the notion of a true origin/original" by recruiting mothers in the Ken community to improvise a brief, unscripted biblical scene that offered an archetype for the prototype of a Mexican-United States-Jewish-mother stereotype. The scene is taken from the Book of Ruth, the story of a non-Jewish Moabite who marries a Jew and converts, and from whom King David is descended.

Okon provided the women with oral fragments of the story, some stage directions, and props, and then videotaped them, capturing "near stream-of-consciousness improvisations," which are projected on the gallery walls and envelop the viewer. Each woman enacted highly subjective interpretations that allowed her to project "her own fantasies, biases and desires into the stories, ultimately breaking the surface of her life to reveal hidden aspects of her own deep personal notion of identity." At the same time, the performances followed certain conventional narratives of Jewishness that the performers had been inculcated with from childhood. That the videos achieve a kind of baroque spectacle reinforces their being a hybrid pastiche of elements, mirroring the community itself. Okon believes that "by going beyond the stereotypical surface of the community's life, the goal is to point to the concealed portions of the individual members and hopefully, by means of comparison, to be able to obtain valuable insights about the complex questions surrounding the notion of this group's essential identity."

The project has allowed Okon to explore how people create "exclusive communities which attempt to mark differences and limits and also to construct identities." The location of the community on the United States–Mexico border also complicates its identity. Its members come from as far away as Guadalajara

while others still have businesses in nearby Tijuana; Jews from Brazil and Turkey also have ties to the group. As the artist noted in his project description,

> This multiplicity of origins and cultures in contrast with the notion of preservation inevitably brings up many questions: What is it that the community is attempting to preserve? Is there an essence? Is there a true origin/original? What are those "roots and values" that the Ken community (or any given community for that matter) is based upon? What are the distinctions and similarities between preservation and reservation? Where are those limits, those frontiers that define what is outside and what remains inside the group? The limits between a Mexican and a US citizen? Between Jewish and non-Jewish? Between an Ashkenazi and a Sephardi Jew? What are the differences, if any? How artificial are these constructions?[74]

The team of Israeli-born Tirtza Even and American Brian Karl has created an interactive audio and video installation, entitled *Definition,* based on their audio interviews with more than twenty individuals living mainly in New York City. Their contacts are both Jews and non-Jews from a variety of backgrounds (e.g., the adoptive lesbian mother of two Chinese girls; a sixty-five-year-old Brooklyn-born Jewish experimental filmmaker; a black magazine editor; a half-British, half-American Jewish scholar; an immigrant Palestinian musician; an Arab Jewish visual artist; an Israeli Palestinian graduate student in psychology and social welfare; a Moroccan Jewish taxi driver; an Israeli writer married to an American non-Jew; the American-born son of a Jewish father and a non-Jewish mother; a Turkish *converso*). Asked what "Jewish" meant to them, the individuals' answers depended upon a multiplicity of contingent events: where they happened to be born and grow up, who they encountered in their lives, what they perceive sharing with others more or less like themselves, or how they fit within the shifting boundaries of the groups to which they appear to belong. "One goal," according to the artists, "is to interrogate fixed notions of what it means to be 'native' to any locale or culture, and to 'belong' to any perceived ethnic or national group. We aim to demonstrate the shifting, contingent manifold of psychological and social understandings which make up the idea of 'self' and 'others.'"[75] The interviews, similar to those of Rainer Ganahl, consist of narrations of memories and mappings of interactions with others. But unlike Ganahl's installation, here we are given no idea what these subjects look like, and our efforts to imagine them open up a space for us to consider how we might be stereotyping even those we cannot see based on what they say. Thus the work also neutralizes the way in which identity is visually mapped onto the body.

As viewers listen to excerpts from the interviews and the sounds of different voices fade in and out, they see a continuous panoramic video projection panning six different settings that appear as semblances of documentary footage of the everyday world, where seemingly neutral actors—singly, in pairs, or in other small groups—move in and out of view, touching, eating together, or otherwise interacting. The actors make emphatic gestures, a sign language consisting "of a 'lexicon' or vocabulary of invented and choreographed physical gestures embodied in the context of otherwise ordinary behaviors and postures." Strung together from actual documented gestures culled from a variety of scientific and popular sources, the artists see these movements as "indicative

Figs. 16–17
Artists Tirtza Even and Brian Karl used nineteenth-century illustrations such as these as inspiration for the gestures performed in their installation *Definition*

of continuing cultural attributes that are embraced or rejected, consciously or not" (figs. 16, 17). Even and Karl use "the metaphor of a sign-language 'dictionary'" enacted by a single performer seen in a separate video projection to "serve as a formal access point." Since we cannot see the people whose voices we hear, their intonations, accents, and patterns of speech are all we have to go on. Not meant to be in sync with the sound track, the gestural lexicon both heightens the effect of and marks as arbitrary the kind of ethnic marking that fascinated sociolinguists in the early twentieth century.[76]

The world that Even and Karl visually stage encompasses the public and the private, the pedestrian and the highbrow, worlds that many of us move between, sometimes on a daily basis, particularly in a place like New York: the actual locations include the nineteenth-century Beaux-Arts (neo-baroque) interior of Lowe Library at Columbia University; a gritty street in Williamsburg, Brooklyn; a modest apartment on the Lower East Side; and several others. But the artists have digitally manipulated the scenes to achieve two effects: on the one hand, to heighten our encounter with the familiar; on the other, to expose its inverse facet, the uncanny. It is the latter that adds a haunting effect to the installation.

Viewers interact with the work through their ability to access the audio interviews by manipulating two motorized pendulums suspended from the ceiling. The pendulums are programmed to move whether the visitor interacts with them or not, and their movement triggers a series of sound clips following a set of predetermined instructions programmed by a computer to select thematically linked parts of the interviews based on words that index some eighty different themes (for example, anti-Semitism, assimilation, discrimination, exclusion, family, food, inclusion, Palestine, parent, politics, ritual, social justice, Zionism). Viewer interaction determines the duration and "dialogue" between the audio clips so that we might hear, say, two to four minutes of one speaker, some brief overlap, or other variations and lengths. A graphic projection on the floor allows viewers to track who is speaking and the particular theme that has been accessed. As we listen closely, the random bits and pieces of the interviews work in conjunction with the visual elements to mirror the process of how individuals reveal themselves in a perpetual state of becoming shaped by contingent social and psychological factors. There is no beginning or end, no attempt at a linear narrative. One hears instead the constantly unfolding process of identity formation in different stages of becoming.

To a large extent, this exhibition has been informed by a concern for the visibility of Jews of color in an imagined American Jewish family album. Thus, at first glance, an advertising campaign featuring European American, Asian American, and African American models by the Anti-Defamation League (ADL) in the early summer of 2004 seemed to be an unexpected validation of the possibility that mainstream Jewish organizations were catching on to the message that had been urged in the United States for almost a decade at the grassroots level by multiracial and multicultural Jews and their families. The campaign, called "Anti-Semitism Is Anti-Me," consisted of print ads that would appear on several hundred telephone kiosks across New York City from mid-July through early September, which included the heady period of the Republican National

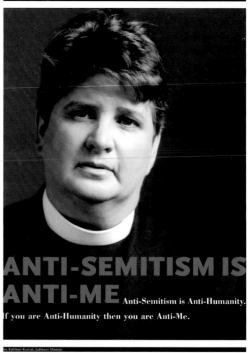
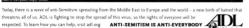
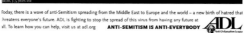

Figs. 18–20
Anti-Defamation League poster campaign: "Anti-Semitism Is Anti-Me" (2004)

Convention.[77] However, the campaign's message was intrinsically yet unintentionally ambiguous. It meant not to alert us to racism within the Jewish community, but to connect anti-Semitism to racism and other forms of religious and gender prejudice in the wider community: to show that "anti-Semitism is everyone's problem."

The campaign consisted of three posters, one featuring supermodel Naomi Campbell, who is African American; one representing one of the nation's leading Lutheran Christian ministers, Rev. Kathleen Rusnak; and one with a three-and-a-half-year-old Asian American child, named Jacob (figs. 18–20). While he has a biblical name, whether for the purpose of the ad Jacob is Jewish or was intended to be recognized as Jewish is entirely ambiguous. According to the ADL's press release, "The new campaign, aimed to reach and engage a broad and diverse audience, is designed to change the perception that anti-Semitism is strictly a problem for Jews." According to Abraham H. Foxman, the ADL national director, "Anti-Semitism is everyone's problem. Anti-Semitism in a society is an expression of hatred of the other, it is contrary to our values of democracy, diversity and acceptance." In fact, given this objective, I would argue while the campaign at first seems to open up the possible visibility of Jews of color, the presence of the child in the group, especially, uncannily reinforces an ambivalence that would deny the possibility of Jewishness to anyone beyond a stereotypically white American Jew.

The core challenge of any consideration of American Jewish identity within a multicultural society is the ability to shake off the conventions that we take to be natural or essential to Jewishness. A collective culture cannot be defined by language, skin color, dress, food, livelihood, nor even "religion."[78] So what makes "us" Jewish? As Laurence J. Silberstein has written: "The customary discourse of Jewish identity posits certain attitudes, beliefs, or practices

as constitutive of or essential to Jewish identity. Scholars construct question-naires based on the premise that Jewish identity 'already is.' . . . Judgements are rendered as to whether it indicates a 'growth' or 'decline' of Jewish identity."[79] But one recent study of Jewish identity has seriously called into question such a modus operandi, suggesting that typical indicators of Jewishness such as syna-gogue affiliation and conformity to cultural norms are arbitrary and not accu-rate measures of the strength of Jewish identity, an elusive quality from the outset. Those who do not fit in to statistical categories are then seen as anom-alies. According to this study:

> People who might have strong psychological attachment to their personal sense of Jewishness can and do score low on behavioral or objective measures of identifica-tion. Moreover, in recent years, with the growing incidence of intermarriage in the American Jewish population, there have been at least some instances of people scoring fairly high on measures of Jewish identification even if they happen not to be Jewish. How else would one describe a Hebrew-reading, generous philanthropist to Jewish causes, who attends synagogue services weekly with his wife and day-school-attending children, but as someone with a "strong Jewish identity"—if only the per-son were not a practicing Catholic. And how else would one describe a successful leader of a rock band with several pierced body parts, who emigrated from Israel to the US as a child and his only serious attachment to his heritage is a deep commit-ment to using his music to raise money for orphaned children in various war-torn parts of the world, but as someone with a "weak Jewish identity." But, this person has never forgotten the meaning of *tzedakah*. Of course, in both these examples it becomes readily apparent that the concept of "strong" and "weak" as applied to identity and, indeed, the very notion of identity can quickly become anomalous, fail-ing to capture important aspects of human attachment or disconnectedness.[80]

As this paragraph suggests, mainstream discourse on Jewish identity is increasingly acknowledging the multiplicity of Jewish identities at certain lev-els. Nevertheless, there remains a tremendous lag in the assimilation of more complex Jewish identities that are diverse in terms of ethnic and racial subjec-tivities. The photographic projects in *The Jewish Identity Project* may help us to overcome our instinct to privilege unity over multiplicity, and thereby to make room for more fluid, overlapping, and quotidian expressions of Jewishness and Jewish life in the United States.

Oy, Are We a *Pluribus?*

ILAN STAVANS

A virgin world where doors of sunset part,

Saying, "Ho, all who weary, enter here!

There falls each ancient barrier that the art

Of race or creed or rank devised, to rear

Grim bulwarked hatred between heart and heart!"

—Emma Lazarus, "1492" (1889)

Quick: name a Woody Allen movie that has a leading black actor in its cast. Time's up! Now mention a *Seinfeld* episode in which Elaine, Jerry, George, and Kramer socialize in the Upper West Side apartment with some Korean friends. How about a story with Cuban Americans written by Isaac Bashevis Singer?

Movies, television, literature—all genres in which these three American Jewish giants offer a striking picture of urban life in the United States. Their portrait of New York City in particular is complex: the landscapes range from the old building where the *Jewish Daily Forward* was located on East Broadway to Tom's, the corner cafeteria on 113th Street near Columbia University, from a scenic bench on the banks of the Hudson River to the Central Park reservoir. At times they also depict Miami as a tropical haven for retirees and Los Angeles as a capital of starstruck lawyers and athletic fulfillment. The composite image, one might confidently say, is nothing short of hypnotizing. Leon Edel, a biographer of Henry James, Willa Cather, and the Bloomsbury group, once ingeniously suggested that, had Dublin been destroyed by air strikes in World War II, it would be possible to re-create it, street by street, tavern by tavern, using James Joyce's *Ulysses* as a map. One might say something similar about Manhattan: Allen's movie *Hannah and Her Sisters,* episodes such as the legendary *Seinfeld* about the Nazi soup kitchen, and novels like Singer's *Shadows in the Hudson* are essential maps (fig. 2). Thanks to gargantuan media exposure, the degree of familiarity with Manhattan among people who have never set foot in it is eerie.

But even maps are subjective. Just as Joyce's image of Dublin is the product of a begrudging Irish émigré stationed, at various times, in Italy and France, the representation offered by Allen, Seinfeld, and Singer is a skewed one. For, where in those representations is the multifaceted, ethnically diverse population of Manhattan: the Dominican restaurants of Washington Heights, the African American chess players in Harlem, the Asian street vendors of Delancey Street? Of course, the question must be asked: Why should Jewish artists offer a comprehensive portrait when non-Jewish artists also fail the test? Think of the HBO series *The Sopranos.* What is the relationship between Tony Soprano's Italian Mafia and New Jersey Jews? Or else, think of Spike Lee's Bensonhurst representations in movies like *Do the Right Thing* and *Jungle Fever:* They include blacks and Italians, but where are the Mexicans? And when Jews show up in Lee's films, are they anything but moneylenders and slanderers? Why are their habitats—the Upper West Side, Crown Heights, and the like—not ever depicted by him on the screen?

Fig. 1
Sammy Davis Jr. and May Britt on their wedding day, under the *huppah* (wedding canopy), 1960

Yes, there is a tropical setting in *Bananas,* a movie in which Woody Allen becomes a Fidel Castro–like leader of a fictitious South American country (fig. 3); and, in Allen's more recent *Melinda and Melinda,* guilt may have finally taken its toll, as there is a leading black character in the film. Even though it is about Puerto Rican and Italian gangs set in the projects, Leonard Bernstein's Broadway musical *West Side Story,* an updating of Shakespeare's tragedy *Romeo and Juliet,* distills a Jewish sensibility. Meadow Soprano, Tony's daughter, has a biracial Jewish boyfriend from Los Angeles who is in her freshman class at Columbia University and whom Tony forbids her from seeing (not because he is a Jew but because he is black). And isn't there the *Seinfeld* episode of the Puerto Rican Day Parade? It made headlines for the wrong reason, true, but isn't it proof—albeit tangential—of a propensity for multiculturalism, for example, the halfhearted interest among Jews of *lo hispánico,* things Latin? Plus, when searched with a magnifying glass, references to a Puerto Rican cleaning lady are to be found in Singer's oeuvre. His story "Alone," in *Short Friday and Other Stories,* about a hurricane in Miami, features a sexually starved, hunchback Cuban woman.

It is also true that other Jewish writers have offered more consistently intricate multicultural pictures. Think of Jewish figures within the Beat Generation, especially Allen Ginsberg, whose *Kaddish* is a tribute not to his father but to his mother. Or the poetry of Philip Levine, whose humane poem "The Sweetness of Bobby Hefka" starts thus:

> What do you make of little Bobby Hefka
> in the 11th grade admitting to Mr. Jaslow
> that he was a racist and if Mr. Jaslow
> was so tolerant how come he couldn't
> tolerate Bobby? The class was stunned.
> "How do you feel about Jews?"
> asked my brother Eddie, menacingly.
> "Oh, come on, Eddie," Bobby said,
> "I thought we were friends." Mr. Jaslow
> banged the desk to regain control.
> "What is it about Negroes you do not like?"[1]

Think also of the stories of Tillie Olsen (*Tell Me a Riddle*) and Grace Paley (*The Little Disturbances of Man* and *Enormous Changes at the Last Minute*). And of the novels of E. L. Doctorow, especially *Ragtime,* with its polyphonic tableaux. Think of Bernard Malamud's earnest stories about Jew and black and about Jew and Irish. He understood Jewish history to be "suffering, exploitation, renewal." In "Angel Levine," the messiah appears in the form of a black visitor in Brooklyn. Or, again, of poetry, in particular the work by Adrienne Rich, who reaches for a far more private note in her poem "Yom Kippur 1984," where she asks:

> What is a Jew in solitude?
> What would it mean to feel lonely or afraid
> far from your own or those you have called your own?
> What is a woman in solitude: a queer woman or man?
> In the empty street, on the empty beach, in the desert
> what in this world as it is can solitude mean?[2]

Fig. 2
Photograph of Isaac Bashevis Singer (1986) by Abe Frajndlich

Fig. 3
Woody Allen as the rebel leader of San Marcos in *Bananas* (1971)

Fig. 4
Al Pacino and Meryl Streep, in the 2003 HBO television production of Tony Kushner's *Angels in America*

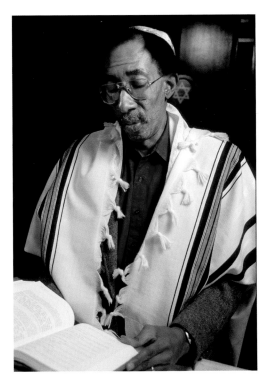

Fig. 5
Photograph of Julius Lester (1987) by Stan Sherer

Indeed, Rich, in her volume *Sources,* published in 1986, reflected on her womanhood in the context of the Jewish tradition:

> For years I struggled with you: your categories, your theories, your will, the cruelty which came inextricable from your love. For years all arguments I carried on in my head were with you. I saw myself, the eldest daughter raised as a son, taught to study but not to pray, taught to hold reading and writing sacred: the eldest daughter in a house with no son, she who must overthrow the father, take what he taught her and use it against him. All this in a castle of air, the floating world of the assimilated who know and deny they will always be alien.

And the work of playwright Tony Kushner, in particular his Pulitzer Prize–winning double play *Angels in America* about the AIDS epidemic, explores the crossroads between Judaism and homosexuality (fig. 4). The play itself does not openly use Jewish themes but its sensibility is unquestionably Jewish. This, too, is an aspect of a more diversified identity making its stamp in mainstream culture.

These explorations have allowed for some incisive meditations on the Jewish body itself that break with pre-established modes of perception. Sander L. Gilman has discussed the way plastic surgery has defined female beauty for white, secular Jewish women. He has also reflected on Freud and Kafka as paradigms of male Jewish physique.[3] The famous photograph by Diane Arbus of the Jewish giant and his parents, grotesque as it is—and her art surely walks the boundaries of the gothic and monstrous—has become a benchmark. Add to this Julius Lester's memoir *Lovesong: Becoming a Jew* (fig. 5); Rod Steiger and Jaime Sánchez in the Oscar-winning 1964 movie by Sidney Lumet, *The Pawnbroker,* about a Holocaust survivor and a Puerto Rican in New York (fig. 6); and the efforts by rappin' groups like Hip Hop Hoodíos that intertwine Jewish and Latino influences (fig. 7). Maybe even Barbra Streisand dressed as a *yeshiva bokher* in her atrocious Hollywood musical *Yentl* passes as a feminist critique of Jewish tradition.

But these goodwill examples are exceptions to the rule. In fact, the opposing view is the prevailing one. In the movie *Blazing Saddles,* Mel Brooks includes a scene with Native Americans—Brooks himself is their chief—speaking in Yiddish (fig. 8). And the lead character, played by Cleavon Little, is the Old West sheriff Rock Ridge, whose race becomes the target of numerous jokes. Does the movie use stereotypes to undermine them? Maybe, insofar that it is a critique of racism and all its attendant destructiveness and absurdity. (After all, Richard Pryor helped write the screenplay.) But that is, it seems to me, the extent of Brooks's transethnic adventures. Through its humor, one is able to understand the approach that Jews take to other groups in the Melting Pot: They coexist with them but never attempt to understand their circumstances. The same might be said of films like Woody Allen's *Mighty Aphrodite,* in which the director does include a black female actress. Unfortunately, what role does she play? A prostitute. Casts of Allen's movies such as *Crimes and Misdemeanors* and *Bullets Over Broadway* may incorporate Italians, but, again, they are invariably Mafiosi commissioned to perform a killing job. And Philip Roth, in his novella *The Dying Animal,* portrays a love affair between one of his alter egos and a young, voluptuous Cuban female. The portrait, once more, is atrociously

Fig. 6
Rod Steiger and Jaime Sánchez in *The Pawnbroker*
(1964). The Museum of Modern Art/Film Stills Archive,
New York

Fig. 7
Cover of album by the Latino-Jewish group Hip Hop
Hoodíos

simplistic. True, this book is not representative of his approach. For instance,
The Human Stain grapples quite seriously with racism and the plight of African
Americans and portrays an African American family in compassionate and sym-
pathetic terms. But where are the Chicanos, Filipinos, and Koreans?

The absence of solid, ongoing multicultural faces in Jewish depictions of
the American scene is indeed disconcerting. If the screen, big and small, is but
a mirror of life, what does it say about American Jews? Where does this near-
sightedness come from? Haven't Jews been considered agents of social change
since time immemorial? What role do Jews play in the multicultural tapestry
that is the United States today? What kind of future should they expect? I want
to ruminate on these questions in this essay, and juxtapose the personal and
the scholarly modes. My objective is to ask, not to answer, questions.

The two tenets of multiculturalism, pluralism and tolerance, have allowed Jews
to prosper in America.[4] The capacity to live a civil life through instigating as
well as demanding the respect of others accounts for the success of the Ameri-
can experiment over more than two centuries. Think of George Washington's
letter to the Hebrew Congregation of Newport, which, stating that the United
States government "gives to bigotry no sanction, to persecution no assistance,"
eased the place of Jews in America.[5] But pluralism and tolerance, as Isaiah
Berlin, the twentieth-century British thinker, has asserted, are concerned with
faith and a philosophy of life, one whose foundation dates back to the German
and French Enlightenment.[6] How can people of different persuasions, religious
and ideological, coexist without stepping on one another's toes? Is it possible
for Anglicans, Unitarians, and Episcopalians to be peaceful neighbors? Can
the same be said of the three main world religions, Christianity, Judaism, and
Islam? What set of laws must be implemented, and upheld, in order for respect,
freedom, and the pursuit of happiness to affect everyone?

Multiculturalism is about diversity, which the *Oxford English Dictionary*
defines as "the condition or quality of being . . . different or varied." That differ-
ence might be based on appearance, origin, verbal strategies of communication,
dietary habits, and, yes, the opinions that result from these characteristics. It
isn't that others aren't like me because they hold political beliefs that are unlike
mine. Diversity establishes difference based on provenance, and provenances
allow for cultural variety. The treacherous argument in favor of multicultural-
ism in the United States is that no single group—no party, no group, no
church—can go it alone. We are all in this together: the one and the many. To
survive as a society, a balance between individual and collective rights has to
be found. In other words, as diverse cultures struggle to find their own space,
their interfaces—internally and with the whole—are in an ongoing negotiation.
In the Melting Pot, they give and take in equal share, shaping their identity
according to the political and social climate of the day. Continuity, obviously,
becomes a buzzword: how to cope with changes without sacrificing the essential
components that make the group distinguishable?

The Jewish journey in multicultural America began at the outset, with the
settlement in 1654 of Portuguese-speaking Sephardi Jews from Recife, Brazil, in
New Amsterdam, part of the Dutch colony of New Netherland, with indications
of ambivalent tolerance. (Ironically, of the original group of twenty-three, all but

Fig. 8
Mel Brooks in Native American headdress in *Blazing Saddles* (1974). The Museum of Modern Art/Film Stills Archive, New York

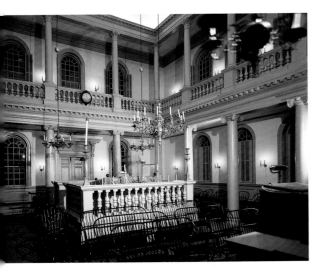

Fig. 9
Interior of the Touro Synagogue, Newport, Rhode Island

one, Asser Levy, left what would become the United States within a relatively short time.) Peter Stuyvesant, who served as director general of this diverse town, wanted to keep them out. He described them as "deceitful," "very repugnant," and "hateful enemies and blasphemers of the name of Christ." But Jews were also seen as agents of economic growth, and Stuyvesant eventually allowed them to stay. As it turns out, this would be the origin of a community allowed in initially for its mercantile talents but embraced for its intellectual stamina.

It would systematically grow over a period of 350 years, from an original "twenty-three souls, big and small" who arrived in the French frigate the *Ste. Catherine,* to between 200 and 300 in 1700, then between 938,000 and 1,058,000 at the end of the nineteenth century, and between 5,340,000 and 7,700,000 at the end of the twentieth.[7] By 1680 there were Ashkenazi Jews coexisting with their Sephardi counterparts. That coexistence was never without tension as the community sought its way in the mainstream, fighting xenophobic sentiments. George Washington's Revolutionary War and the efforts of the Founding Fathers turned pluralism and tolerance into republican values, emphasized, not without much peril, by Abraham Lincoln during the Civil War and thereafter. The result was a sum of parts, what came to be known in the early part of the twentieth century as the Melting Pot, a term popularized by the British Jew Israel Zangwill—author of *Children of the Ghetto* and *The King of Schnorrers*— in a 1908 play of that name about America as a land of additions. These additions came in the form of successive waves of immigrants—Irish, German, Italian—added to the Native Americans, the British core, and the African slave population.

What about the Sephardi ingredient in the New World? It started with the Anusim (*conversos*), Crypto-Jews, and New Christians whose roots are traceable to the Iberian coexistence between Muslims and Jews that came to an end with *La Reconquista,* a project of Catholic unification that took the better part of three centuries. *La Reconquista* was accomplished by the monarchs Isabel and Ferdinand in 1492, at which time an edict expelling all Jews from Spain was issued. The early figures in American Judaism were people like Haim Isaac Karigal, a visitor to the colonies from Hebron, Palestine, who in 1773 preached a sermon in the Touro Synagogue of Newport, Rhode Island, calling for loyalty, which in his view meant "obedience to the crown," and denouncing "public commotions and revolutions" (fig. 9). Or else, like Mordecai Manuel Noah, a journalist and playwright (he is the author of *The Fortress of Sorrento* and *Natalie: Or, The Frontier Maid,* among other plays) who in the first half of the nineteenth century explored the inherent tension between being an American and being a Jew. Karigal wrote profusely on Jewish topics, among other things correcting some distortions of Jewish life in Daniel Webster's Senate orations.

Ladino-speaking Jews, as well as the Ladino media, have now been all but written out of American Jewish history. This is evident even in volumes like the award-winning *American Judaism: A History* by Jonathan D. Sarna, published in 2004 to commemorate the 350th anniversary of the foundation of the Jewish community in the United States.[8] His attention to nonreligious Sephardi Jews is minimal. In any case, in my view, it was Emma Lazarus, a friend of Ralph Waldo Emerson and a poet unfortunately eclipsed in the contemporary Jewish American canon, who explored in the cultural realm, if not for the first time,

Fig. 10
Photograph of Emma Lazarus. American Jewish Historical Society, Newton Centre, Massachusetts, and New York

surely in a wholehearted fashion, the multicultural identity of American Jews (fig. 10). This is no accident: Lazarus's father was Sephardi, her mother German Jewish. In 1883 she composed the poem "The New Colossus" to aid the Bartholdi Pedestal Fund that paid for the structure on which the Statue of Liberty sits:

> Not like the brazen giant of Greek fame,
> With conquering limbs astride from land to land;
> Here at our sea-washed, sunset gates shall stand
> A mighty woman with a torch, whose flame
> Is the imprisoned lighting, and her name
> Mother of Exiles. From her beacon-hand
> Glows world-wide welcome: her mild eyes command
> The air-bridged harbor that twin cities frame.
> "Keep, ancient lands, your storied pomp!" cries she
> With silent lips. "Give me your tired, your poor,
> Your huddled masses yearning to breathe free,
> The wretched refuse of your teeming shore,
> Send these, the homeless, tempest-tost to me,
> I lift my lamp beside the golden door!"[9]

In her mature years, Lazarus's ideal for America was to make it a safe haven for the persecuted from all around the globe, although at the end of her life she also became an advocate for the creation of a Jewish state in Palestine. It was the news of the anti-Jewish riots in Russia in the 1880s that made her an advocate of Jewish causes. The United States, for Lazarus, needed to become the true Promised Land, a nation that upheld an economic and moral code that applied to everyone regardless of race, wealth, and religion. It was a worthy dream, based on the principles of social justice displayed in the Talmud. She translated the German poet and apostate Jew Heinrich Heine as well as some of the Hebrew poets from Spain, among them Yehuda Halevi and Solomon ibn Gabirol (although these translations, too, she made from German). Plus, Lazarus wrote scores of poems about the Maccabees and King David. She trusted that America was a land of Jewish continuity, where "the sacred shrine is holy yet."

It seems to me a worthy endeavor to rescue from near oblivion Lazarus's pluralistic views. They should become the paradigmatic lens through which to understand much of what has happened since her death in 1887. For it was around then that the American Jewish landscape changed substantially. Between 1881 and 1924, a so-called Great Tide brought to these shores another type of Jew, and from then on the American Jewish community reoriented its goals. *Ashkenaz* (Germany), not *Sepharad,* became the genealogical root. Almost instantaneously, a wave of religious and intellectual leaders, as well as social activists marked by the ideological debacle in Czarist Russia and torn between "isms" such as anarchism, socialism, communism, bundism, and the messianic dream of Zionism, made the United States an extension of the Old World. The novelistic work of Abraham Cahan, the controversial editor of the *Jewish Daily Forward* newspaper, of Anzia Yezierska, and of the Yiddish writers Yehoash, Mani Leib, Joseph Opatoshu, and Moyshe Nadir engaged in discussions that, if anything, pointed to the Pale of Settlement.

The tension between the one and the many, between an ethnic minority and the mainstream majority, became a staple. How to live a normalized American life, just like everyone else, and at the same time retain a sense of uniqueness? How to embrace the American values of democracy and freedom and yet not disappear as a millenarian people? The literature produced by Jews in the United States is filled with examples of dualism. Characters are inhabited by a polarity that cuts the heart in two. Am I an American? Or should I identify myself as the member of a distinct minority? At times the tension between the opposites gives rise to a harmonious marriage of the two, but it also might produce a wrenching impasse that appears to be impossible to resolve. As Mary Antin, author of the autobiography *The Promised Land,* put it, this country pulled the immigrants in different directions. In Antin's story "The Lie" she has a Russian Jewish student named David respond to a teacher who asks how come he does not sing along with everyone else in class Samuel F. Smith's patriotic hymn "America." He responds by asking her what the line "Land where my fathers died" means. She answers, but days later he still does not sing. "Then tell me, David, why you don't sing it," the teacher asks again. Antin writes: "David's eyes fixed themselves in a look of hopeless longing. He answered in a whisper, his pale face slowly reddening. '*My* fathers didn't die here. How can I sing such a lie?'"[10]

American *and* Jewish—a divided self. Or is it *American-Jewish,* with a hyphen in the middle that stands as a bridge between the two sides? And what is our ethnic identity all about? Is it an identity under threat?

Being divided, or fragilely linked by a hyphen, is something I know a bit about. I, too, come from a region known for being ethnically homogeneous, or at least that is the impression most people get from Mexico, a mestizo country defined by its deeply felt Catholicism. I was born and raised in the nation's capital, in a community predominantly constituted of immigrants from shtetls and ghettos in Poland, Lithuania, Russia, and the Ukraine who made it across the Atlantic Ocean between approximately 1890 and 1930. Anusim (*conversos*) Jews escaping the mighty fist of the Inquisition had settled in the country centuries before, but the Ashkenazi Jews who immigrated from the late 1880s until the 1930s were indifferent to them. These Ashkenazim had little patience for history. Their prime objective was to survive in a welcoming environment. Yiddish, not Ladino, was the language of the newly arrived.[11]

The Mexican Jewish community is tiny when compared to our north-of-the-border neighbors: only around 35,000 strong. Our contact with the gentile environment was limited. Schools, synagogues, and sports and community centers were built as meeting places. There were a bare minimum of public figures with a recognized Jewish identity, let alone novels and movies portraying our dilemmas. Since we accounted for less than .03 percent of the overall population, our interests and concerns were marginal at best when seen from the nation's perspective. Among us interracial and interreligious marriages were hardly a question. Full assimilation to the culture was not desirable: We were born Jews and were expected to die as such. For in many ways, we lived happily in the shadows. Mexico offered us a welcoming place. But the immigrants chose to live the life of a small ethnic group: They kept to themselves, mingling in the centers

they built. And indeed, they thrived financially, educationally, and socially. Today the number of businessmen, doctors, and educators is extraordinarily high, while the number of mixed marriages remains comparatively low: about 17 percent. In other words, in the Mendelssohnian paradigm, they were less Mexican Jews than Jewish Mexicans.[12] But many of us nurtured ingrained envy toward our United States brothers and sisters. Unlike us, they did not live on the periphery of culture.

As Mexican Jews, the admiration for our United States equivalents was unavoidable. Yes, in our eyes Jews in the United States were patriotic in ways we were not allowed to be. They were ready to make the ultimate sacrifice, dying for their country from Normandy to Vietnam. But that was hardly the source of our jealousy. What we most appreciated in them, the raison d'être of the envy, was the overall position that American Jews enjoyed in the vast cultural landscape of their nation. They had rights and responsibilities like any other citizen. In terms of numbers, they constituted 2.2 percent of the total American population, a cipher which, even if minuscule, was considerably above ours. More important, they were influential in ways of which we could never even dream. Their concerns were not irrelevant. On the contrary, the country had influential figures in moviemaking, theater, literature, music, television, and, crucially, in the political arena. The White House paid considerable attention to American Jewish voices. There had been prominent judicial and diplomatic figures, from Supreme Court Justice Louis D. Brandeis to Henry Kissinger, who served, for better or for worse, as representatives of the Jewish community in the larger social spectrum. This representation, obviously, would flourish in the decades to come, resulting in Senator Joseph Lieberman being the first Jew on a presidential ticket, during the Al Gore campaign in 2000, and turning the "hidden" Jewish identity of political celebrities like Madeleine Albright, Secretary of State during the Clinton years, and Democratic presidential hopeful John Kerry into decisive news items around the globe.

Our synagogues were sound but small. Theirs, instead, were a light to the world. Religiously, they were structured through movements—Orthodox, Conservative, Reform, and Reconstructionist—that negotiated the liaison between devotion and secularism in different ways. Ideologically, American Jews also mattered. The vast majority voted Democratic even while financially they stood in an elevated position. But since their numbers were small, the actual vote mattered less than the influence it carried. Candidates courted them because of their financial wealth and their tradition of supporting with their pocketbooks the politicians they liked. Their relationship with the state of Israel was wholeheartedly supportive, politically and economically. American Jews had intellectuals and journals of opinion—from Lionel Trilling to Alfred Kazin and Irving Howe, from *Partisan Review* to *Commentary* and *The New Republic*—that together reflected on the national and collective plight in a way that was not only meant for Jews. They had Jewish community centers and cultural institutions like the 92nd Street Y that somehow served as temples of secular Jewishness, private day schools, and publishing houses like Schocken. Writers like Saul Bellow, Philip Roth, and Bernard Malamud wrote novels everyone read, and that stand à la par with the work of, say, F. Scott Fitzgerald and Ernest Hemingway. Mel Brooks, Barbra Streisand, and Sammy Davis Jr. were not

necessarily typecast as Jews (fig. 1). They were also considered American origi-
nals. Yes, American Jews knew who they were, what they wanted. They were
conscious of the largesse of their gravitas.

It was not until I immigrated to New York, in the mid-eighties, that I real-
ized, slowly but surely, that there is another side to the coin. I had an uncle and
aunt on Long Island who served as my bridge to the larger world. He was a suc-
cessful Avenue of the Americas lawyer, she a devoted housewife. They had two
children a bit older than I who had been raised in an assimilated milieu. But as
soon as the younger of them began dating a gentile girl, the parents became
scared and immediately switched gears. They not only attended a Reform
synagogue regularly but got involved with the temple's board. Soon they were
emphasizing their Jewishness in a way I had never seen before. By the time
their daughter-to-be married into the family, she had undergone a conversion:
Not only did she embrace Judaism as a religion but, lo and behold, domestically
she became the center of attention. Soon the newlyweds moved to his parents'
home, arguably in order to keep the family together.

The odyssey of my Long Island relatives was not anomalous. I have come
to recognize a trend toward inclusiveness in some Jewish quarters. In defining
Jewish identity, the Reform and Reconstructionist movements, breaking with
rabbinic tradition, have accepted patrilineal descent. Plus, having a convert in
the household, having non-Jews in Jewish households, having different races
in Jewish households, having different immigrants in the household, is, and
has been for some time, the trend. At the turn of the twenty-first century,
demographers stumbled in counting the number of Jewish people in America
mainly because of the fluid ways in which Jews and non-Jews identified them-
selves. Obviously, Ashkenazi monoculturalism was already besieged when I left
Mexico to be part of the American Jewish experiment. In surveys released at the
dawn of the twenty-first century, it became known that for the first time since
the arrival of Sephardi Jews from Brazil in 1654, the Jewish community in the
United States is shrinking. From the 1940s, when Jews were 3.7 percent of the
total population in the United States, the number has gone down to between 1.9
and 2.2 percent in 2000.

According to the most recent statistics available, by the end of the twenti-
eth century the largest number of American Jews lived in the New York metro-
politan area, with approximately 2,051,000 in New York City, Long Island, and
northern New Jersey. The Jewish population of California was an estimated
999,000, including 668,000 in the area consisting of Los Angeles, Riverside,
and Orange Counties. Florida was home to approximately 620,000 Jews, in-
cluding 331,000 in Miami and Fort Lauderdale. About 2,850,000 lived in the
Northeast, with 2,424,000 in the Middle Atlantic states and 426,000 in New
England. The area consisting of Philadelphia, Wilmington, and Atlantic City,
had an estimated Jewish population of 285,000, and the Midwest had approxi-
mately 706,000, with about 270,000 in Illinois, 110,000 in Michigan, and
62,500 in Missouri (54,500 in Saint Louis alone).[13]

Aside from the suburbanization of American Jews, about which I have
written before, a significant factor to keep in mind has been the drive by Jews to
the frontier, from Louisiana to Texas and New Mexico. Although the number of
Jews today in places like Texas (Houston, Galveston, Dallas), Arizona (Phoenix,

Mesa), or even Oregon (Portland), Washington (Seattle), Colorado (Denver, Boulder, Greeley), and Georgia (Atlanta) is solid, their presence in those regions is far from recent. From the colonial period to the time of the Gold Rush in the mid-nineteenth century, Jews have been entrepreneurial in their quest for fresh American landscapes in which to settle, a fact that has exposed them to other, non-European cultures. In the late sixteenth century, the Carvajal family, whose activities in northern Mexico have been well documented—Luis de Carvajal the Elder, governor of the state of Nuevo León, was known as "the pacifier of the Indians"—were sacrificed at the stake in an auto-da-fé that publicly condemned them for being "Judaizers."[14] Then, around 1849–50, scores of Jews from the East Coast and even from places in Europe like Hamburg traveled to California in search of riches. A number of Jewish Mexican families in the American Southwest established financial dynasties, such as F. Auerbach & Co. and Marks & Myers. Scores of prominent Jewish sheriffs, mayors, and other political figures—Abraham H. Emanuel of Tombstone, Arizona; Sig Steiner in Escondido, Arizona; and Adolph Solomon of El Paso, Texas—left their imprint in political life, often in a fluent Spanish. One of the wives of Wyatt Earp, Josephine Sarah Marcus, or Josie, whose name later changed to Sadie, was Jewish. These pioneers' interaction with Native Americans forced them to negotiate their Jewish identity, thus bringing forth a different mix.[15] It is important to state that the contemporary Jews on the frontier do not necessarily break that pattern. In spite of making their habitat in the Southwest, their class and ethnic status is strikingly similar: They are descendants of white Europeans and belong to an economically successful, self-enclosed community. But their interface with other minorities, more than that of the usual suspects in the Northeast, Florida, and California, at least announces different types of partnerships in the social chessboard.

In any case, even though there are nowadays more and widening definitions of who is and is not a Jew, demographers have noted a decline in comparison with the growth of the overall population of the United States, and this decrease of American Jews is found frightening. What factors explain it? One of them is the fertility rate. With the exception of Orthodox Jews, the average number of children in Jewish households dropped from 2.6 to 1.8. But there is a more significant cause for this decline. Maybe the biggest danger to American Jewish life is posed by interracial and interreligious marriage. Do these types of marriages end up adding to or subtracting from the demographic? Again, a more flexible definition of Jewish identity would count this as an asset. Some of the *goyim,* as gentiles are referred to in Yiddish, do undergo a process of conversion. Almost every Jewish family in America today has at least one relative not Jewish by birth, be they Protestant, Christian, Muslim, Buddhist, from any other faith, or even an atheist. This is felt at every level of domestic and public life. My own wife is the child of a father of Welsh descent and a Jewish mother. Christmas trees are a regular feature in the household, as they are in millions of Jewish homes.

It is in humor, I believe, that American Jewish responses to interethnic and interreligious marriage, and to assimilation in general, are best appreciated. They range from S. J. Perelman and Groucho Marx to Leo Rosten, whose *The Joys of Yiddish* was, arguably, the quintessential American Jewish lexicon of

comedy in the seventies. The angst that comes from being exposed to people unlike "us" gives way to hilarity. In one joke a Jew marries an Episcopalian and decides to convert. Still, he takes his yarmulke and prayer shawl to church on Sunday. His wife asks, "What are you doing with those things?" "*Oy gevalt*," he answers, "it's my *goyisher kop!*" The fear index of mingling with other ethnic groups is acute in these types of comic tales. A Jewish man returns home one day and tells his mother that he is about to marry a Native American. "Her name is Shooting Star," he says. "How nice!" the mother responds. He then adds that he has also been given a Native American name, "Running River," and that the mother needs to address him with it from now on. "How nice!" again she replies. "You have to have an Indian name, too, Mom," he states. "I do," she says. "Just call me Sitting Shiva." Or then there is the joke about a Hebrew teacher who announces to her class: "The Jewish people have observed their 5,759th year as a people. Consider that the Chinese, for example, have only observed their 4,692nd year as a people. What does that mean to you?" At this point, one of her students raises his hand and says, "Well, it means that the Jews had to wait 1,067 years for Chinese food."[16]

For sure, the humor of Woody Allen, Mel Brooks, and Jerry Seinfeld has a similar endo-ethnic tone. It emphasizes the sense of righteousness and self-sufficiency among American Jews. Other cultures surrounding American Jews exist only so that Jews might be able to understand why they are, as Abba Eban once suggested, just like everybody else—except a little bit more so. On occasion, that decidedly Ashkenazi angst, as it manifests itself in the mainstream, also applies to Sephardi, Mizrahi, and other non-Yiddish-based Jews. In the entry on "Ashkenazi" in *The Joys of Yiddish*, Leo Rosten writes triumphantly—and nearsightedly, too, subscribing to the "lachrymose view of Jewish history":

> Ashkenazic Jews are distinguished from Sephardic Jews in many ways: The Yiddish they speak, their style of thought, their pronunciation of Hebrew, aspects of their liturgy, many customs, food habits, ceremonials. This is not surprising, given the considerable differences in history and experience across a span of a thousand years.
>
> Yiddish is an Ashkenazic invention—and universe; the vernacular of Sephardic Jews is Ladino. The culture of Ashkenazim is markedly different from that of the Sephardim. At the core of Sephardic thought, says Abraham Menes, lay the question: "What must a Jew *know?*" At the heart of Ashkenazic life, stirred the challenge: "What must a Jew *do?*"
>
> The Sephardim were sophisticates, enlightened, cosmopolitan: merchants, physicians, philosophers, advisors to bishops and kings; the Ashkenazim were peddlers, peasants, proletarians, fundamentalists in faith, steeped in poverty, bound to orthodox tradition and superstition and fervent Messianic dreams. They resisted the secular world and scorned secular knowledge. Their intellectual world was bound by the *Torah* at the one end and the *Talmud* at the other. They held to dogged piety and boundless compassion. They were resigned to the humiliations and brutality of the world around them. They considered themselves (please note) God's hostages for the redemption of mankind![17]

Needless to say, multiculturalism and interracial marriage go hand in hand. This is as clear among American Jews as among anyone else. In religious terms, Episcopalian and Unitarian couples of divergent backgrounds are frequent.

And when one views this phenomenon from an ethnic perspective, the numbers are even higher. Italians, Irish, blacks, Latinos, and Asians are also marrying outside their immediate milieu in elevated numbers. Indeed, according to one survey, between 70 and 82 percent of interreligious marriages raise the children in a dual faith or with no faith whatsoever. An American life today probably means growing up with a divided religious loyalty, or else without one.

According to the National Jewish Population Survey, interethnic and inter-religious marriages among American Jews at the beginning of the twenty-first century remain at a record high: 47 percent.[18] And scholars like Gary A. Tobin claim that in cities like San Francisco they reach 70 percent. As Jews solidify their status at the heart of the Melting Pot, inner doubts have emerged about the road the community has taken in order to become fully American. Have we given up too much of our ethnic identity? Was complete assimilation the sole way in, as it was thought in the fifties?

It took me a decade to feel at home, to become part of the American Jewish community. I am now one of the older siblings. Looking back, I am actually amazed by the way the community embraces outsiders like me. Married and with children, I belong to a synagogue, send my children to Hebrew school, and have made lasting friendships. As a Mexican, I have been asked to lecture about the labyrinthine ways of Jewish life south of the border. The interest people have in my upbringing is not unique. I know of countless Jews from Argentina, South Africa, Iran, Chile, Canada, Turkey, Egypt, Venezuela, and Russia whose odysseys are similar to mine. Curiosity about who we are and where we come from is considerable. We are expected to be part of the larger cultural landscape but are not asked to give up our exotic baggage. Instead, progressive people invariably remind us that our multiculturalism makes the American Jewish community more pluralistic.

And then there is immigration. As a result of political instability and with the collapse of Third World economies, Jews from south of the Rio Grande, from Cuba, Argentina, and Brazil to Mexico, Panama, and Peru, have moved north in search of freedom and happiness.[19] Likewise with Jews from Russia and the for-mer Soviet bloc, as well as those from countries like South Africa, Syria, Iran, and Egypt: Tired of the anti-Semitism on their own turf and eager to grant their children a good education, many have relocated in some of the major centers of Jewish life in America. Since its inception in 1948, Israel has also been a mag-net for Jews from around the globe. But the political impasse in the Middle East has unquestionably made *aliyah* unattractive to thousands.

My own arrival in New York coincided with dramatic changes at the core of Jewish American identity. After the Civil Rights era, the homogeneousness of the community gave way to more elasticity on a number of fronts.[20] This was not an isolated case: the United States as a whole changed significantly in this period, as racial and ethnic boundaries blurred. Miscegenation was prohibited in numerous states until 1967, when interracial unions became legal at the federal level. Plus, a number of immigration restrictions imposed in the twenties were lifted in the sixties, contributing to further mixing between people who origi-nated in diverse parts of the globe. In 1965, in a Civil Rights march through Selma, Alabama, Rabbi Abraham Joshua Heschel walked arm in arm with the

Fig. 11
James Karales
Untitled *(Martin Luther King Jr., Ralph Bunche, and Rabbi Abraham Heschel, Selma to Montgomery March),* 1965. Gelatin silver print, 11 x 14 in. (27.9 x 35.6 cm). The Jewish Museum, New York, Purchase: Photography Acquisitions Committee Fund, 2000-10

Fig. 12
Amy Eilberg, the first Conservative woman rabbi to be ordained at the Jewish Theological Seminary (1985), photographed by Joyce Culver

Reverend Martin Luther King Jr., Ralph Abernathy, and Ralph Bunche (fig. 11). Soon a wave of openness swept various movements. Reform and Reconstructionist communities embraced an egalitarian religious service, and ordained women as rabbis (fig. 12). Feminist activists, many of whom were Jewish, invited the public to value the role of women in society more fully. In a speech delivered in 1970, Betty Friedan, author of *The Feminine Mystique,* said: "Down through the generations in history my ancestors prayed, 'I thank Thee, Lord, I was not created a woman.' From this day forward, I trust women all over the world will be able to say, 'I thank Thee, Lord, I *was* created a woman.'"[21] It might be argued that feminism as a political philosophy radically changed the Jewish American community, from allowing a sizeable number of women to enter the workforce, to redefining domestic relations, to enabling women to be ordained.[22]

Likewise, after the historic events at the Battle of Stonewall in Lower Manhattan in 1969, within the gay movement in the United States there has been an attempt to define the turf where Jewish and homosexual identities intertwine.[23] The fight for equality for gays and lesbians was part of the agenda of secular Judaism, and it colors various facets of life, from education to the law and the entertainment industry. This was also the time when suburban life, which started in the fifties as a response to the collapse of inner cities, established itself as a norm. This move carried with it a fundamental revolution of Jewish identity. Among the features of this revolution was the sense of privacy and individuality it carried. Jews, more affluent than their immigrant parents, could afford to have automobiles, backyards, memberships to country clubs, and the like. Their previous sense of surroundings changed as they dispersed through certain geographical sections. The social function of the synagogue also changed. Modeled after the Protestant church, it became a cultural, educational, and political meetinghouse as well as a religious site. Even its architecture was transformed from the European model that emphasized active study and debate to a more passive, theatrical (that is, frontal) one in which the rabbi was perceived as a priestly figure orchestrating the weekly praying service. The move to the suburbs meant that Jews, much like the rest of Americans, approached culture from a number of parallel satellites rather than from a single, unifying center. This became significant, for even though New York, Los Angeles, and Miami remain the most important centers of Jewish life in the nation, Jews do not have to reside in them. Instead, they can commute from miles away, as they do for work and entertainment.[24]

All in all, the sixties opened up a path to a transformation that had been long in the making but that reached its apex then. That transformation affected Americans in general and Jews in particular. Heterogeneity allowed for multiculturalism to consolidate itself as a philosophy of life affecting all patterns of behavior, from faith to cuisine. But by the eighties and early nineties, a new conservative agenda was on the rise, and Jews, yet again, played a crucial role. The move in the fifties from the city to suburbia underwent a reevaluation as young Jewish professionals opted to return to urban centers. The embrace of public education in the sixties was also overturned in the eighties as private religious schools, following the theories of Solomon Schechter, pedagogue and chancellor of the Jewish Theological Seminary, sprang up all over. (The first Schechter schools were founded in the 1960s.) Affirmative action in higher

Opposite:
Fig. 13
Recipe for latkes with *mole*

education and the workplace came under attack, and bilingual education, as a by-product of the Civil Rights era, was dismantled in several states. Jews had supported these federal programs when they first came about, but then grew weary of them as their results were questioned by right-wingers. Add to this the radicalization of Middle Eastern politics, which pushed American Jews to take a more critical stand toward the state of Israel. Pundits decry the unconditional embrace of left-wing causes by American Jews, which often results in a denunciation of Likud figures in Israel. This agenda moved even further as the new century began. Judging by the results of the 2004 presidential election, more American Jews are voting Republican, at least in comparison with 2000 and 1996. This might be a passing trend, but it cannot be ignored. And politics is not the only sphere where change is palpable.

I became an American citizen in 1994, almost a decade after I first settled in Manhattan. Since then I have become part of the fabric of Jewish and Latino life north of the Rio Grande. But as I stated in my memoir *On Borrowed Words,* the addition, and contrast, of these two identities result, in the United States, in an exotic mix as exemplified in my family recipe for latkes with *mole* (fig. 13). Among Hispanics I am described as *el güero,* the light-skinned, non-Catholic, blondy one. In certain circles, this makes me an interloper. On the other hand, Jews see me affectionately as an alien, a bit like the charming Martian played by Robin Williams in the television show *Mork and Mindy.* Clearly, of the two identities, the Jewish one allowed me entrée into the United States. I enrolled in the Jewish Theological Seminary while I was a correspondent for Mexican newspapers. This educational step is a privilege few south-of-the-border immigrants have.

What have I learned in my American odyssey? Are Jews in the United States more divided today than ever? I believe so. But there is also another feature: people's return to their immigrant roots. Over time I have come to appreciate the various layers of Jewish communal life. Maybe American Jews are mighty in their cultural production, but the overall picture one gets seldom reflects the divergent communal voices. More important, it seems to me that the dream of full and unequivocal assimilation embraced by Ashkenazi people born in the thirties and forties is drastically being reversed. Young American Jews are, as ever, proud to stress the *American* half of their identity. But they are less unequivocal about losing their ethnic identity than their forebears had been. Indeed, their objective, I believe, is to be what I have described as *hyphenated* Jews, ethnic creatures loyal to their minority background without sacrificing their patriotism.

All this, in my view, amounts to a thorough process of what I would call "re-ethnification," a collective recognition by American Jews not only of their Jewishness as a form of ethnicity but also of the fact that to be Jewish in the United States one does not need to trace one's roots to Central and Eastern Europe. American Jews come from everywhere. There are African American Jews, Asian American Jews, Native American Jews, and Latino Jews, not to mention those who define themselves in multiple census categories, as well as "other" Jews, and, obviously, Sephardim and Mizrahim. In short, to be a Jew and an American one must recognize one's own "hyphenated" nature. This re-ethnification process, in my view, is of dramatic relevance. It is not about purity at either end of the hyphen. Instead, it is about cross-fertilization on all sides.

Latkes con Mole (Potato Pancakes with Mole)

For mole:

2 tbsp. vegetable oil
1 onion, chopped
1 8-ounce jar mole base
5 cups chicken stock
1 to 2 squares bittersweet chocolate

For latkes:

See potato latkes recipe (below)
Shredded lettuce for topping (optional)

1. Make the mole: Heat the oil in a large saucepan over medium heat. Add the onion and cook, stirring often, until soft and translucent.

2. Add a heaping tablespoon of the mole base to the saucepan, stirring to combine with the onion. Add 1 cup of the chicken stock. Bring to a boil, then lower heat and simmer, stirring regularly, until the mixture reaches the consistency of a thick soup.

3. Alternate adding heaping tablespoons of mole base with cups of the stock, keeping the mixture at a simmer and stirring regularly. This will take about 20 minutes.

4. Continue cooking, stirring occasionally, until the mole reaches a syrup-like consistency. Then let it gently simmer for another 10 minutes, until it becomes a thick, rich sauce. Add the chocolate to taste, stirring until it melts. Remove from heat and set aside while making the latkes.

5. Make the latkes: Follow the potato latkes recipe (below).

6. To serve, spoon mole over the latkes. Serve with sour cream and applesauce on the side. If desired, sprinkle lettuce over the top. Serve hot.

Makes about 3 cups.

Potato Latkes

2 pounds russet potatoes
1 onion
2 eggs, lightly beaten
2 tbsp. unbleached all-purpose flour
Salt and freshly ground pepper to taste
Vegetable oil for frying

1. Preheat oven to 200 degrees. Peel and grate the potatoes. (This can be done in a food processor, but the texture is better if done by hand.) Place the grated potatoes in a colander with a plate beneath it. Sprinkle salt on the potatoes, cover them with a layer of paper towels, and then place a heavy object (such as a heavy bowl or can) on top. Allow the potatoes to drain for 10 minutes.

2. While the potatoes are draining, peel the onion and grate it by hand. Set aside.

3. In a large bowl, combine the potatoes, onion, eggs and flour and season generously with salt and pepper. Mix well.

4. In a large, heavy skillet, add oil to a depth of about ¼-inch and heat over medium-high heat. Drop ¼ cup of the potato mixture into the hot oil, flattening with a spatula. Fry the latkes until deep brown and crispy on both sides.

5. Drain the latkes on paper towels (pat them with the towels on both sides) and keep them warm in a single layer on a baking sheet in the oven until all of them have been made.

The tremendous growth of minorities like Latinos and Asians in the United States has already transformed society for good. If for a long time the nation remained, at its core, white, Anglo-Saxon, and Protestant, in the last fifty years multiculturalism has set in. The uncrushed majority is already under threat and, as established by the Census Bureau, is destined to lose its place in the middle decades of the twenty-first century. Latinos alone have already become the largest minority group, with a total of more than 40 million people, a number that constitutes 17 percent of the entire population in the country. One out of every four Americans already traces their origins to a Spanish-speaking country in Mexico, Central and South America, or the Caribbean Basin. Asians have also multiplied in number, totaling 27 million, which constitutes 11 percent of the entire country. Blacks, on the other hand, have, like Jews, slowed their growth.[25]

What does the future hold? In an increasingly heterogeneous America, Jews will have to establish bridges and make alliances with groups of non-European origin, whose idiosyncrasies, it might be assumed, are likely to require a different kind of cultural sensibility. For it might be argued that, as they have been dwellers on European soil ever since the destruction of the Second Temple in the year 70 C.E., Jews are in tune with countries with a European culture base, and America has been one for the past two centuries. But that base is losing ground. In recounting Jewish history in general, American Jews seldom stress the period of *La Convivencia* on the Iberian Peninsula prior to the expulsion. Now that Latinos in the United States are crucial players in the social chessboard, are Jews familiar enough with the Hispanic psyche to create partnerships with the various Latino subgroups, such as Mexican Americans, Cuban Americans, Dominican Americans, and Puerto Ricans on the mainland? Do American Jews know what makes each of these subgroups tick? Do we understand the nature of Hispanic anti-Semitism, both the Church-sponsored and the spontaneous one as featured on Websites like *The Nation of Aztlán?* And do we understand the tensions that exist among different Latinos? Fragile, precarious bridges with these different subgroups have been established at different times. During the Civil Rights era the number of Jews connected with the Chicano Movement of César Chávez and Dolores Huerta was not insignificant. Similarly, the political alliance between Jews and Cubans in Florida in general, and Miami in particular, is not inconsequential. Can these bridges be the foundation of a more multifaceted transethnic dialogue?

And how about Asian Americans, whose geographical origins in East, Southeast, and South Asia, point to areas of the globe where Jews have lived in minuscule numbers? Joey deVilla writes of the junction where ethnicity and popular culture come together:

> We were the kids cleaning up in math and science class
> We have a strong showing in the computer world
> Strong family ties
> Our mothers tend to be overbearing
> Some tendencies towards clannishness
> Strong pressure from the parentals to get a university degree
> Thick black hair requiring the strongest gel
> Cosmetic surgery (Jews: nose jobs, Asians: eye jobs)

A love of Chinese food

Hiring Filipino domestic help

Run-ins with the original Axis of evil (Jews: Hitler, Asians: Hirohito, who got off too easy)

Signature cars (Jews: VW Rabbit/Jeep YJ, Asians: Honda CR-V, Honda Civic)

And dammit, we own New York, baby![26]

Might Jewish sympathies for Japanese Americans because of the episode of imprisonment on American soil after Pearl Harbor be enough to help them understand the overall dilemmas this ethnic group faces in the country? Are there points of comparison in these dilemmas with those affecting American Jews? What about Korean Americans, who often look to Jews as models on the road to a successful integration into the American way of life? Might the return to ethnicity of younger Jews in the United States complicate this relationship? And what to say about the Filipino, Vietnamese, Laotian, and Cambodian communities? What do they share with Jews?

Arguably the two most significant ethnic groups in the American mosaic with whom Jews have a troubled history—and for different reasons—are blacks and Muslims (fig. 14). Black-Jewish relations hit a distinctively hopeful note during the Civil Rights period, as the two ethnic groups, for radically divergent reasons, sought equality. While for Jews the struggle was about social justice, for blacks it was about bringing down the still-current legacy of slavery, whose foundations had been shaken, but not dismantled, in the second half of the nineteenth century with the Civil War. Yet the 1960s rekindled not only old hopes but also longstanding animosities. From the seventies onward, programs like affirmative action enabled Jews and Latinos to make advances in the educational, labor, and governmental spheres. But the race-sensitive strategies accentuated the differences between blacks and Jews, allowing for misunderstandings between them that, rather than emphasize their similarities, stressed their differences. Although the black middle class experienced ample growth, in an essentially racist society the group remained marginalized. The Middle Eastern conflict has pushed a number of prominent African American intellectuals to side with the Palestinian cause, and to see the Jews as the enemy.[27]

Up until the terrorist attacks of September 11, 2001, the relationship between Jews and Muslims in the United States commanded little attention. The Arab-Israeli conflict was the principal source of debate connecting these two ethnic and religious groups. In the last few years, discussion of their conflicts and alliances in the Melting Pot has increased, although that discussion for the most part has been in newspapers and magazines. It is unquestionable, though, that as the threat of terrorism continues to define American foreign policy, and as Jews and Muslims in America face each other in various spheres, from the domestic to the political, their attempts at a mutual understanding will be crucial. Can they appreciate their identities beyond the Middle Eastern conflict? Can their similarities be explored at times when their differences are highlighted? Will the fact that Jews have become an integral part of American society become an issue for a Muslim community ostracized as a result of world events? Are Jews capable of appreciating the fact that, in their history, they have lived harmoniously with Muslims in various corners of the globe, among them Turkey, Egypt, Iran, and Spain?

Fig. 14
Cover of the 1995 book *Jews and Blacks: Let the Healing Begin* by Michael Lerner and Cornel West

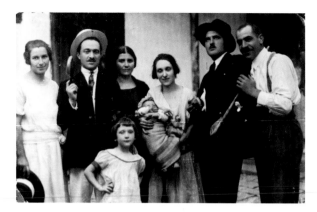

Fig. 15
Group portrait of a Yugoslavian Jewish family before the German invasion, Belgrade, 1924. Courtesy of the United States Holocaust Memorial Museum

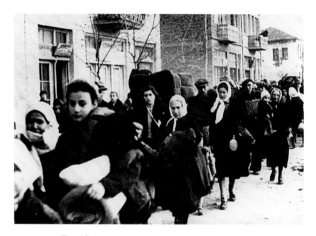

Fig. 16
Greek Jews being deported from Northern Greece to a concentration camp in Poland. Courtesy of the Yad Vashem Archive, Jerusalem

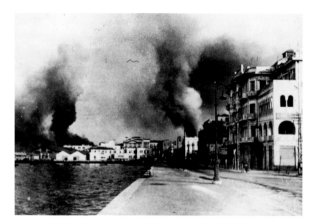

Fig. 17
Salonika, Greece, during the German Occupation, September 4, 1941. Courtesy of the Yad Vashem Archive, Jerusalem

The recognized cornerstone of American Jewish identity is the tension that arises from the Holocaust and the Middle Eastern conflict. The destruction of European Jewry during World War II also needs to be discussed (fig. 15). Its influence over politics and memory is incommensurable. One might argue that the Holocaust is the single historical event that made the Jewish community in the United States coalesce and speak with a unifying voice. The fear of a once-again widespread anti-Semitism in Europe and in the Muslim world impregnates the collective identity, to the point that it might have replaced religion as a glue binding people together. It has catered to an enormous industry—at times described, in derogatory fashion, as the *Shoah* business—that has produced an expansive literary shelf comprising memoirs, fiction, and poetry, as well as abundant scholarly studies, films like *Schindler's List,* and major museums and memorials, all of which have had enormous impact in the curriculum in primary and higher education.[28] Critics of this wave argue that it perpetuates the image of Jews as passive victims. Similarly, the argument has been made repeatedly that the representation of Jews in the 1939–45 period is disproportionately homogeneous at the ethnic level, eclipsing the destruction at the hands of the German army of the Sephardi communities in Greece, Turkey, Egypt, and the Balkans (figs. 16, 17). Similarly eclipsed is the Nazi attack on gays, Gypsies, and other "undesirables." Are these mere accusations from a politically correct crowd? Has the *Shoah* become such a potent cultural magnet that it erases social nuances?

Will the Holocaust remain a fundamental source of definition? What about the state of Israel? Two decades after my arrival in the United States, I am mesmerized by the degree to which America exists as a splintered, fragmented society. Minorities, to a large extent, keep to themselves. But few are as elastic, in terms of their talent to adapt, as Jews. This is not surprising: Jews, after all, are perfectly acquainted with the role of outsiders. The Diasporic journey has taught us that geography is temporal. What appeared at one point to be an enviably solid existence in Babylon, Spain, or Germany turned out to be but a chapter in a much larger narrative. Can we finally accept that to be Jewish in America is to have multiple ethnic roots?

Multiculturalism has been a feature of the United States since its inception. But as the population numbers have changed, so have the texture of society and also its principles. It used to be that new immigrants would eventually be allowed a space within the mainstream culture. But multiculturalism has finally changed the mainstream: It has subverted and decentralized it. Currently 12 percent of the nation's entire population is non–United States born. And by the mid-twenty-first century only one American in four will be of European descent. To what extent will the motto *E pluribus unum*—the eighteenth-century motto, translated into English as "Out of many, one," suggested by Pierre Du Simitière and chosen by the first Great Seal committee of the republic in 1776—still be applicable? In particular, will Jews continue to have a comfortable place of their own in the mosaic? Since the Enlightenment, Jews have served as agents of modernization. They have helped make America competitive on almost every level. But internally, self-perception has become stagnant. There are transethnic dialogue groups in cities like San Antonio, Miami, New York,

Los Angeles, and Chicago, but their effect is minuscule. Similarly, artists and intellectuals have been concerned with reaching out to other minorities, but, as discussed, the artistic representations leave much to be desired. To the question "Who are we?" a majority of American Jews, I believe more by inertia than anything else, still respond as they did after World War II, pointing to Europe as the source of cultural and religious sustenance. Yet, a major demographic metamorphosis has taken place, one that has given rise to a less homogeneous, more varied self—one attuned to the nervous, assorted nation we live in. Throughout history Jews have strived in diversity. But that multicultural self is still not recognized as a communal feature. It needs to become one if we are to recognize as our own the face in the mirror.

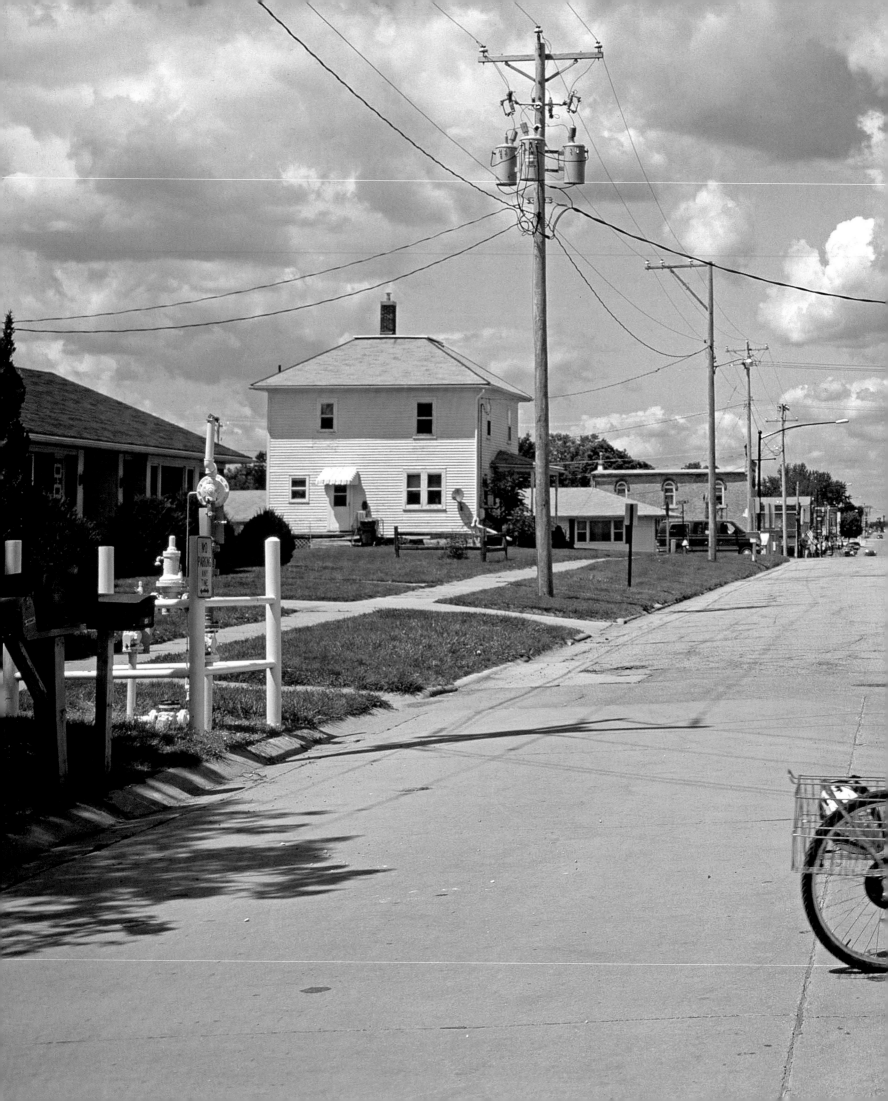

Artist Portfolios

Dawoud Bey

I think a portrait is something that results from an implicit agreement between subject and photographer. The subject first consents to the attention of the photographer and the camera. Because the introduction of the camera disrupts the normal social situation, what happens at that point takes on an aspect of personal theater and performance. I, as the photographer, become a kind of director, attempting to provoke a credible performance on the part of the subject, a performance which nominally reads in the photograph as a kind of nonperformance actually, since the role, as such, that the person is "performing" is his or her self.

Following pages:

Samantha, 2004

Claire, 2004

Zenebesh, 2005

Sahai, 2005

Jacob, 2005

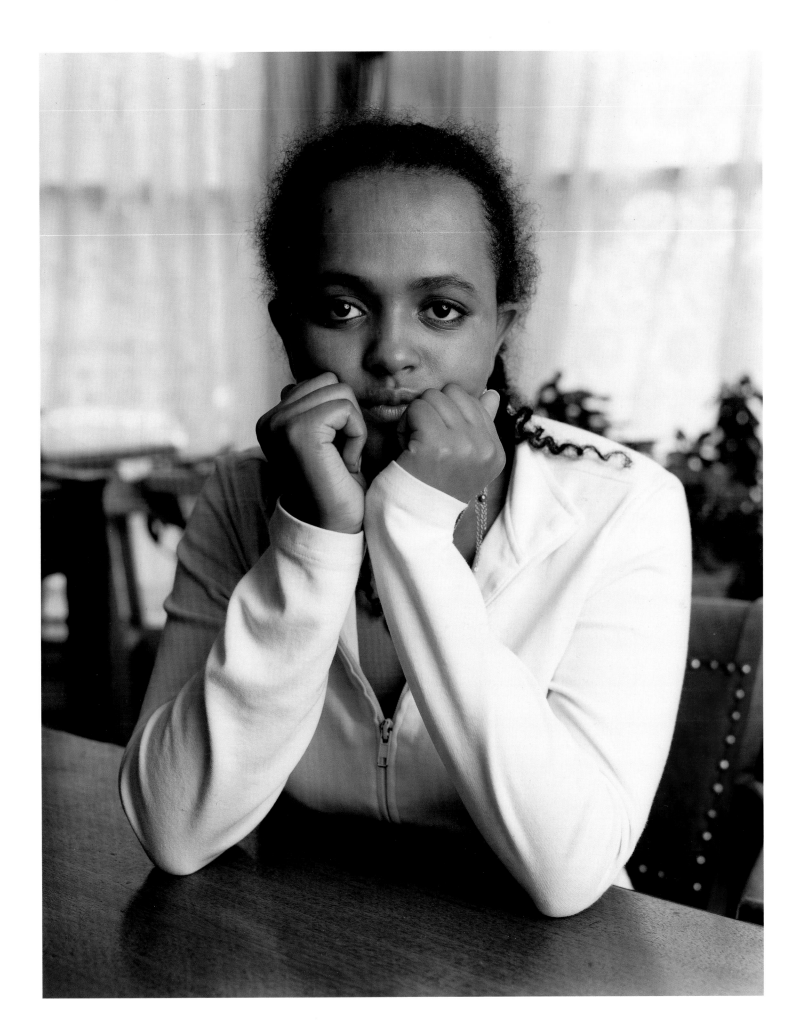

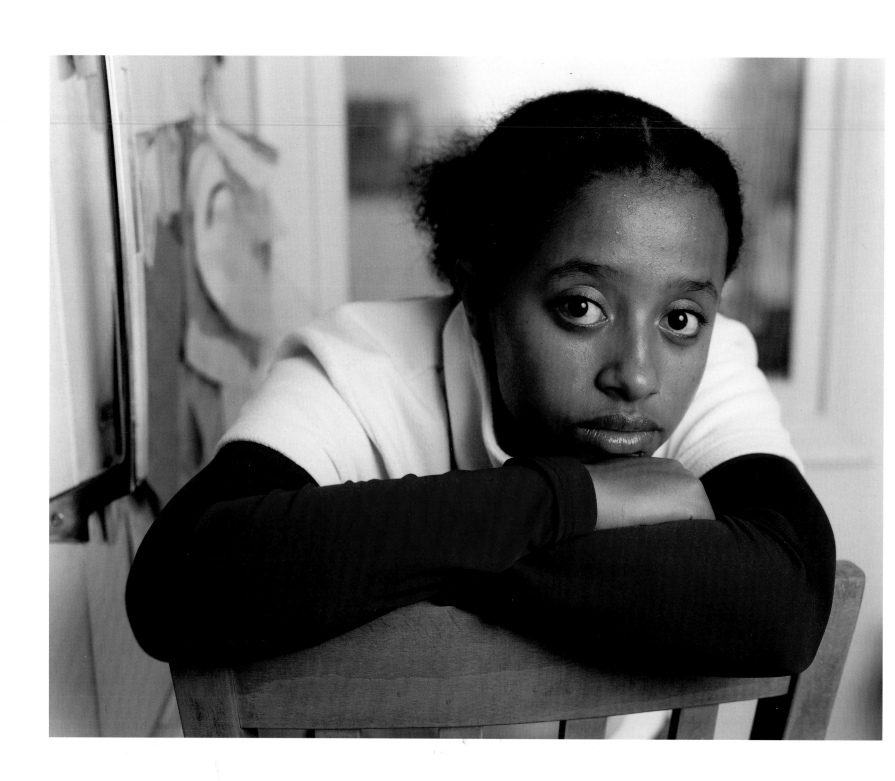

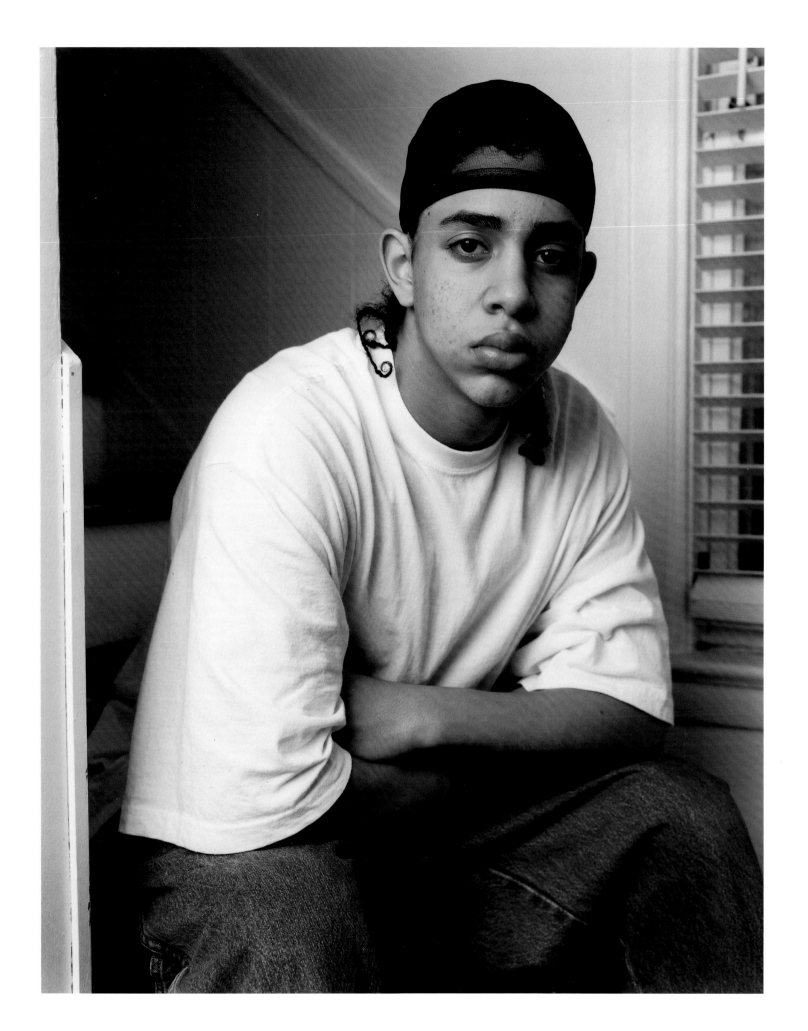

Tirtza Even and Brian Karl

Definition, 2004–5

Melinda Ring, choreographer

Todd Holoubek and Scott Fitzgerald, programmers

It is too easy for even the most well-meaning and thoughtful individual to fall back on habitual ideas (and this applies to us as well!)— especially regarding issues of identity as expressed through ethnic definitions. Part of the aim of our project is to open up conversations that might otherwise be fixed, predictable, or shut down because of such preconceptions, and to enter definitions that would be fresh or revealing because they are more layered, problematic, or even contradictory. We wish to add to the depth of the piece by evoking crucial ethical and political ambiguities.

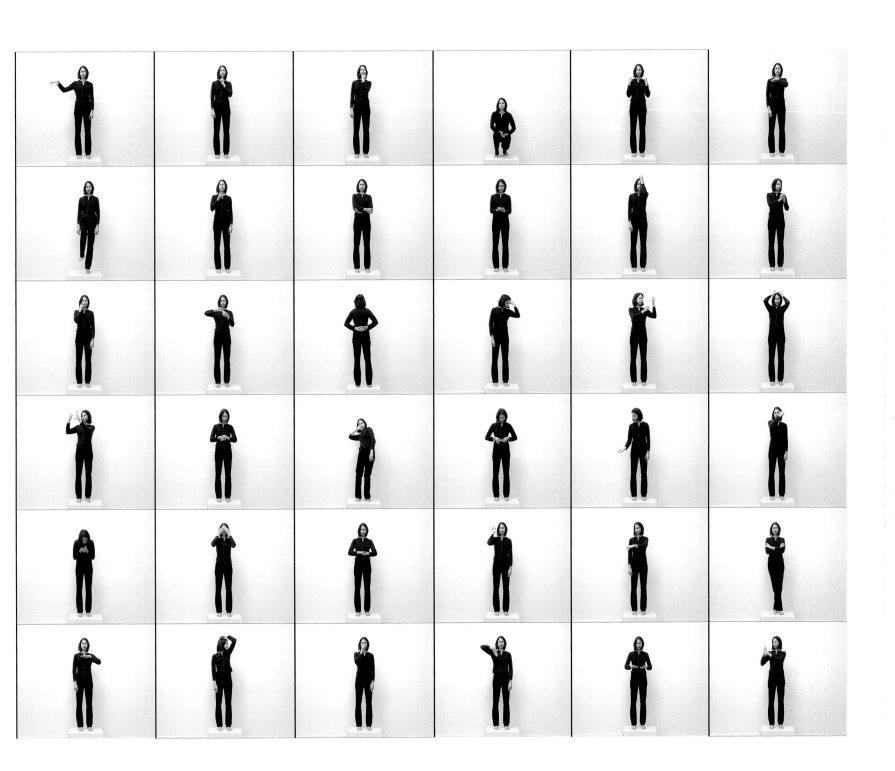

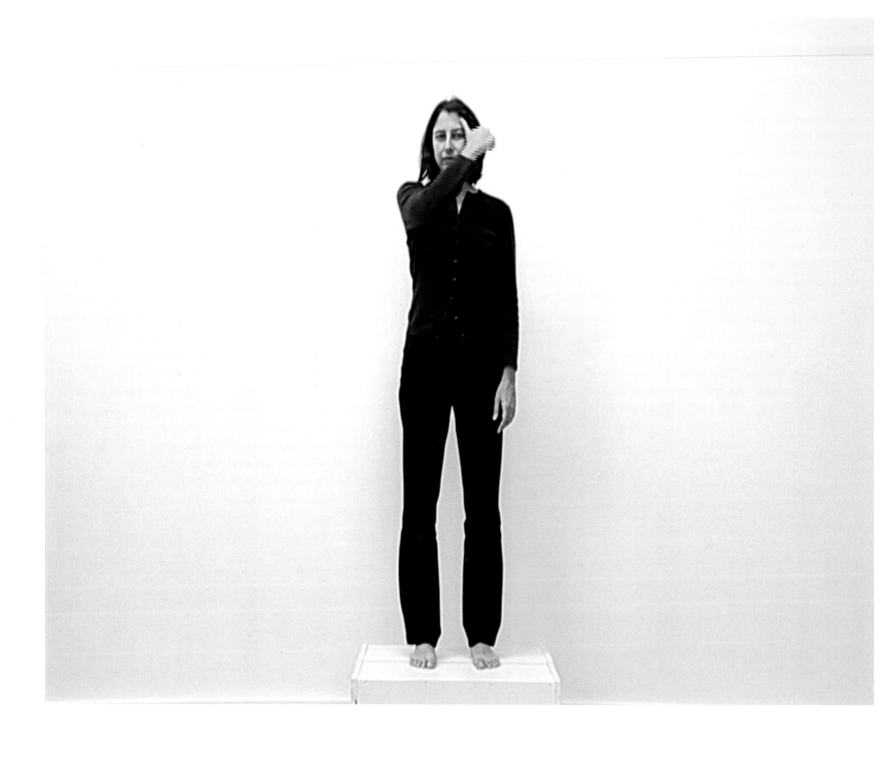

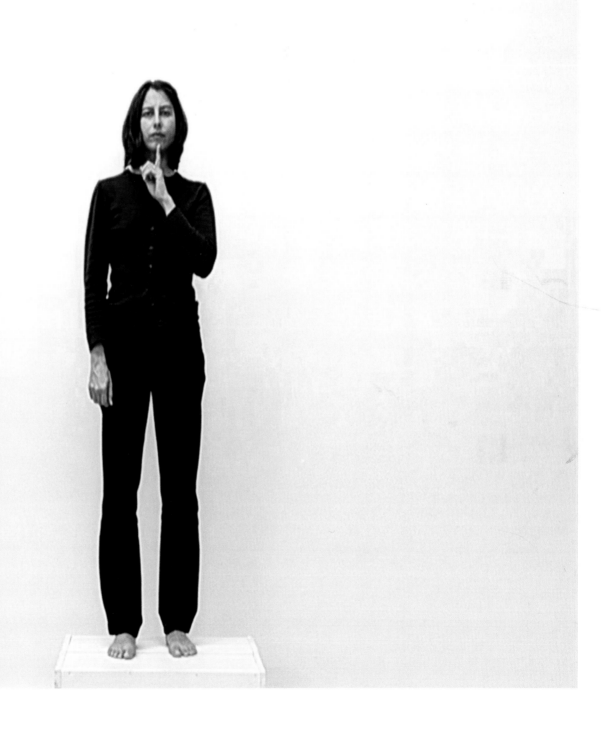

Speaker A (Censorship, Questioning, Education):

. . . and he said, "God is your conscience, that thing that tells you what good and bad is," and he started tapping on kids' heads and saying that's where God is, God's in there. And kids went home and told their parents, and the parents pretty much interpreted it as this rabbi is telling their kids that God is a figment of their imagination. And two weeks later the rabbi was fired. From then on I realized that there were really two forces in Judaism: that one is what I consider really Jewishness, which is the playful inquiry—let's start a fire, that no ground is too sacred— . . . and this other—which I think is incorrect and anti-Judaic—fundamentalist refusal to engage in dialogue lest it damage our children, hurt Israel, and make God not like us and cause another holocaust. And it makes me sad that the Jews are not the best shepherds of this thing called Judaism today.

Speaker B (Moral License, Righteousness, Questioning):

. . . the historical space of Jewishness becomes a kind of moral license to speak out about the occupation and about the racism and injustices and about what the alternatives really are. . . . I encounter people who make what are completely historically inaccurate, insensitive comments which mask a lack of knowledge and a kind of racism. . . . I have on a number of occasions invoked my own cultural heritage as a way of saying that I have a right of being critical of Israel.

Speaker C (Questioning, Lapsed):

It's just a decision that if I'm going to have spiritual context in my life I'm going to need to build on what's already there and not find something that's completely new. Or at least find a way to use what's already there and not throw it away. I think there's a lot of great things in Judaism and Jewish culture, I think most of them are obscured today. It's something like the old thing of throwing the baby out with the bath water, and maybe you have to do that for a while, but I think that I've decided I don't want to throw the baby out.

Speaker D (Humanity vs. Group, Social Justice, Insulation, Exclusion, Assimilation):

I also have come to know that my cultural Judaism is very different than somebody else's cultural Judaism— somebody who was raised with different foods and different smells and the joys and warmth of Judaism as I defined it, well they could have that same warmth only it's a whole different sensory intake than I had. I also realized that I couldn't give that to my children, it's only unfair for me to define Judaism in the Eastern European way that I was raised for my children who are converted, who were taken to the mikveh but who are Chinese. . . . I think that there are countless Jews whose value system and sense of humanity is in conflict with their Judaism. . . . They see the world in a very narrow perspective. . . . There are people in the Jewish community who are terrified of those that are different than them. I don't get it. . . . I don't think that across the board, the Jewish community can say that it cares for the greater humanity of the world. Or that it is accepting of difference. I wonder if even in my temple if all of a sudden 30 percent of my temple were biracial, what would happen. It still is very Eastern European in identity.

Speaker E (Humanity, Palestine, Zionism, Social Justice, Struggle):

. . . when I look at how kind she was and how smart she was about everything, and then hear comments come out of her mouth such as saying Palestinians don't deserve to live, not even children. And I said back, "You know you don't mean that." And she looked me in the eyes and said, "Yes I do." And I struggle because she's still in my life and she's still doing great things for the community in New York, and that still burns a hole in my heart. . . . How can you have a kind, giving, caring outlook, you know, except for one people?

Speaker F (Palestine, Israel):

As a Palestinian, Jewish means a lot of bad memories. Checkpoints. Home demolition. Machine guns. Soldiers. Settlers. Land confiscation. Most people experience the same thing back home. I never had contact other than with soldiers in my life, that's the only way we saw them . . . a tank and a jeep and arms and force and superiority.

Speaker G (Synagogue, Language, Yiddish, Social Justice):

Jewish—what does it mean, *Jewish?* It means this background. . . . I was up with the women in the second level with a curtain closed, peeking. It was very lovely. The rabbi told the story that there were two brothers and someone came across one of the brothers standing in the street, and he's pointing a mirror, he's just holding this mirror, and this person would see this boy doing this day after day at a certain time. The boy would appear and hold a mirror. And this great mystery. And one day he finally said to the boy, "Why are you doing this?" And the boy said, "My brother is sick, he's in this hospital, he's in a room that never gets the sun, and I'm bouncing the sun."

Speaker H (Discrimination, African Origins, Exclusion):

I remember a particular person was trying to hook me up in a Shiduch kind of situation, and it never really struck me that someone in the community would say that, you hear it in other contexts because of your color, but she said "I have a really nice young lady that I'd like to introduce you to and she happened to be an Ashkenaz girl and she says the reason why I immediately thought of you is because you're not too dark." And I was just struck by it . . . she said to me "yeah you're not too dark and you're very bright and intelligent and you speak well." Now I've always heard the speaking well part growing up because that was just part of what people would say to young black children that happened to have a vocabulary past the fifth grade and meanwhile you're in the tenth. But when she made that comment to me I said my goodness that as a Jew of color I'm actually good enough to be introduced to someone who's white and Ashkenaz, but if I was a little darker in hue then that would really make a difference.

Speaker I (Palestine, Exclusion, Insulation, Israel, Zionism, Wall):

. . . the wall is interesting. I think it's for Palestinians a very strong symbol of the occupation. For the Israelis it's a symbol of some version of what we want to be, of being cut off from the surrounding countries and defining our identity behind walls and not through negotiation and dialogue but through our own definition of what is us and what is them and what is out. The physical reality of the wall . . . it's really sad seeing Israel as a homeland, and it's a homeland I would like to share with everyone else. But it's really being brutally dissected. Physically the zigzag of the wall is demolishing so much beautiful landscape and trees and groves that are the livelihood of Palestinian villagers. And it's because we haven't decided what we want to be. On the one hand we want to enclose ourselves inside this thing, on the other hand we don't want to move the settlements that are in Palestinian areas. . . . The wall is a combination of these two things . . . it keeps going back and forth between trying to delineate a border and realizing that there can't be a border because the Jewish and Palestinian communities in the greater Israel and Palestine are too mixed by now.

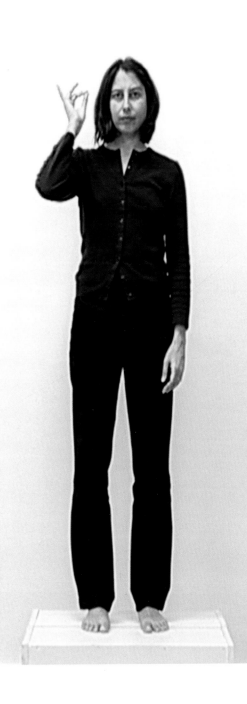

Rainer Ganahl

Language of Emigration, 2003–5

I cannot tell what effects my interviews might have had on my interview partners, but I left many houses with mixed and shared feelings of compassion, love, understanding, and some sadness. Sadness that it is not possible to keep up visiting and sadness that life has an inevitable end. Since most interviewees from my *Language of Emigration* series are not only very old but also very lucid and young in spirit, and tended to be somehow lonely—many seemed to have survived their friends—I often felt like an immediate friendship was established that the interviewee and I would like to continue. The impossibility of living up to this undiscussed promise is saddening.

LEDERER FAMILY

Gerda Lederer
Born: Vienna, 1926
Emigration: 1938 Paris, 1939 New York
Profession: sociologist
Three children

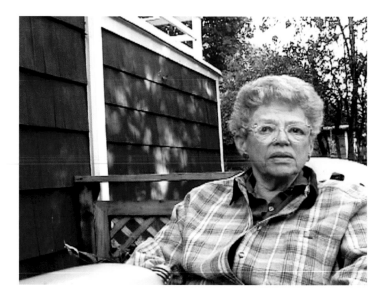

Gerda: In 1934 we went with our car to Italy to spend a vacation. . . . I met a sister and brother who came from Germany. . . . then came the day when I told them we were going home tomorrow because school was starting. And then the little girl said, "We don't have to go home." I said, "No? Don't you have to go to school?" "No," she said, "we are emigrants." And so I thought, that must be such a delicious thing to be if you can stay on vacation forever. . . . So then I was eight years old, that's the first time I heard about immigrants. I was told by my sister, from her great wisdom of being age ten, that that meant that they couldn't go home.

Rainer: What language did you keep speaking at home? **Gerda:** My sister and I were very soon very insistent on speaking only English and saying to my parents, how will you learn it if we don't speak it, and they were willing, so we spoke English at home . . . almost immediately.

Rainer: So who were your friends at this time? **Gerda:** I found that I had so little in common with the American children that I went to school with. . . . In the end I joined a group called the Austrian American Youth, which was during the war and which was Austrians with backgrounds like my own. And we had a lot of companionship and a lot of activities together.

Gerda: I came to a realization . . . which is that there is such a thing as a Jewish heritage and a Jewish culture and it does not mean that it is identical with belief in a Jewish God. So I was able to be comfortable saying I am Jewish without having to pretend that I believed something I didn't believe any longer. . . . On the other hand, . . . even now—we've just finished Yom Kippur, which is the holiest day of the year, and which my family always observed—I cannot experience that day without some emotional trauma to this day.

Rainer: How did you handle that situation—that identity—in relationship to your family? **Gerda:** Badly. . . . My ex-husband [who was German and whose father was Jewish] was interned in England as an enemy alien. Jews and non-Jews who were from German-speaking countries were interned and he was sent . . . to Australia, and he spent two years in very primitive and difficult circumstances in Australia in two different camps. He felt that if life had taught him anything it had taught him that he did not want to raise children in the Jewish faith because that was going to make life unnecessarily difficult, or could. . . . My middle daughter, since her partner is Jewish, made a commitment to Judaism by sending her eight-year-old daughter to a Jewish private school, and they belong to a synagogue.

Gerda: All three of my daughters have partnerships and all three of my daughters have children with their partners. And the most solid, happiest, most delightful family is undoubtedly the youngest, where you have the diversity of two different cultures coming together, which are the Jewish Austrian background of my youngest daughter and the West Indies background—black, New York, and West Indies—of her husband, and not because they are different but because they are the individuals they are and perhaps because they found each other. That family writes its own rules. They don't live according to the high cultural desires of the background on our side nor probably to the background of Rodney's side. But what they have built themselves is such a wonderful, giving, enjoying relationship and family . . .

Gerda: I taught a course with Albert Lichtblau called "The Generations after the Holocaust," and it involved the conversation between generations of those who had been on one side or the other of the Holocaust and their grandchildren. He brought students whose grandparents had been in the Wehrmacht, and I brought students whose grandparents had fled the Holocaust. And we had the same text and the same studies that we concentrated on, and then the students did projects together to compare the difference in understanding, teaching, reacting to the experience of the Holocaust. . . . This is what I am teaching at the moment, the persecution of Jews and homosexuals under National Socialism. . . . We're studying texts that have to do with that, among them the controversial and unusual text *Maus*, where Spiegelman—Artie Spiegelman—elicits the life story of his father in interviews. We're also studying Gabriele Rosenthal's study of perpetrators and their grandchildren and victims and their grandchildren.

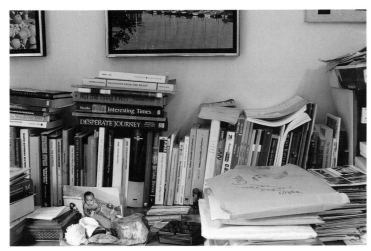

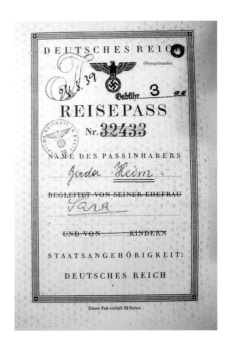

LEDERER FAMILY

Catherine L. Lederer-Plaskett

Born: Catskill, New York

Profession: reproductive rights advocate; president of WCLA–Choice Matters; founder of the Ridge Historical Society, which focuses on the contributions of people of color to the development of Westchester County

Two children

Rodney Lederer-Plaskett

Born: New Jersey

Profession: stockbroker, practiced law for ten years and then changed professions to work on Wall Street

Two children

Aliza Lederer-Plaskett

Born: New York State, 1990

Profession: high school student

Lucas Lederer-Plaskett

Born: New York State, 1993

Profession: middle school student

Catherine: My parents spoke German as the *Geheimsprache* [secret language] and so we learned it; I learned it. Because that's how you learned what the secrets were at the dinner table.

Catherine: I don't know that this is the experience of anyone else but . . . for myself I never felt like I had a country. I spent the best times of my youth and my teenage years in Europe. And in my home my father always spoke of Europe as the best place. And the United States was the country of their safety, but we didn't really belong anywhere. . . . And we weren't American. I was not raised in an American home. . . . My father believed very strongly—and I watch now in Europe and maybe he wasn't wrong—that it would happen again.

Catherine: As a mother I have become much more conscious of discrimination as a whole. . . . In the Northeast . . . anti-Semitism is clear but it is less prevalent than racism.

Catherine: I am, as I said, an activist by nature. . . . I say to my husband all the time, our neighbors, look, they just go to work and they come home, and they don't try to save the world or change the world or make it different. I don't know if it's my parents' history that made it different for me. I don't know. I just can't do that. I think otherwise you're just taking up space.

Catherine: I feel in my soul—minus that small component of being an atheist as far as a deity—I am a Jew, and I really don't label myself very easily.

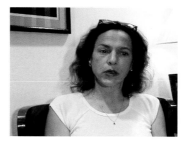 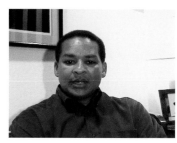
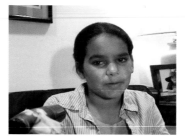 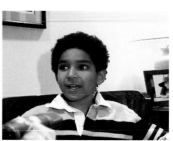

Rodney: I definitely believe in God, some days more than others. I like to think that there is some sort of almighty being that is trying to make the world a rational and better place. Catherine often simply does not.

Rodney: People who know that Catherine is Jewish often, sometimes, ask me, "Well, aren't your children going to be bar mitzvahed?" Because they are very passionate about keeping the Jewish religion healthy and growing. **Rainer**: What do you answer them? **Rodney**: I basically answer that we are considering all our options.

Rainer: I heard that you wrote a very nice story once about your grandmother. **Aliza**: Yeah, that was in sixth grade. **Rainer**: Do you recall what you wrote? **Aliza**: I wrote a diary for her about how she escaped Austria and fled to the U.S. . . . I heard my grandmother talk about it a lot. And I went to her house and I interviewed her to find out more about it, and my mom told me a lot of things as well.

Rainer: Do you want to learn German? **Aliza**: Yeah. I'm going to in tenth grade. That's when I am allowed to take that subject at school. **Rainer**: Are you particularly interested in that kind of culture? **Aliza**: Yeah. **Rainer**: Do you think that it has something to do with your grandma? **Aliza**: Some of my grandmother's friends want me to come visit them and I can't really until I learn how to speak it better and I don't know very much of it at all right now, and so when I do learn more I will be able to visit them.

Rainer: What happened to [your grandmother]? **Lucas**: Did you already ask my sister this? Did you ask my sister all these exact questions? **Rainer**: A little bit different. More or less. **Lucas**: Well, I don't know the exact things, but I know that she escaped Hitler. **Rainer**: And who was he? **Lucas**: He was an Austrian. He was a Nazi. **Rainer**: And what did the Nazis do? **Lucas**: They killed Jews. **Rainer**: And others.

Lucas: I do have a question. Why are you interviewing us? **Rainer**: It's a good question. I am interviewing you because I was invited to make some work about different generations of Holocaust survivors, people who escaped, who could escape, and so just to show a little about the diversity of life, the diversity of how it went on. **Lucas**: Yes. **Rainer**: Like, you know, coming from Vienna and then coming here. Does it make sense? **Lucas**: Yes.

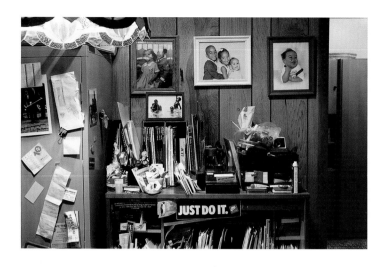

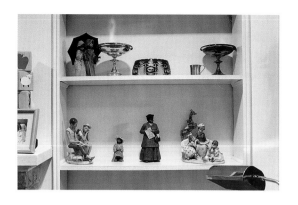

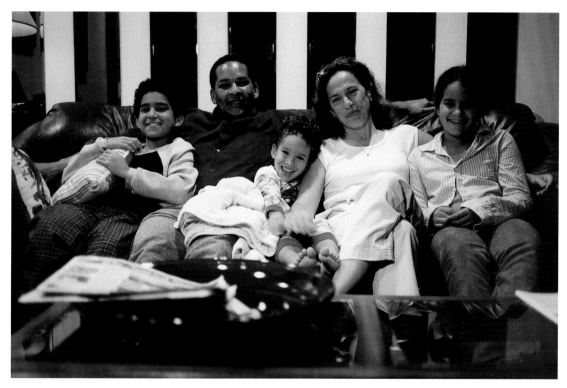

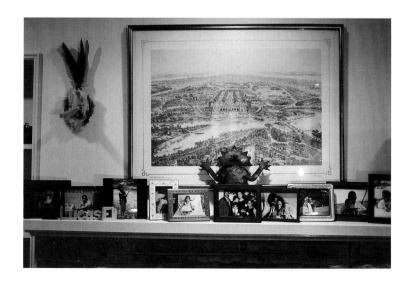

INDENBAUM FAMILY

Gisa Indenbaum

Born: Berlin, 1924

Emigration: 1933 Brussels, 1940 France and Lisbon,

1941 New York

Profession: psychologist

Two children

Gisa: I remember brown shirts marching in the streets and being very frightened.

Gisa: I don't think of myself as German, certainly don't think of myself as Polish or Austrian, so, yeah, just Jewish.

Gisa: We were running. We were running. We never stayed any-place. It's hard to explain the chaos of war if you don't know it.

Gisa: My father had a sister in Detroit so we went there. My par-ents went to Chicago. I mean there was just no place for them. So we came back to New York as being the place, I guess, that felt most comfortable, had the most promise.

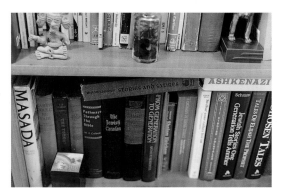

Gisa: Of all the members of my family, my father had the hardest time. He couldn't become a worker again. He had been an inde-pendent businessman. There was really no place for him. He was too old by American standards.

Gisa: They spoke a mixture by the time they got here, of German, French. . . . I thought they spoke German in Berlin but as I am learning Yiddish I have my memories of words that I recognize or that I say—expressions. I think perhaps there was more Yiddish than I remember.

Gisa: My mother became an American? None of us became American. **Rainer**: Just a New Yorker. **Gisa:** Just a New Yorker. So when you say you're an American, I am not sure what you mean by that. **Rainer:** An American passport.

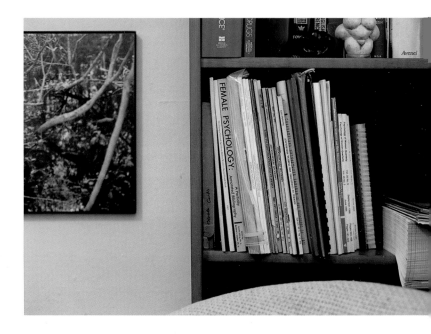

Gisa: The notion that when you get here you're finished with that was never even considered. Part of you is still there. . . . I never went back. **Rainer:** You never went to Berlin? **Gisa:** I never went to Brussels. **Rainer:** Never went to Brussels. **Gisa:** Why would I go? **Rainer:** Some people go back to see places where they . . . **Gisa:** Those places don't exist anymore.

Gisa: My brother and I had made a pact when we came here that we would continue to speak French, but not German.

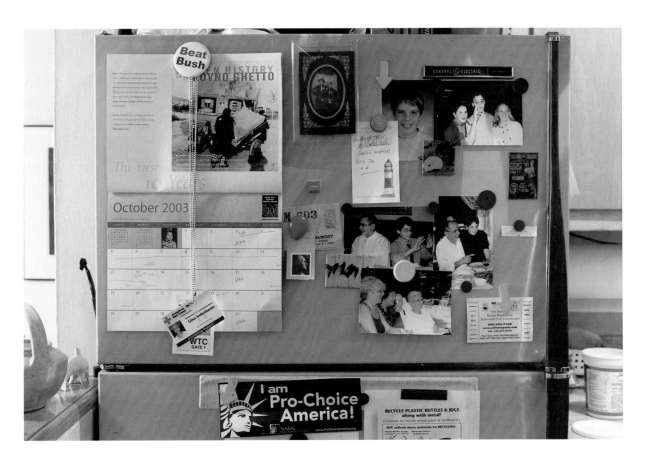

INDENBAUM FAMILY

Miriam Indenbaum, Ph.D.
Born: New York
Profession: school psychologist
One child

Wilfredo Rodriguez, Ph.D.
Born: Jersey City, New Jersey
Profession: school psychologist
One child

Michael Rodriguez
Born: Philadelphia, 1988
Profession: high school student

Miriam: I actually just thought of myself as an American because I was raised speaking English. Because we grew up with the other American kids doing all of the same things that all the other kids in the neighborhood did. I didn't particularly feel like an outsider or anyone different. As a young child I grew up in a neighborhood that was largely Jewish. I'm sure at that point there must have been people who were also immigrants, but I was a younger kid and I really didn't pay attention to that.

Rainer: What language was spoken at home? **Miriam:** English only. And actually I was annoyed. One of those things. Mom, why didn't you speak French or German or whatever? Because that way we would have grown up knowing more than one language, which I always wanted to do. And she actually very intelligently said to me, well, because your father didn't speak French or German, so the language of our home was the language my parents spoke with one another and then the one that they spoke with us, which was all English.

Miriam: Now the language spoken when my mother, my uncle, and my grandparents got together was not English, unless it was to us, the kids, but when they spoke amongst themselves it was either in Yiddish or in German. . . . I loved it actually. I clearly picked up much more that I even knew I was picking up because I apparently use it to a great degree now, and in my workplace people look at me when I use Yiddish words that I didn't realize peppered my vocabulary to the degree that they do. So I am now teaching them all the Yiddish that I know. . . . They're isolated words. I don't really speak the language at all.

Miriam: My grandmother kept a kosher kitchen. At home we did not. We certainly always celebrated, mostly at that time when my grandparents were alive, with my grandparents and cousins and things like that, all of the holidays, but also had all of the American holidays. . . . They were different when I was a child from the Jewish holidays that we celebrated in that there was also Hebrew, and . . . whatever the other religious trappings there were of the particular holidays happened to a great degree. . . . After my grand-

parents died we continued to celebrate all of the Jewish holidays but with less of the formal observance, more of a historical context, more of a family context and less of the formal religious context.

Rainer: When did your parents first tell you about their fate, about their immigration, the reasons they came here? **Miriam:** Always, always. I can't think of a time from the time I was very, very young where the stories of how the family—mostly my mother's family—. . . came from Europe and the years it took to get from—mostly Belgium—the story of leaving Belgium and how they arrived here in this country two or three years later. But I remember those stories from the time I can remember anything. . . . In a funny way they always had meaning. I always told them to other people if it came up in any context in any way. . . . I would always tell those stories. So they were always just very much part of my history, my personal history, even though I didn't live through them.

Miriam: I think the connection, although again it wasn't something overt to me that I was really aware of as a child, but the connection was my mother's sense, I think, of what it feels like to be perse- cuted, having been persecuted as a Jew, and that her translation of that was to fight against any form of persecution. So she became involved in civil rights here in the early sixties. But again I think as a kid my sense of that was much more—when I was younger—was much more rooted only in my knowledge of what was going on in this country, and only as a young adult did I make a connection between persecution is persecution is persecution and that when you live through a form of persecution, a way to manage it, to deal with it, what that can bring out in you, is to fight against it. **Rainer:** And at any point did it create anger or fear [in you]? **Miriam:** No, no. I don't think so. Again, I think because by and large in this country certainly for us we are part of the majority, not the minority. There was at least in my life anyway no overt anti-Semitism that I ran up against.

Rainer: When you meet an Austrian like me you would not automati- cally ask the questions, what did his grandparents do, what did his parents do? **Miriam:** It would never occur to me.

Miriam: [My son] considers himself a Jew. Although as he and another young friend of his made up when they were young—because the two of them have the same heritage—they're Puerto Rican Jews. So apparently there are two of them in the world.

Miriam: We are sort of fairly removed from the observant and more formal religious aspects and yet consider ourselves Jews. If you ask him—my son—I think he will tell you that he is Jewish.

Miriam: While as a child I didn't necessarily consider myself the child of an immigrant, I didn't feel like I was an immigrant, or I was different . . . but as an adult having read several books where often the main characters will be immigrants or the story will be about immigrants—interestingly it doesn't have to be Jewish immigrants from Europe—reading about the experience of being an immigrant is remarkably similar no matter who you are, no matter where you are emigrating from . . . and it's only through that that I realize that, "Oh, you know what? My family were immigrants."

Miriam: I think there was a great deal of a push to be American. . . . I still think there was a desire to become part of the society and the culture here, to not feel like an immigrant, to not be an immigrant only, but to be very much part of the world here and the country here and the language here . . . at least I did in my family in a very American community. **Rainer:** Is there a hierarchy in terms of immigrants? **Miriam:** I think we see it today all the time . . .

some immigrants are okay and others aren't and certainly we see that here with our borders in Mexico clearly. It's not okay to be a Mexican immigrant in many places even though they're needed for their labor. And it's much better to be a European immigrant.

Miriam: Because if someone is not an outsider, if they are not a stranger, if they are not an other, if they have not been objectified in some way, then it is much harder to hate them, and think bad things about them, and believe untruths about them.

Miriam: I think [the Israelis] don't have as many choices to resolve politics. You know when you are in the middle of an armed conflict your choices really can get more narrowed. Which doesn't mean that they don't have a greater array than is sometimes portrayed as well. But I do think that when you are literally in the middle of a war, and they've been at war—for, what?—my whole lifetime, I think that that does narrow [your choices] . . . ; you're less maneuverable, you have less room.

Wilfredo: I was born in Jersey City. . . . My parents were from Puerto Rico.

Rainer: Were there any stereotypes in Puerto Rican culture toward Jewish life? **Wilfredo:** I don't know that I can actually talk about whether Puerto Rican culture has these stereotypes. I don't believe that my parents have any stereotypes like that. I think for them

someone who is Jewish is American, okay, rather than it being either a religion or something that is culturally different. They were just Americans. So my parents certainly didn't have any of those stereotypes.

Wilfredo: We were poor. My father was a dishwasher. He worked at Luchow's restaurant. He managed to make enough money to put food on the table. . . . My parents certainly raised me to believe that education was important. . . . They always wanted us to have a better life than they did. That's how they raised us. **Rainer:** Did that also mean that you had to become American? **Wilfredo:** I don't think that that was what my parents pushed. I don't think that's something they wanted for any of us. My sense is that if anything they would have preferred that, for instance, I remain within the culture. I suspect that my parents were slightly disappointed that Miriam was not Puerto Rican. However, that never stopped them from accepting her being part of the family. When they raised us . . . they never pushed necessarily that we become American. That wasn't something . . . [it] didn't drive them. If anything I may have taken that on myself personally.

Wilfredo: Of my high school friends . . . nobody went to college. . . . I was the first in my family to go to college. . . . I'm the first in my family in any generation to become a doctor.

Wilfredo: While I am Puerto Rican, I don't look it. Would you have ever thought that I was Puerto Rican? . . . All of my older brothers have olive skin, dark hair . . . a heavier accent.

Wilfredo: Miriam—while she is Jewish and while my sense is that culture is very important to her, we have not talked very much about the Holocaust. I know that her family left Europe and were able to escape before Hitler really got a hold and that they managed to leave, and I know how important that history is to Miriam's mother. I don't know how much of a role that plays in our lives other than to be aware, to never forget, to be mindful of what's going on in the world and that stuff like that doesn't occur to anybody. **Rainer:** Has it ever occurred to you [that] . . . back some years ago your son in Germany would have been looked at in a quite different way or your wife in Germany would have been in a completely different position? . . . I have to say that I do it sometimes; it's a trauma for me, too, coming from that place. **Wilfredo:** I don't think that way. I don't imagine what it might be like with Michael or Miriam back in that time during that period. I don't think about it. It's not the way I think. You know, there have been times when I have seen movies about what has happened, what could happen, if a plane is hijacked by terrorists who look for Jews and what would I do in that situation, what might happen. What if Miriam and I were traveling and that were the case? **Rainer:** They would think you are Jewish. Because in their context, you could look very Jewish. **Wilfredo:** Oh, absolutely! **Rainer:** So you think sometimes that? **Wilfredo:** No, I think that what I was saying is that I might try to imagine what might happen if that were the case that my wife or my son—something might happen to them.

Wilfredo: It's a choice I made to live this so-called successful life. You can have it all if you become an American—a white Anglo-Saxon Protestant. . . . As I said, I made my bed and I'm lying in it. My parents had wanted the best for me, and on some level what-ever it is that they did was able to allow me to do the things that I did, and what I want is for my son to have better than I did, and he is doing that in spades. So, you know, do I feel guilty about it? No, I don't think so. Am I unhappy? Maybe. That I made certain choices that excluded, probably, certain things in my life that would have made it probably richer? Yeah, I'm unhappy about some of those things. I'm unhappy about the fact that Michael does not speak Spanish. Michael is, however, exposed to Spanish foods that he enjoys. There are some things that I try to incorporate about being Latino and that has to do with food, but not music necessarily.

Michael: I go to Germantown Friends School. . . . It's based on Quaker principles.

Rainer: Do you see yourself in a religion? **Michael:** Not particularly. We celebrate most of the major Jewish holidays and Christmas. So I don't really see myself as one specific religion. I guess if someone asked me I would say I was probably Jewish. I'd say I'm half-Jewish.

Michael: Some of my friends from my old school, their parents were also Jewish and so they go to synagogues and they had their bar and bat mitzvahs. They were bar and bat mitzvahed. **Rainer:** Were you? **Michael:** No, I wasn't. . . . We did have a discussion about it. I think that my grandmother probably wanted me to be. But it wasn't something that was particularly important to me or something that my parents were pushing toward, so it never really happened.

Michael: We learned a lot about World War II, for example, in school. And I knew that my grandmother came from Germany . . . I think my cousin had to do something for school and he asked her about it. . . . I don't remember ever just sitting down and talking about it. It's just always been something that I've sort of known.

Michael: Every once in a while, like . . . during Christmastime my dad will make Puerto Rican meals and we'll eat rice and beans and *pastellas* and lots of yummy Puerto Rican foods.

SCHLANGER FAMILY

Lizza Schlanger
Born: Vienna, 1924
Emigration: 1938 England, 1938 New York
Profession: retired businesswoman
Two children

Sam Schlanger
Born: Chicago, 1922
Profession: retired mechanical engineer
Two children

Lizza: I was born in Vienna in 1924 and we left there in 1938. I went to school, originally to an ordinary school, but then to a Gymnasium. Before we left I had to stop because Jews were no longer permitted.

Rainer: Did your father have problems in the shop? **Lizza:** He was very well liked. Not anything terrible, not until when the Nazis came in, yes. . . . They threw stones. . . . It was clear that they were not happy with us. . . . As soon as Hitler arrived everything changed, everybody all of a sudden was a National Socialist and they had no time for Jews at all. And they put a commissar into the shop because Jews were no longer supposed to have any kind of property.

Lizza: [My sister and I] were called down to scrub the street. That was one of the first things that the Nazis did. They had you scrubbing streets because there were a lot of graffiti, mostly slogans. They wanted . . . gone. I mean they wanted to clean up the place.

Lizza: It was very difficult. I was an Austrian, you know. What did they want from me? I was as good an Austrian as anybody else I thought. And the realization that I was persona non grata was not very good. It was at a time when I was, you know fourteen, which is a very iffy time for a girl growing up anyway.

Rainer: Did you ever go back to Vienna? **Lizza:** For my sixtieth birthday. . . . **Rainer:** How was that? **Lizza:** It was good. Except, oh, yes, when I arrived I stayed at one of the nicest hotels. . . . It was very upsetting to me because the man at the desk looked at my passport and he said in German, "ya, ya, ya, es tut mir leid das die frau, das die genaedige frau so viel mitgemacht hat" [yes, yes, yes, I am sorry, dear woman, that you went through so much suffering]. And I found that particularly condescending and insincere. . . . It was so obvious that this man probably cheered for Hitler right along.

Sam: I went into the service then [during World War II]. I finished my schooling in the New York City area at the Merchant Marine Academy on Long Island and at Cooper Union in New York City.

Sam: My dad had died when I was twelve There were always jobs around for kids. I mean they weren't good jobs but they were jobs. The ones I can remember paid about twenty-five cents an hour.

Rainer: In the neighborhood you lived in, was this a predominantly Jewish neighborhood? **Sam:** I lived in several different neighborhoods. I don't think any of them were predominantly Jewish, but some of them were more Jewish than others. **Rainer:** So were there any, was there, I mean like . . . ? **Sam:** Anti-Semitism? **Rainer:** Yeah. **Sam:** Some of the neighborhoods I lived in were predominantly Polish and they were the worst anti-Semites.

Rainer: What kind of effect had World War II to you? **Sam:** Everything. I wouldn't have married this woman if it wasn't for the war. . . .

SCHLANGER FAMILY

Debby Schlanger

Born: New York, 1956

Profession: dietician

Two children (adopted)

Rainer: So, tell me a little bit about yourself. **Debby:** Oh, myself. Like what? I grew up on Long Island. Where 99.9 percent of the people were Jewish. Very homogeneous . . .

Rainer: And you go to a synagogue now? **Debby:** Traditionally, I feel very attached, but religiously, I don't feel very attached. You know our synagogue is beyond Reform, I think Reconstructionist—it means renewal.

Debby: We searched—we really wanted something to fit into our, you know, be welcoming to us, to accept us, and to have diversity because our kids are kids of color and we wanted that diversity, and we found it very much so. You know there is a gay synagogue, and we didn't feel as comfortable there actually because there wasn't the diversity. I mean those people . . . I don't know, obviously they've adopted children, too, but for some reason we didn't feel— and they're Conservative, too, which may have had something to do with it, but we felt more comfortable. **Rainer:** So, yours is the more liberal? **Debby:** Yeah, very liberal, very nice. **Rainer:** And so there are other women who live together who have adopted children? **Debby:** Or biological children . . .

Rainer: Is your partner also Jewish? **Debby:** Yes. My mother was very happy about that! [laughs] **Rainer:** Yes? Talking about that, was your mother always happy about your choice or your partner choice? Like the sexual orientation? **Debby:** Well, happy, no, I can't say she was jumping up and down, but she accepted it.

Rainer: What do you see of the gay community, how has it evolved in the time you were here, there was that huge thing last year with marriage? **Debby:** I mean, I'm not that political, but with marriage, really to be treated as a second-class citizen is unbelievable. . . .

Rainer: So you both are mothers. **Debby:** I'm *Ima,* which is *mother* in Hebrew. And she is Mom. . . . **Rainer:** And the kids, they know that they're adopted? **Debby:** I mean why would you keep that a secret? There's nothing wrong with it. And you know it's pretty obvious. And now pretty common these days—good for the kids to know other kids who are adopted. . . .

Rainer: It's also interesting to see, uh, you know, this formation of identities, even if they go across the usual stereotypes. **Debby:** Uh-huh. We actually are in in, uh, it's not a group that you belong to, but it's a group that is a multi-ethnic Jewish organization [Be'chol Lashon] and we've been on retreats with them. And we go to events sponsored by them. And, you know, they have rabbis from Uganda— I mean growing up, who would know? It's been eye-opening for me and it's good for the kids. They had a program a couple of weeks ago, where a congregation from, I believe it was Philadelphia, all black, came, they were Jewish from a temple, and their choir put on a show basically, and it was great.

Rainer: And Uganda, was this like a Jewish community there, original Diaspora? Or they became Jewish? **Debby:** Uh, both, I believe, because they've converted a lot of people to Judaism. But this guy was second or third generation.

Rainer: Back to that community, I think it's very interesting. Is it a synagogue? Or a particular organization? **Debby:** No; no religious, uh, really affiliation. **Rainer:** So it's more like a group of adoptees? **Debby:** Well, actually it was started by a man and a woman who adopted an African American boy and they felt that there was not enough, either not the diversity in the Jewish community, or they wanted him to see more. And so they actually started this group and started doing outreach. And it just blossomed. So you know, at the retreats there were, you know, couples who had married, an African American woman and a Caucasian man, and they have children and the Caucasian man is Jewish, or in some cases the woman, one of the women came from a biracial marriage. Very interesting mix of anything you want, it's there.

Rainer: So, in this area here, can we say, like, the kids, they don't encounter any signs of racism. Or do they still? Do you discuss that? That such a thing exists, or existed? **Debby:** I think they know that more in the context of Martin Luther King and why he was shot, and what his, you know, what his goals were, and why did that happen, the struggle for civil rights. **Rainer:** Who explains that? **Debby:** It happens in school, and we might go over it, too. You know I think she knows about discrimination that way, I don't think she applies it to herself particularly, and I don't think we've encountered anything like that, it's just such a diverse area, not that—I mean, I'm sure it exists, but we haven't, thankfully, encountered it.

Nikki S. Lee

The Wedding, 2005,

from the *Parts* series

In *Parts* the identity issues are more hidden, and while it's the same person in every picture, I look slightly different in each one because I'm in a different romantic relationship in each one. That's my setup point— so it's about how my personality gets affected by other personalities. For example, if you hang out with person A, you feel like a gentle, sweet woman, but if you hang out with person B, you feel bossy, and with person C you feel dependent. . . . They each touch a different part of your identity and it comes through you. So that's what I wanted to review because I think everyone has within them all these different characters, and they emerge through the people they're with.

Right, and following pages:

The Wedding (1), 2005 (not in exhibition)

The Wedding (2), 2005

The Wedding (8), 2005

The Wedding (3), 2005

The Wedding (5), 2005

The Wedding (6), 2005

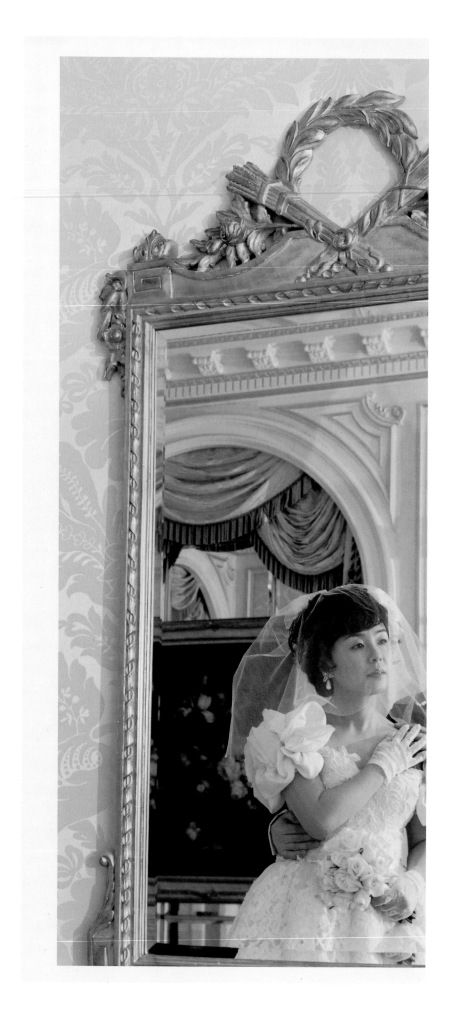

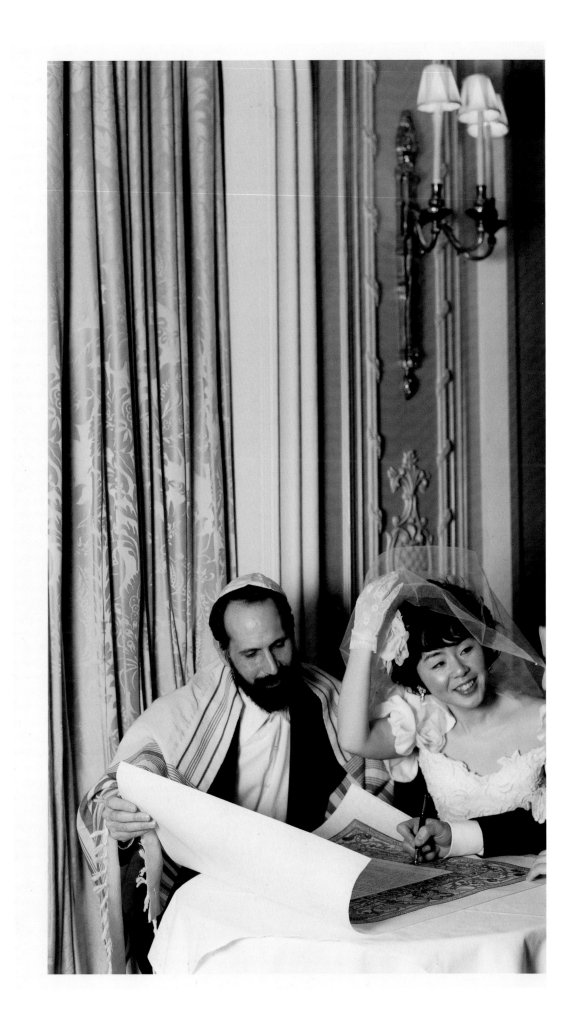

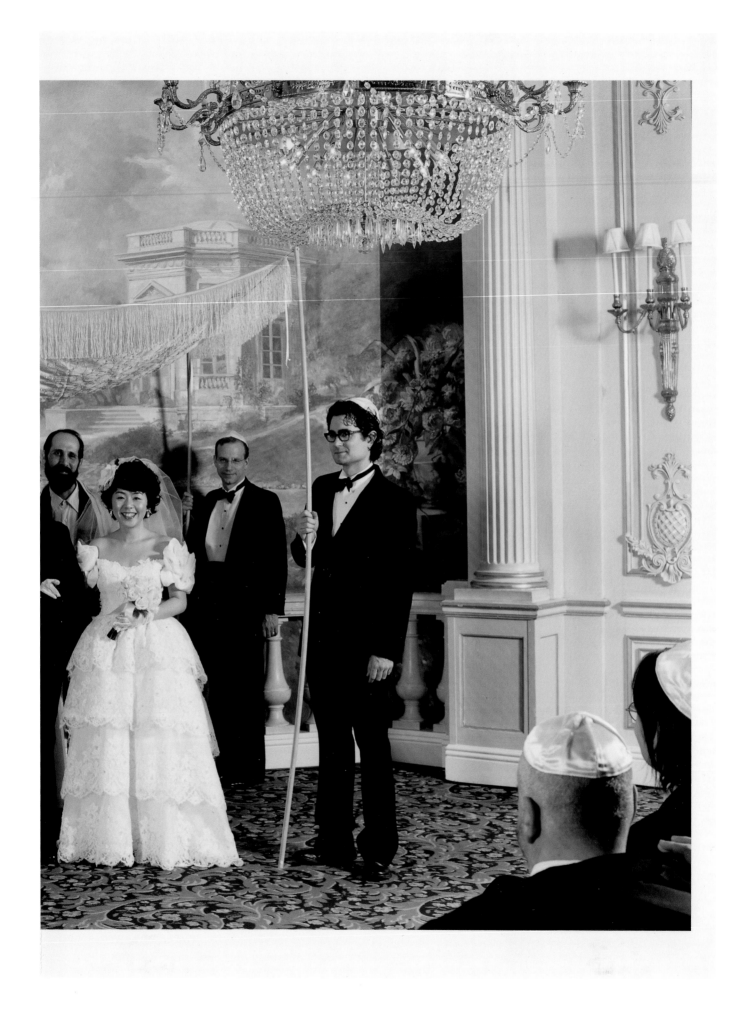

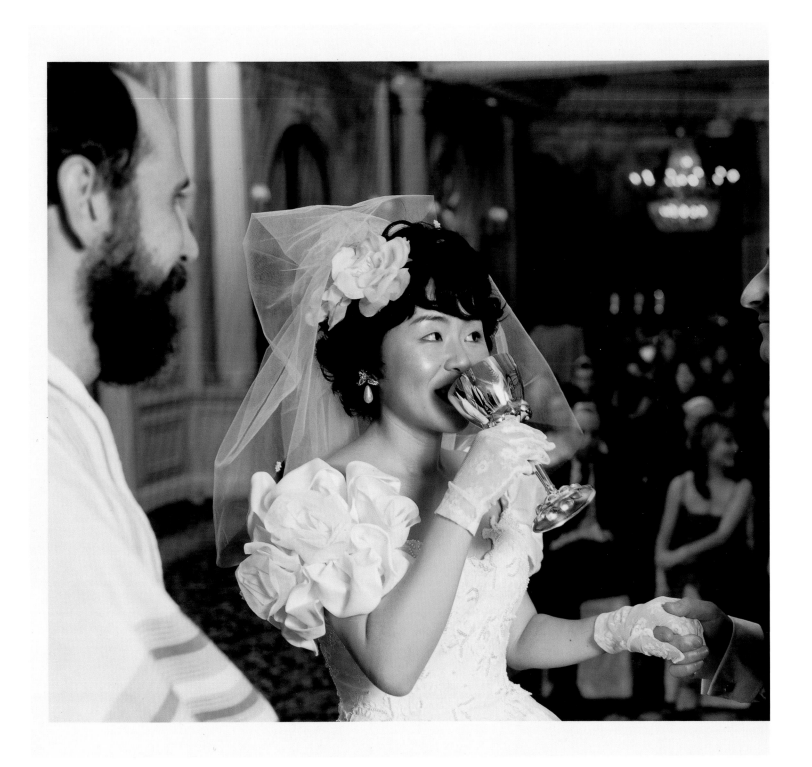

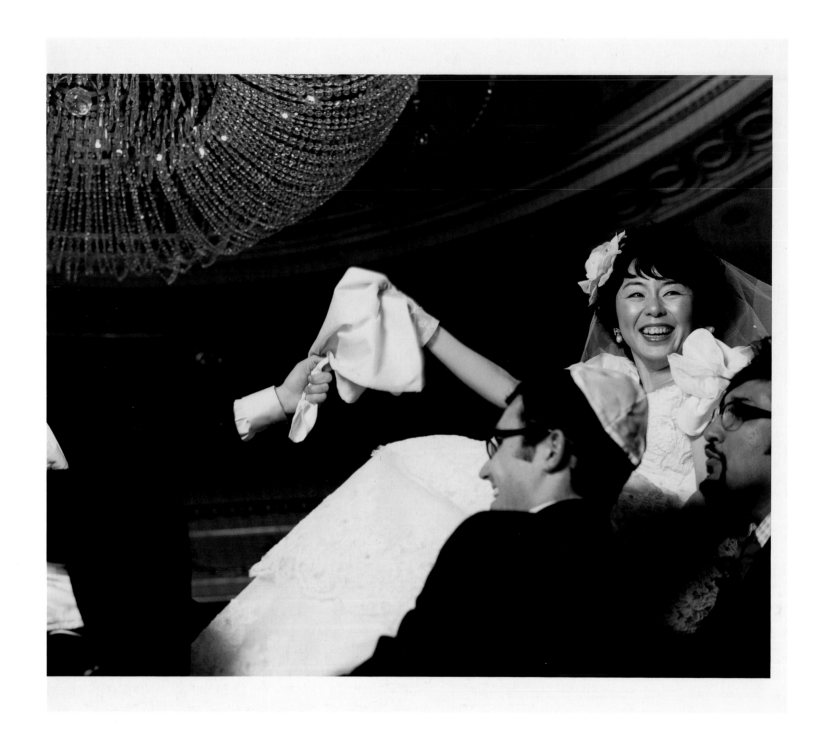

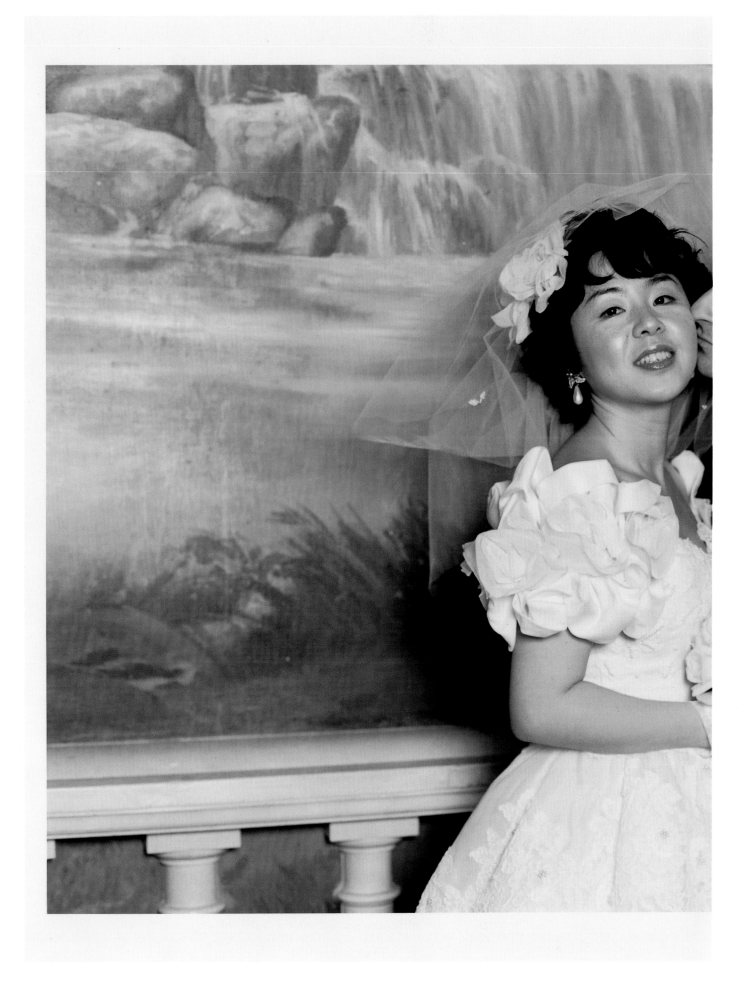

Shari Rothfarb Mekonen and Avishai Mekonen

Judaism and Race in America, 2005

We try to balance our vision for the project as directors while nurturing a two-way relationship about the complex subject matter we are tackling—identity—with the people whom we portray. . . . A core element of this film is that it is being presented *from* the points of view of Jews of color. . . . In doing so, we hope that their subjectivity and agency will come through and that their stories will provide key insights into the human experience of having multiple racial, ethnic, cultural, linguistic, and other identities.

Page 93, top to bottom:

Rabbi Angela Warnick Buchdahl of New York, reading from the Torah

Rabbi Capers Funnye of Beth Shalom B'nai Zaken Ethiopian Hebrew Congregation, Chicago, pointing out Jewish Diaspora communities on a world map

Rabbi Buchdahl, who is also a cantor, playing the guitar

Page 94, top to bottom:

Avishai Mekonen and Brooklyn Jews

Gershom Sizomu of the Abayudaya in Uganda, a rabbinical student in Los Angeles, with J. J. Keki

Rabbi Rigoberto Emmanuel Viñas of Lincoln Park Jewish Center, Yonkers, New York

Page 95, top to bottom:

Avishai Mekonen and Jews from the Caucasus region

Professor Ephraim Isaac of Princeton University

Rabbi Funnye with a congregant in Chicago

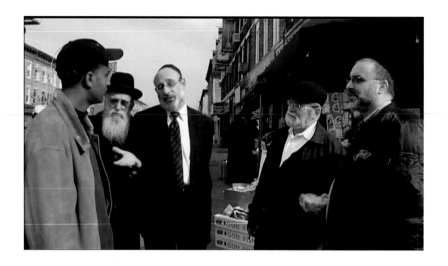

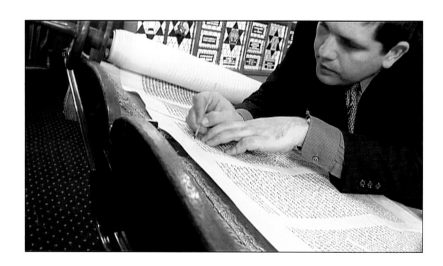

Yoshua Okon

Casting: Prototype for a Stereotype, 2005

My role is that of providing the subjects with a context in which their input can acquire meaning. I am not so much interested in my own point of view, I'm interested in creating a platform where other people's points of view (conscious or unconscious) become apparent. But beyond the individual's point of view, through the individuals, I am also interested in providing insight into the bigger structures beyond them. Nevertheless, I'm not into pushing a specific point of view; I'm interested in making works that stimulate thinking and therefore enable people to develop (or reveal) a point of view. . . . The work itself is about the process of getting to know them.

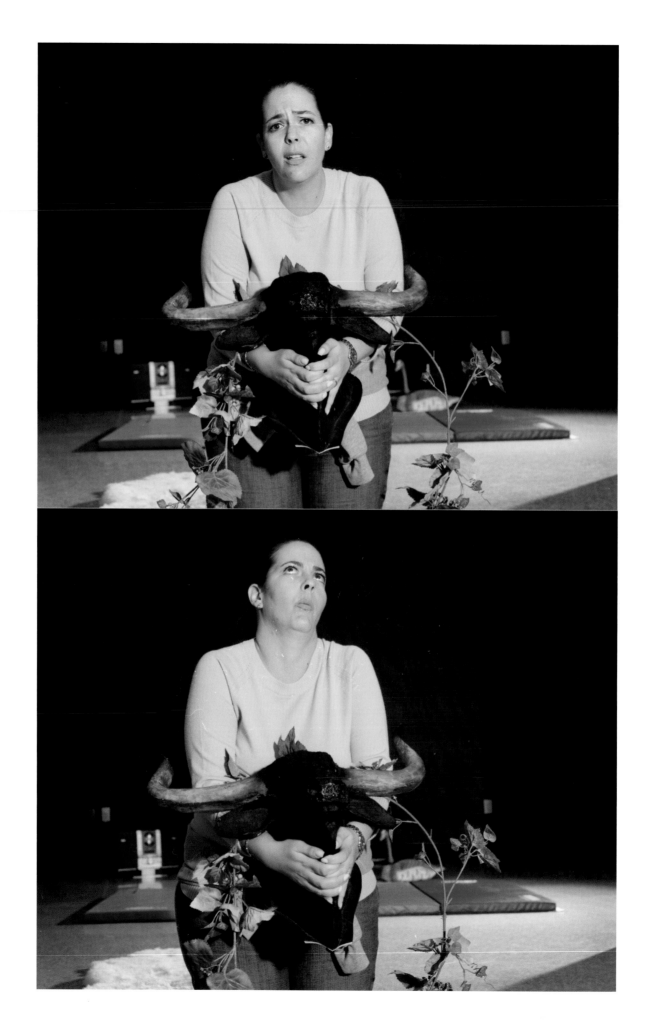

YOSHUA OKON

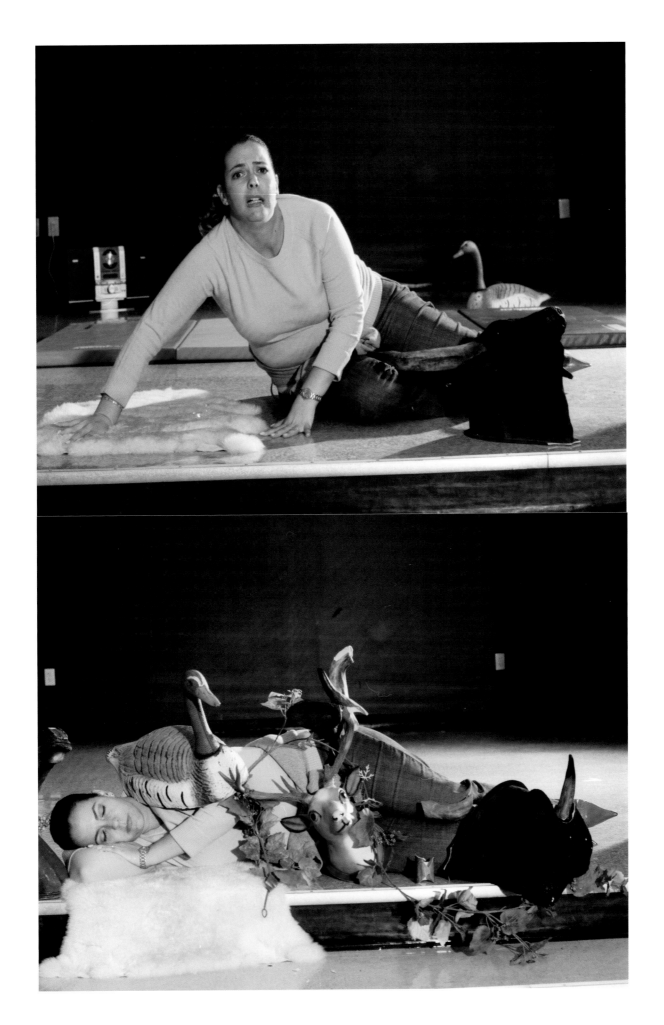

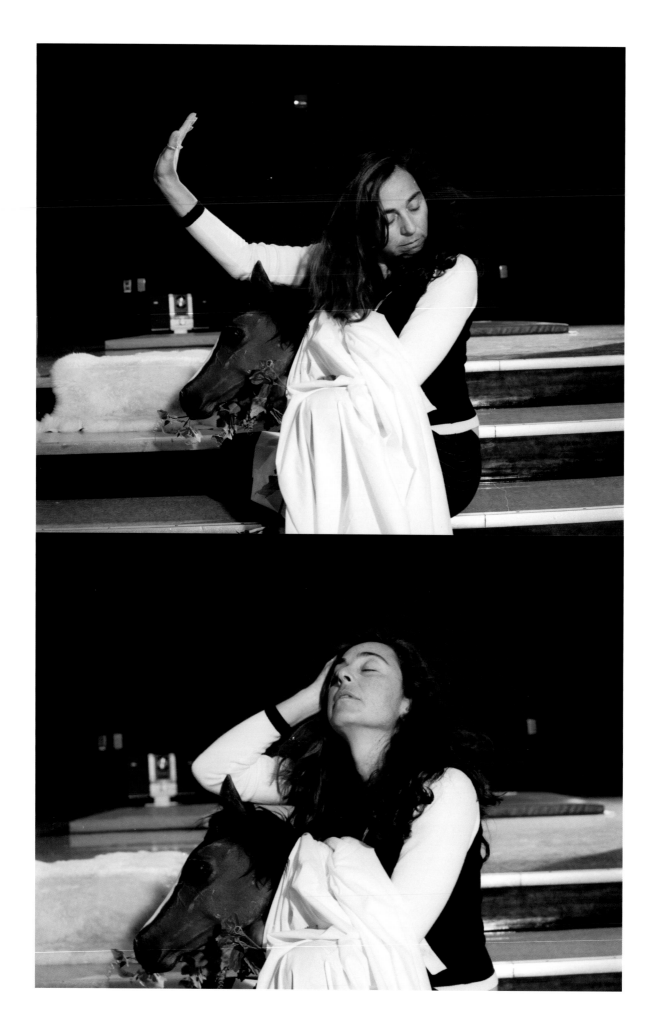

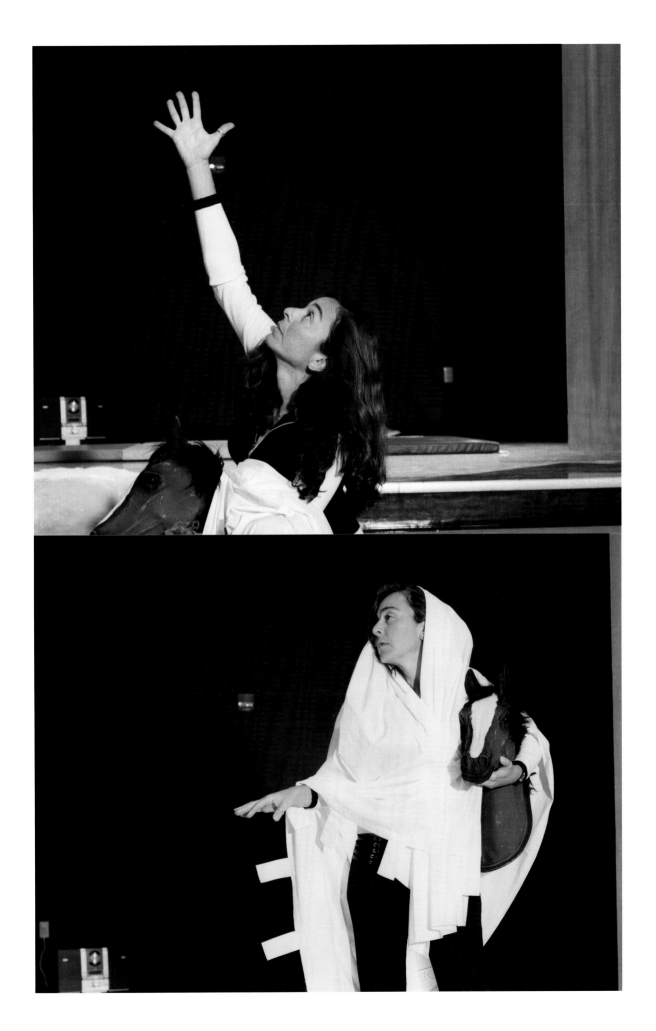

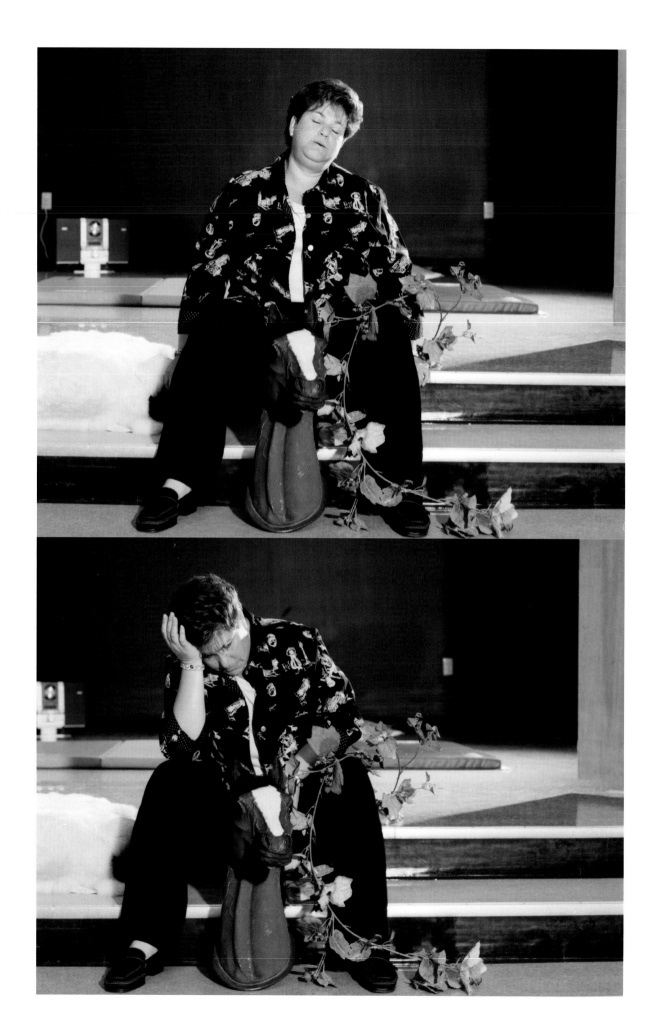

YOSHUA OKON

YOSHUA OKON

YOSHUA OKON

Jaime Permuth

La Conversión de Carmen

(Carmen's Conversion), 2003

One portrays a person as events unfold. A person is portrayed in terms of the photographer's perception of their individuality but also in terms of the role they play in their communities. Again, it is important to stress that a person's trust is reciprocated by a photographer's empathy and compassion. Why speak of compassion? One's scrutiny renders another person vulnerable, a dynamic that can easily lead to exploitation on the part of the photographer. Whereas it is important to remain a critical observer, compassion tempers our gaze and reminds us of the other's humanity.

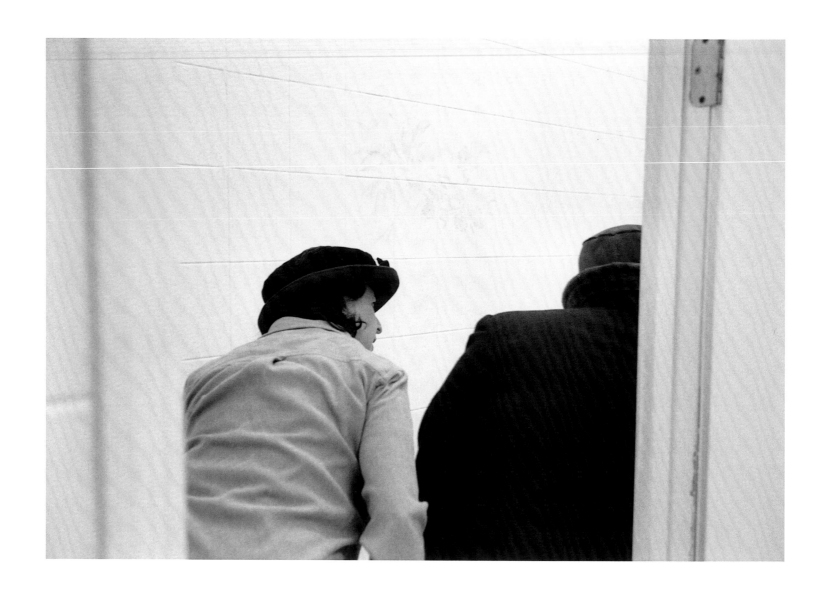

The second anniversary of my conversion coincided with the days and events leading up to the sixtieth anniversary of the liberation of Auschwitz. A friend by the name of Reuven and I decided to attend the General Assembly session in which Elie Wiesel spoke. Not having seen Reuven in months, it was easy to spot him in the crowd. He was dressed, except for his shirt, totally in black. Ditto for me. We had not coordinated colors at all. But I was aware that what he was thinking in his choice of color was also what I had been thinking when choosing a wardrobe that day. During the entire ceremony, I cried. Reuven sat with his head buried in his hands, the pain all too evident.

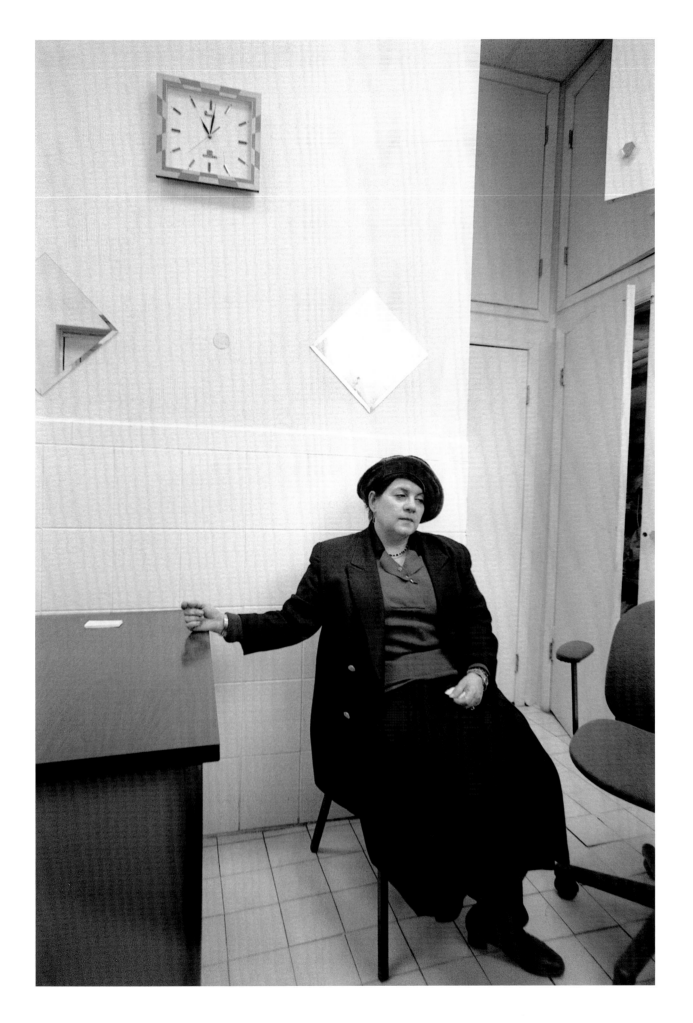

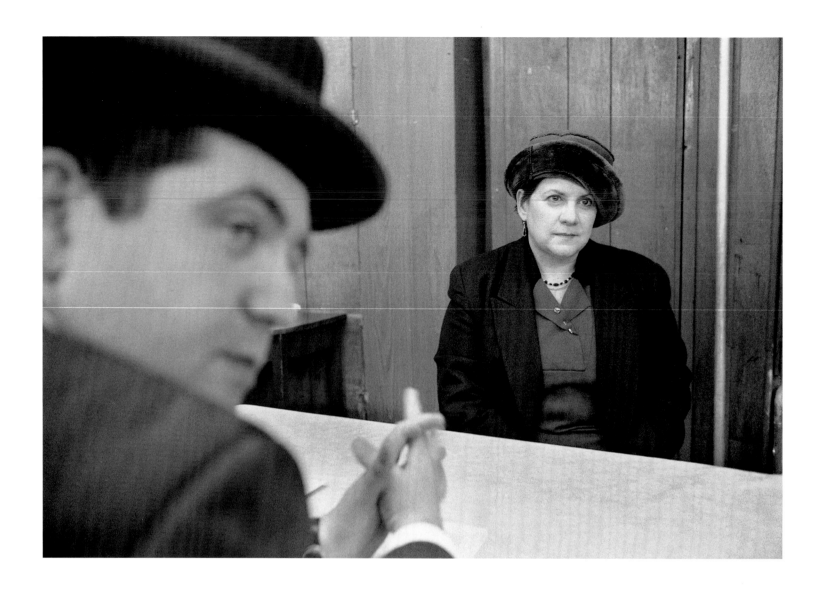

To be able to feel beyond my daily concerns, and to feel, if I may express it, retroactively to events of sixty years past just amazed me. Because my sorrow at the General Assembly, sitting next to a friend who was also shaken to the core of his being remembering those who never made it and those who suffered unspeakable sorrow and horror, made me aware that I had begun to feel not only the joy of Torah but also the millenary anguish of our transpired history.

A man recently told me that I was probably at Sinai. Meaning that I too was a Jewish soul back then. Rabbi Viñas, right after my conversion and in front of Rabbi Bomzer, told me that he only converted

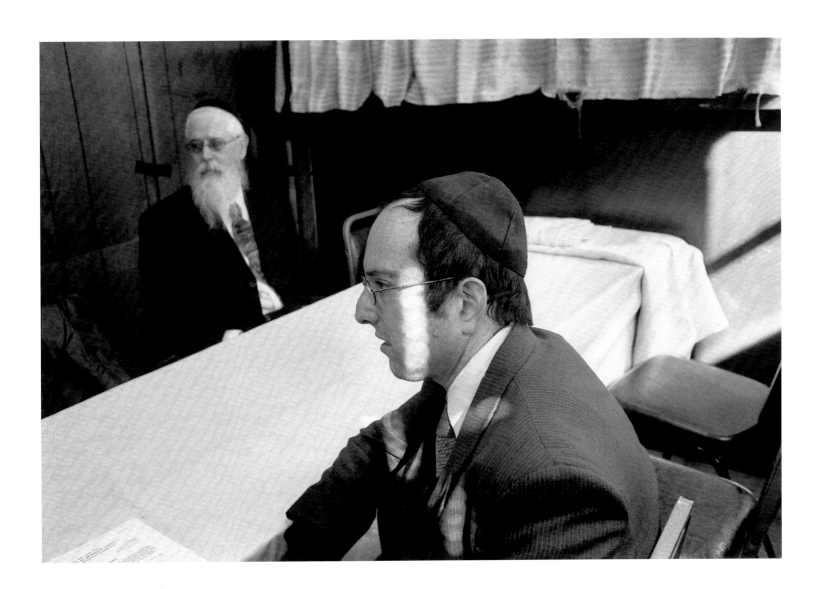

Jews to Judaism. People say this to me in different ways, meaning that I have always been Jewish.

During the Farbrengen that followed my conversion at Chabad in Riverdale, a lady congratulated me and told me that a rabbi had told her that after the Holocaust, Hashem had allowed Jewish souls to be born to non-Jewish parents. That the Jewish community had been so decimated that it would take a few generations before families could increase their numbers to receive all the souls wanting to return and to be observant by embracing Torah fully. So Jewish children were being born in all parts of the world, ready to be "converted" and come home again.

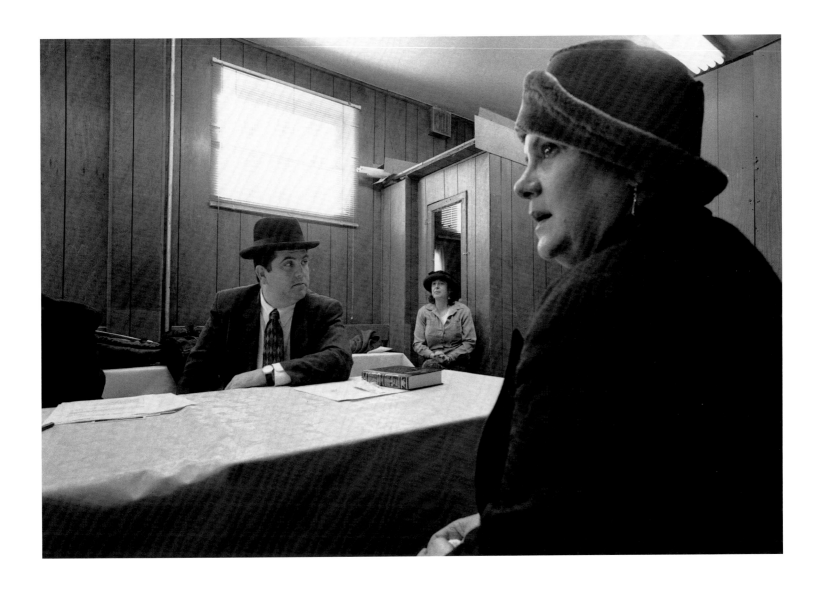

Also during the recent Auschwitz commemoration, I asked Candy Lora-Dudley, the administrator at Lincoln Park Jewish Center—Rabbi Viñas's *shul* and my spiritual home—if she knew of a camp survivor. She did. Her name: Mrs. Irene Staub. I called Irene for an interview and she, through tears, was able to give me one. She spoke of having lost all of her family, she spoke of not being able to say anything positive of what she and others endured, and she concluded with, "Why did we ever have to go through so much horror?"

I cried again, not being able to contain myself. I cried along with Irene, for her family, recalling my own recurrent dreams of my family in Sefarad packing their belongings on that fatidic Tisha B'Av of 1492,

looking around the house during one last glimpse of ancestral homes while people—the mob—was screaming outside for the Jews to finally leave! I dream and relive the sorrow of walking, literally walking out of Spain, grandparents and infirm people dropping dead along the way, too fragile to continue the trek for their spiritual survival, refusing to stay and survive as a convert. What my ancestors did was to survive spiritually, walking out of Spain not to sever their eternal link to the Magnificence entrusted to Jews back at Sinai. My Spanish ancestors refused to give up this Treasure for which their own ancestors had also walked out of Misrayim en route to Israel.

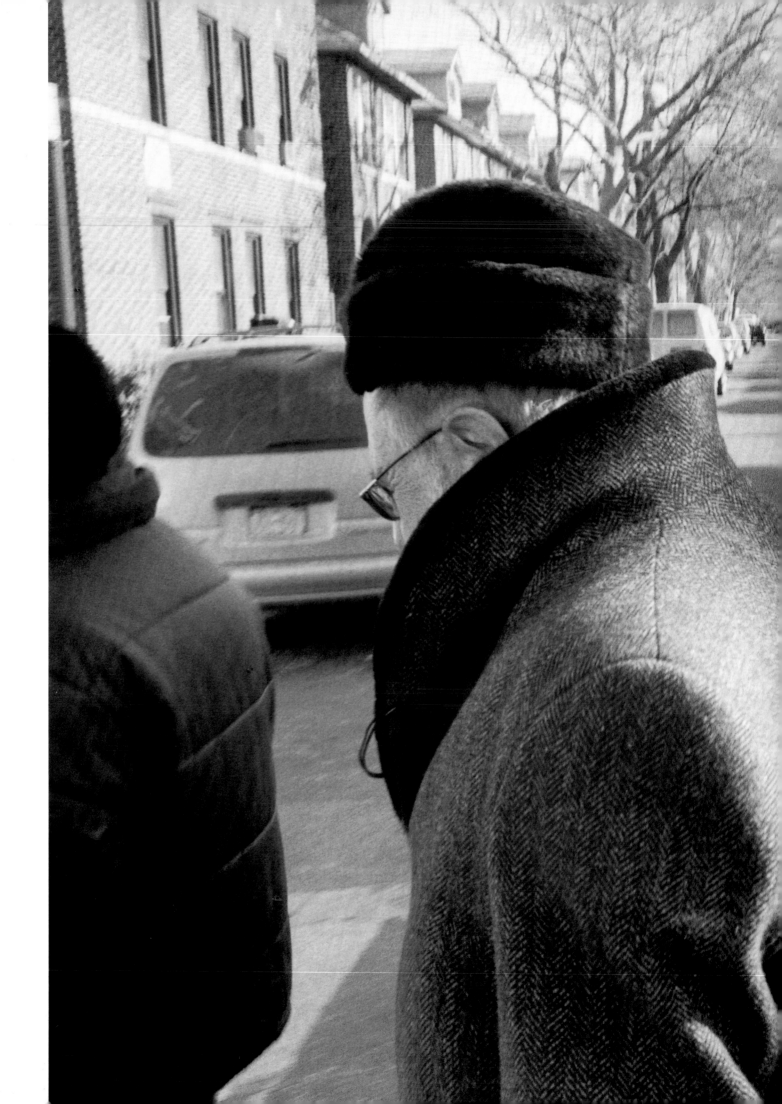

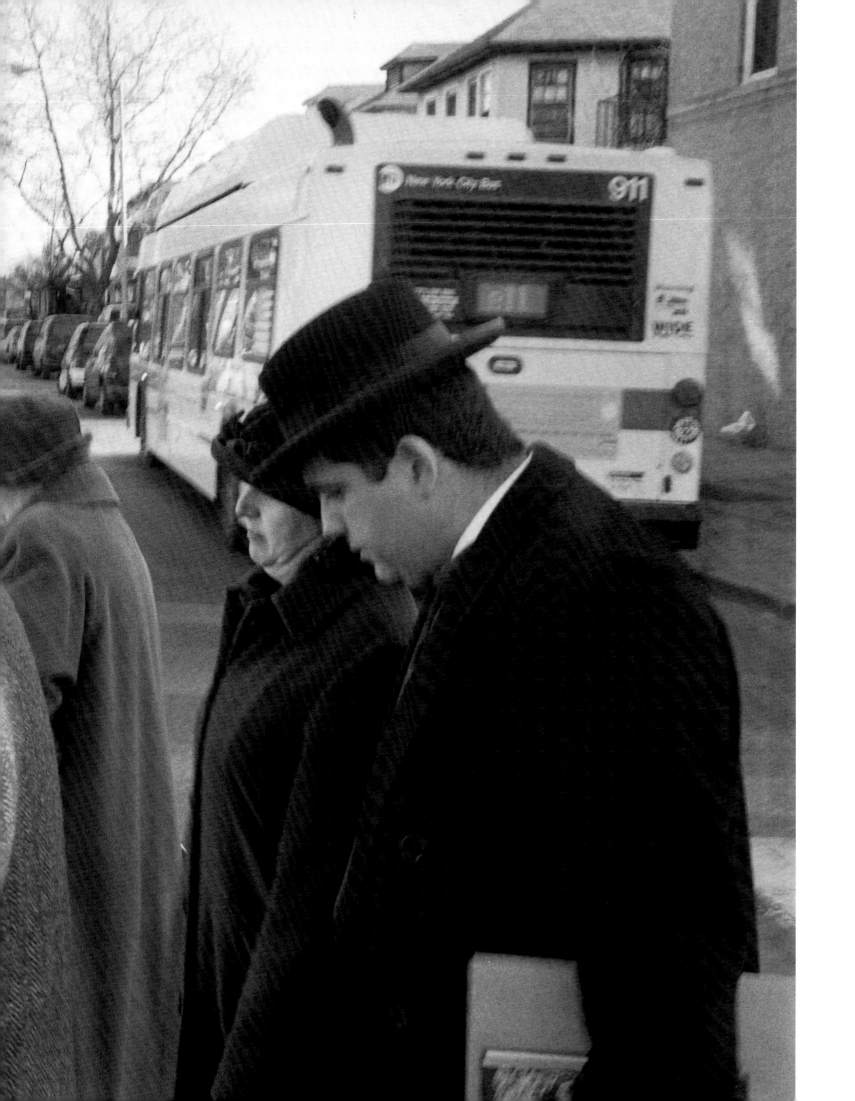

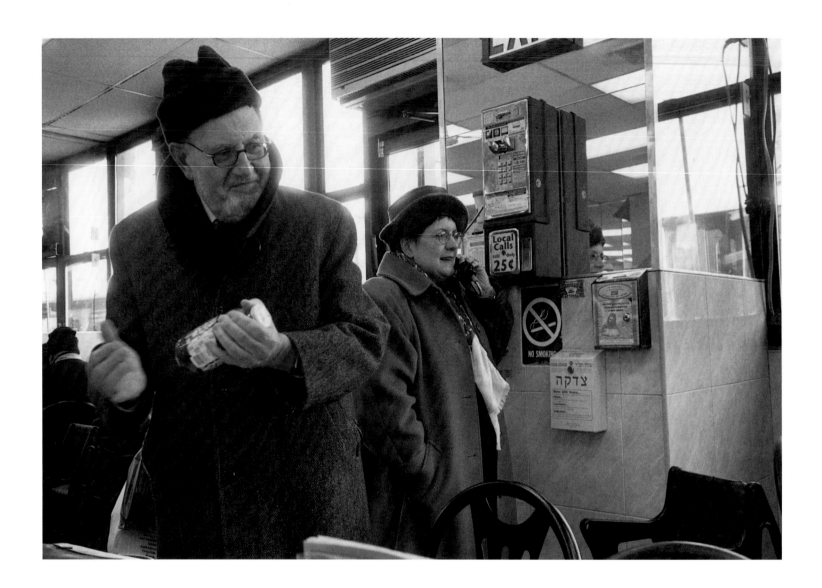

I would have embraced Irene if I could have at that moment of her recollection. I thought of Wiesel's words to the General Assembly, that during the Holocaust not all victims were Jews, but that all Jews were victims.

And I did something that, if in a little way, consoles my heart that this millenary voyage has not been lonely. We are all travelers together. I dedicated a window to Irene and her husband in the *mechitza* at Rabbi Viñas's *shul*. It reads: "To Irene and Martin Staub, survivors of the Holocaust, from a daughter of Jews who fled the Inquisition, all for our Beloved Torah."

Esther Rodríguez de Varona

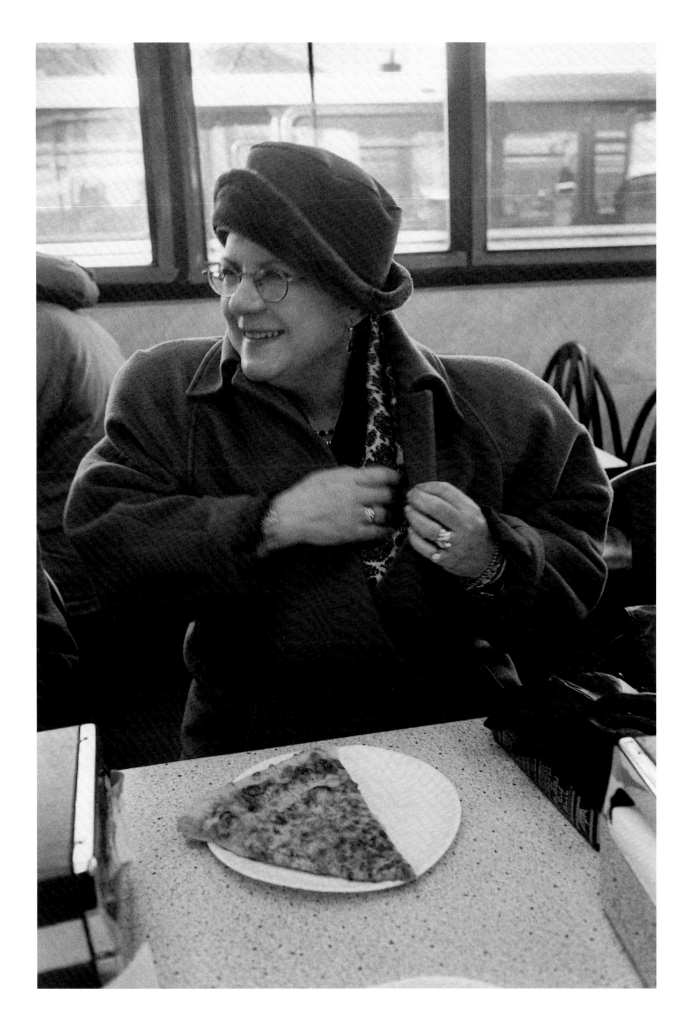

Andrea Robbins and Max Becher

Brooklyn Abroad, 2004–5

We treat each project as an introduction to our approach as well as an introduction to the subject. We are aware of the stereotypes that exist regarding a group of people or place that we work in, but we are always trying to introduce new information and a new context, to use irony to dispel past assumptions. Traditional photography is not a static transmitter of either the subject's or the photographer's intent. For this reason we write a text that grounds the images and creates a new context (our own).

Postville

In 1987, Aaron Rubashkin, a Russian-born Lubavitch Jewish meat provisioner from Borough Park, New York, bought and refurbished a defunct slaughterhouse in the town of Postville, Iowa. His idea was to establish a large meat-processing plant in an area that produces some of the best beef and poultry in the country. The resulting highly successful AgriProcessors Inc. now provides meat products that are Glatt Kosher (the most stringent type of kosher) to Jewish communities around the world. The plant employs 350 workers, many of whom are ultra-Orthodox Jews and mostly Lubavitch, making Postville the home of the largest number of rabbis per capita in the United States. The influx of Hasidic Jews and other ethnic groups that work in the plant, such as Mexicans and Russians, into the town of Postville has brought about many changes in the small homogeneous community. A book about the town's transformation, *Postville: A Clash of Cultures in Heartland America* by Stephen G. Bloom, is despised locally by most of the residents, Jewish and gentile, but has introduced the phenomenon of "Postville" to a wider audience.

The Hasidim that came to work in the slaughterhouse brought their cultural traditions with them from Brooklyn and established a modern shtetl in a small corner of Iowa. They set up a synagogue, two schools including a yeshiva, two ritual baths (one for men and one for women), as well as the first and only kosher market and restaurant in the state of Iowa. A dairy and a pizza company followed, which was aptly named after 47th Street, well known in New York City as a place where Hasidim work.

Many Jewish residents feel isolated and far away from their larger community. But, because Hasidim generally do not shun technology, the modern conveniences of air travel, phone, e-mail, and the Internet keep them in touch with family and the larger Lubavitch community in Brooklyn and internationally. Fortunately, Postville provides the families with many of the joys and safety of country life that are missing in Brooklyn or other urban environments. Affordable, spacious houses with backyards and a very beautiful countryside allow for many activities such as fishing, hiking, bike-riding, swimming, and weekend trips. Unfortunately, along with that idyllic environment come the chores of Midwestern life required by local ordinances, such as mowed lawns and snowplowed sidewalks, as well as other incongruities with the established local culture.

For many of the Jews who settled in Postville, the problems with local residents had a historic precedent in East European shtetl life, where Jewish self-segregation lasted for centuries amidst social intolerance and prejudice. *Shtetl* is the Yiddish word for the towns that were scattered throughout Eastern Europe. Historically, the appearance and rules that distinguish Jews from majority populations have been met with varying degrees of anti-Semitism. While Jews established contractual interactions and exchange with their non-Jewish neighbors, contact often ended there. Shtetls arose out of a need to create a world that met Jews' spiritual, dietary, linguistic, and social practices amidst larger controlling gentile populations. Even in shtetls, Jews were often oppressed and suffered persecution, but these enclaves were havens of Jewish culture for centuries, until their vibrancy met a tragic end in the Holocaust. Lubavitch Jews are known for their outreach to lapsed and secular Jews. With large families as the norm and a commitment to organized outreach, they have increased their numbers from a few hundred at the end of World War II to tens of thousands today.

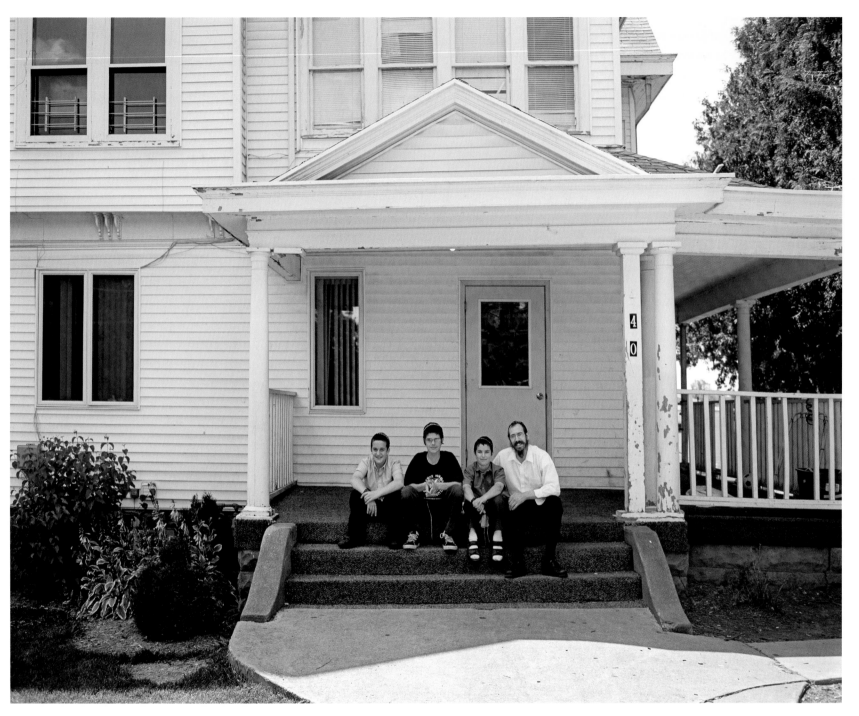

Yeshiva Students and Teacher, 2004

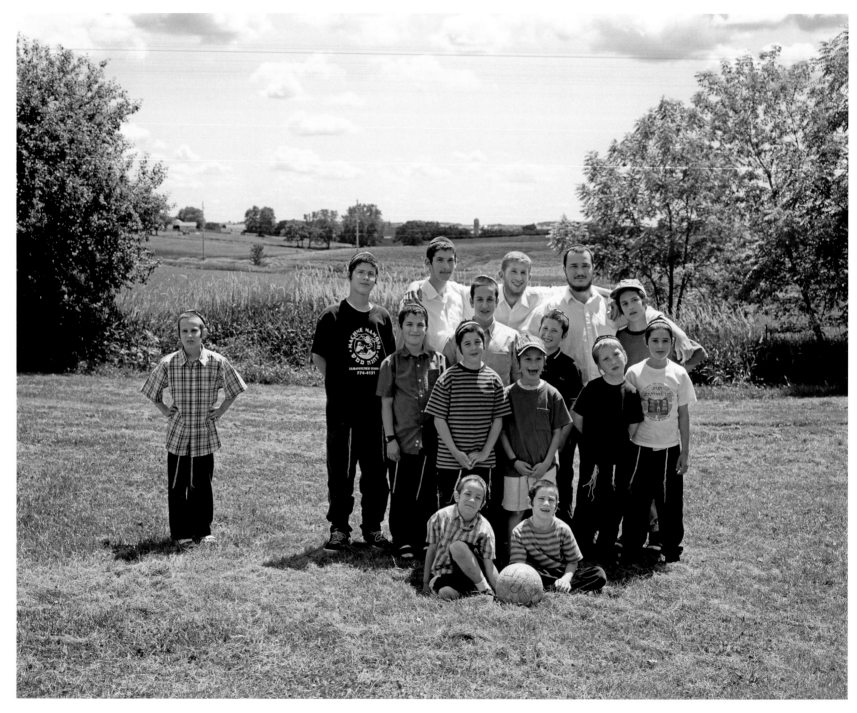

Boy's Camp, 2004

ANDREA ROBBINS AND MAX BECHER

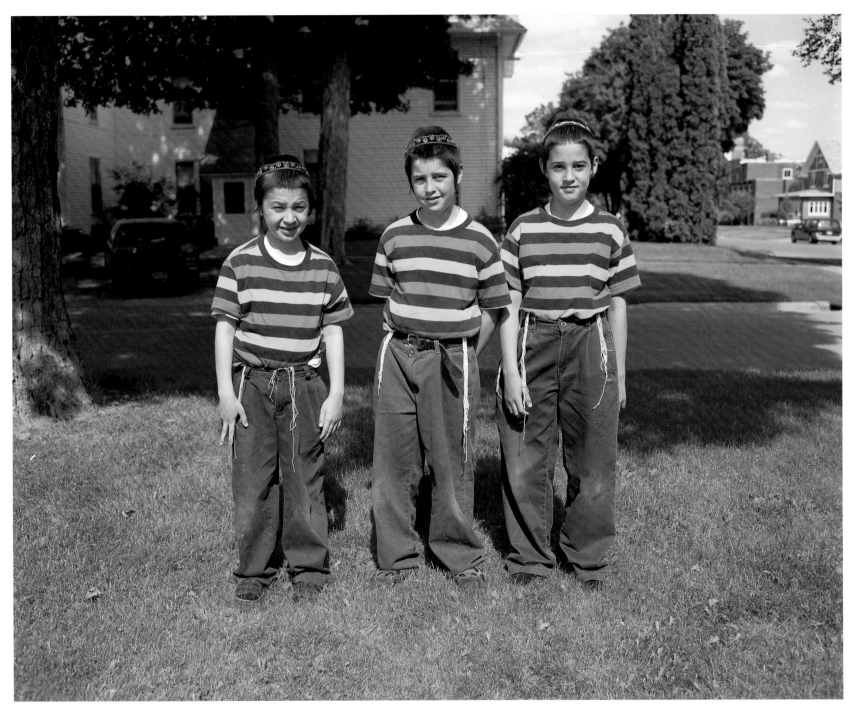

Triplets, 2004

ANDREA ROBBINS AND MAX BECHER

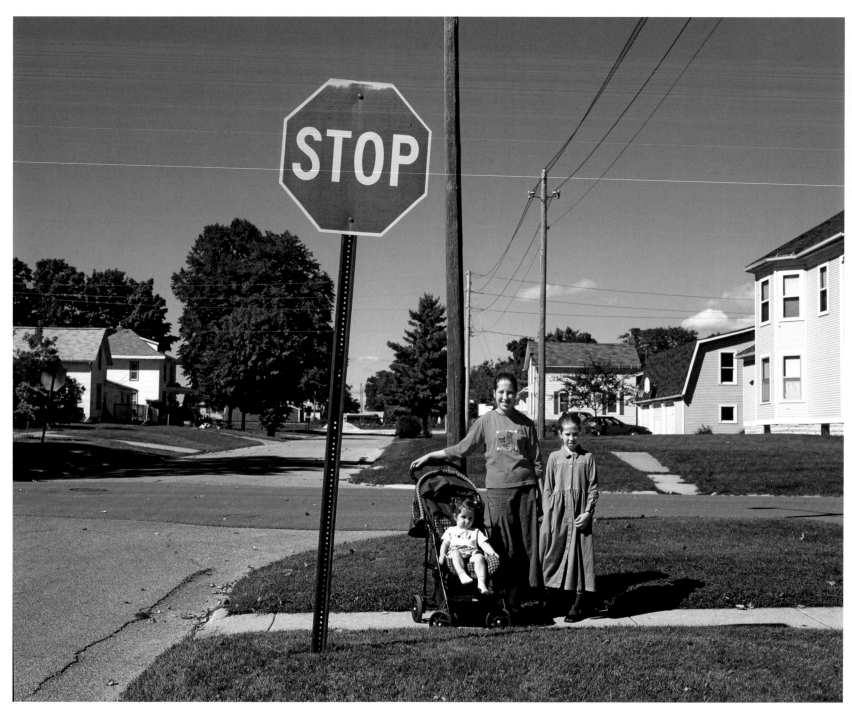

Three Girls, 2004

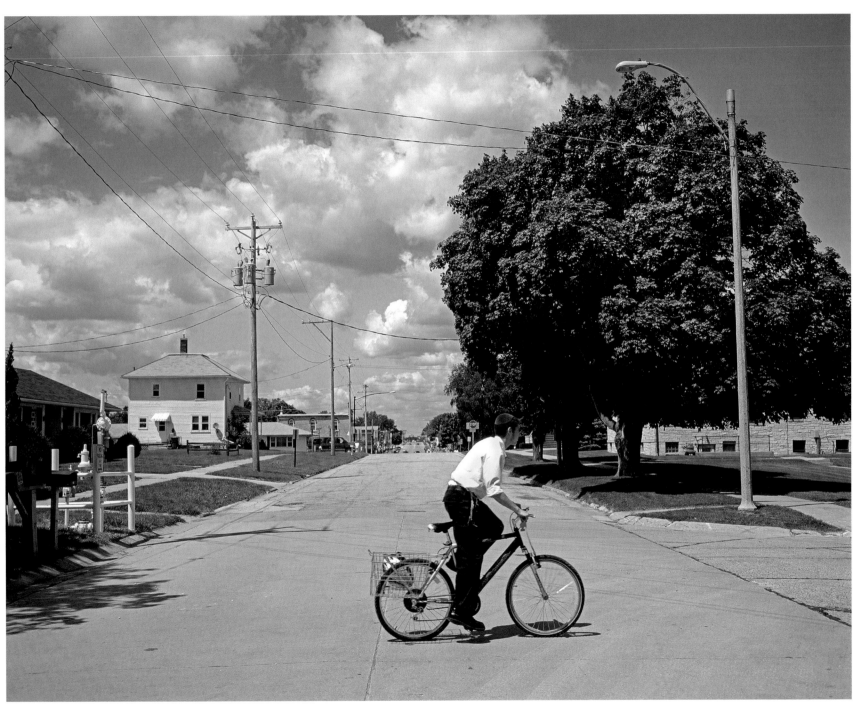

Boy Biking, 2004

ANDREA ROBBINS AND MAX BECHER

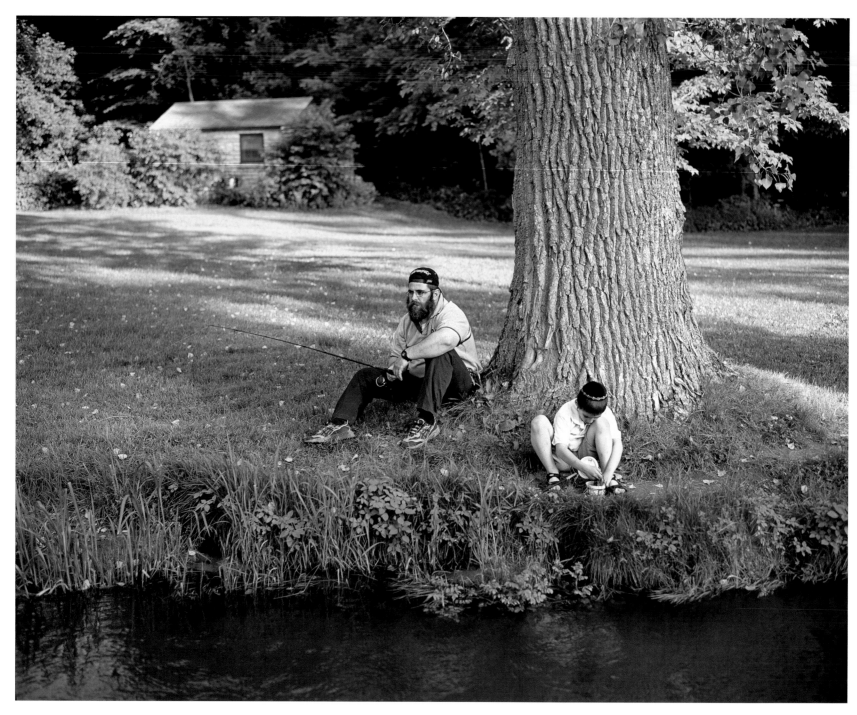

Fishing Scene, 2004

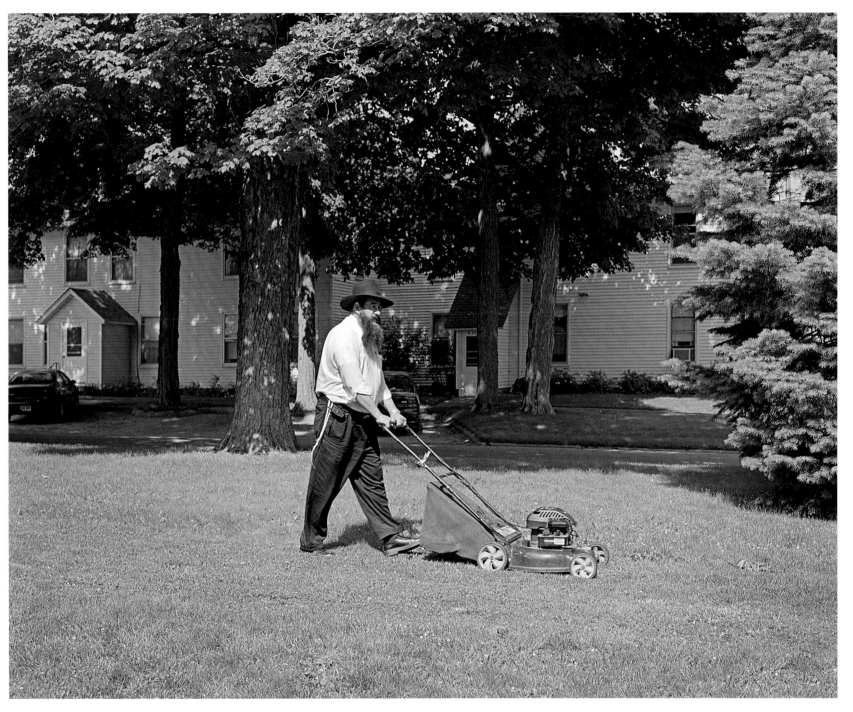

Lawn Mowing, 2004

770

770 Eastern Parkway in Crown Heights, Brooklyn, is a kind of holy ground for Lubavitcher Jews. Many reproductions of this building have been constructed around the world in places like Italy, Argentina, Brazil, and Australia, with many more under construction or in planning stages. In Israel, the three "770" replicas are reputed to be the only three red brick buildings in the entire country. The little Collegiate Gothic Revival–style Brooklyn building is a far cry from what one expects from a landmark in the Holy Land, and is an ironic twist in a country that is rich in the architectural roots of Judaism, Christianity, Islam, and Baha'i.

The worldwide franchising of the 770 Eastern Parkway building—the Rebbe's home as well as the Lubavitch headquarters and synagogue—serves three purposes: It provides a familiar place for the Messiah when he returns; it offers a meeting place for insular Lubavitcher international travelers; and it signifies the importance placed by the Rebbe on his *shluchim*. It has been eleven years since the passing of the seventh and last Lubavitcher Rebbe. While the Lubavitch await his return, they perform the *mitzvot*, the 613 commandments of Jewish behavior, in hopes of bringing this moment to fruition.

The Hasidic movement is a relatively new development in Jewish history. It was created in Eastern Europe in the eighteenth century in response to the more inward, academic Judiasm that was practiced at the time. Some of the different sects of Hasidim are: Lubavitch, Bobov, Belz, Satmar, Vishnitz, Ger, Klausenberg, Skver, Puppa, Nadvorna, and Bratslav. Each group has its own philosophical interests and style of dress. Due to the norm of rapid assimilation, the Lubavitch, and Hasidim in general, did not view the United States as a place where Hasidic teachings and practice could flourish until it was a last option for survival during World War II. In 1940, the building at 770 Eastern Parkway was purchased for the sixth Lubavitcher Rebbe, Rabbi Yosef Yitzchak Schneersohn, who had recently immigrated to the United States to escape Nazi persecution. In 1951, a year after the passing of the sixth Rebbe, his son-in-law Rabbi Menachem Mendel Schneerson officially accepted the title of Lubavitcher Rebbe. The seventh Rebbe received a congregation decimated by the Holocaust.

The concept of *shlichut* was instrumental to the expansion of the Lubavitcher community worldwide. *Shlichut* is a legal concept from the Torah in which one person can appoint another to perform an action in his place. The seventh Rebbe took this ancient concept and transformed it into a way of life for dozens, and now thousands of young families, who go to distant parts of the world to spread the *mitzvot* to lapsed and secular Jews and Jewish communities. In addition to outreach in far-flung communities, the Rebbe encouraged the use of technology for the dissemination of Lubavitcher Jewish teachings.

While Hasidim hold themselves to strictly defined social interactions, limited contact between genders, as well as dress and dietary restrictions, the concept of *shlichut* has made the Lubavitch an extremely mobile and vocal community. While they are not the largest of Hasidic groups, they are the most visible and "high tech."

The majority, but not all, of Chabad Lubavitch followers believe the seventh Rebbe to be the Messiah. This is a claim that the Rebbe neither supported nor outright rejected prior to his death in 1994. In addition to adhering to *shlichut,* these Messianists have gone one step further in rekindling Jewish identity, through the worldwide replication of the Rebbe's 770 Eastern Parkway home.

ANDREA ROBBINS AND MAX BECHER

770 Eastern Parkway, Brooklyn, 2005

Kfar Chabad, near Tel Aviv, Israel, 2005

Ramat Shlomo, Jerusalem, Israel, 2005

Kiryat Ata, near Haifa, Israel, 2005

New Brunswick, New Jersey, USA, 2005

Pico Avenue, Los Angeles, USA, 2005

Gayley Avenue, Los Angeles, USA, 2005

São Paulo Far Shot, 2005

Ramat Shlomo Far Shot, 2005

Jessica Shokrian

One of the reasons I became a photographer in the first place was to somehow connect with my family, especially my father's generation who preferred to speak Farsi, a language still, for the most part, foreign to my ears since my mother is American and we grew up speaking English in our home. I feel I am continually getting to know my family. For me it is in the filming, editing, and then finally the showing of the pieces where I am able to somehow find a sense of connection or communication. If it weren't for this work I feel I might have slowly disappeared from my family's consciousness and perhaps they from mine.

SIMCHAH TORAH, 2004

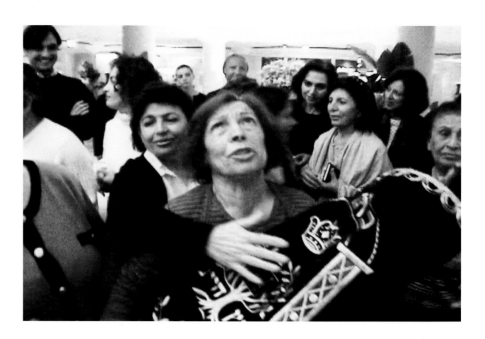

BRIT MILAH, 2004

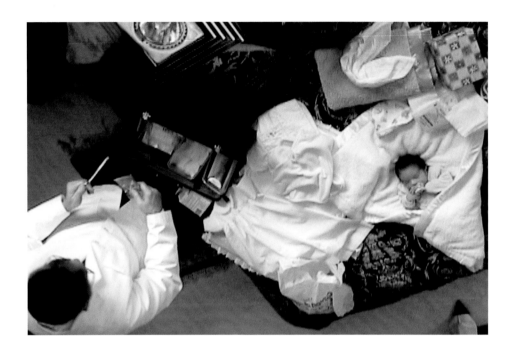

THE FUNERAL, 1999

AMEH JHAN (DEAR AUNT), 2001

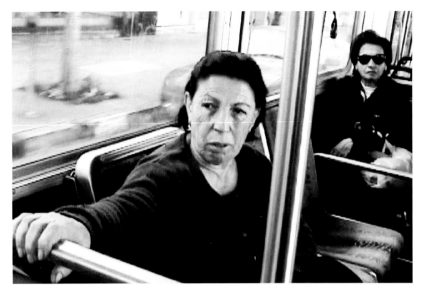

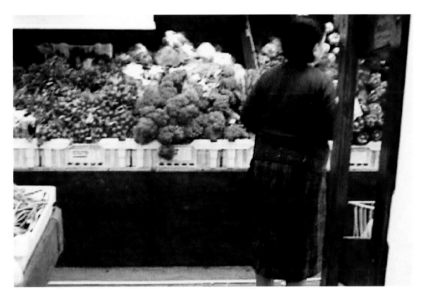

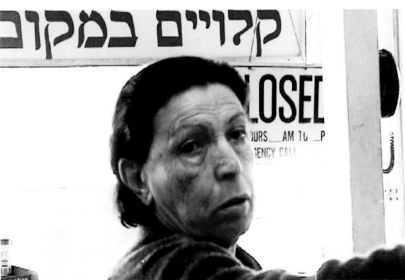

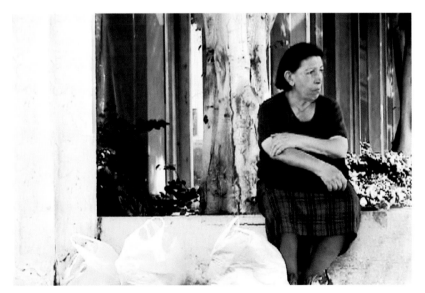

THE ENGAGEMENT, 2003

TURNING IT AROUND, 2005

Chris Verene

Prairie Jews, 1997–2005,
from the series *Galesburg*

I have an earnest, and perhaps old-fashioned belief in art's ability to affirm and ennoble people's experiences. Lots of people don't like cameras, or ask not to be photographed under certain circumstances. Many people have shown me what they like and don't like in their pictures. I am in no hurry to rush out images that would make my people unhappy. I take great care to be an actual friend, and am respectful of people's feelings.

BARRY AND DONNY AND HARRY HAVE BEEN BEST
FRIENDS SINCE CUBSCOUTS.

MY FATHER, DONNY, SAYS THEY ALMOST
MADE EAGLE SCOUT TOGETHER.

HARRY IN THE ENGINEER'S SEAT.

HARRY FOUNDED THE GALESBURG MODEL TRAIN SHOW.

HARRY'S FRIENDS AND THEIR SCALE-
MODEL TORNADO AND RAILROAD DISPLAY.

OUR FRIEND MAX IS NINETY-THREE. HE WAS
CLOSE TO MY FATHER'S FATHER.

MAX ESCAPED FROM THE CAMPS AND CAME
ALONE TO GALESBURG. HIS WIFE PASSED
AWAY IN 1972.

MAX WORKED AT THE JUNKYARD.

MY GRANDFATHER SPENT A LOT OF
TIME OUT THERE WITH MAX.

MARLENE COMES OVER TO HELP MAX.

OUR FRIEND BRENDA DRINKING A TOAST
TO THE FLOWERS!

BRENDA RUNS THE WINE STORE IN GALESBURG.

MY FRIENDS CRYSTAL AND AMBER TOOK ME
TO THE JEWISH CEMETERY, AND TOLD ME
THAT THEY ARE JEWISH WITCHES.

THEY WANT PEOPLE TO KNOW THAT THEY ARE
VERY RESPECTFUL, AND ONLY PRACTICE WHITE
MAGIC THERE.

THREE YEARS LATER, THEY ASKED ME BACK
TO THE CEMETERY. AMBER SAYS NOW SHE
ISN'T REALLY JEWISH, BUT WANTED TO BE.

CRYSTAL SAYS SHE THINKS SHE'S HALF-JEWISH.

CRYSTAL AT EIGHTEEN

Commissions and Collaboration

JOANNA LINDENBAUM

One museum. Ten projects. Thirteen commissioned artists. Dozens and dozens of people across the United States, and more than two years to photograph and film them. *The Jewish Identity Project* provides a rare opportunity to examine the nature of collaborating and commissioning in the process of making art. This text features interviews with each of *The Jewish Identity Project* artists about these topics, while the behind-the-scenes experiences of making the art were still fresh in their minds.

Each of the artists participating in *The Jewish Identity Project* teamed with individuals, families, or a particular community to create a project that portrays and questions complex and layered Jewish identity. For an artist, con- necting with others to photograph or film them involves, in varying degrees, collaboration. Inextricably tied to this are the details and challenges of the artist's working process. Investigating collaboration addresses the challenge of using photographic media as a means to portray and signify personal and com- munal identity: How much interaction does the artist have with the sitter? What type of relationship is established with the subject in order to make a work of art about him or her? How much of the sitter's point of view enters into the work, and how much of it was offered during the process of making the art? To what extent is it important to portray individuals or communities as they want to be portrayed? What are the strengths and limits of the medium in terms of communicating identity? To what extent can an "outsider" portray identity?

The responses about collaboration varied greatly. Some artists religiously take the sitter's point of view into consideration, and in fact, include or exclude certain works based on the sitter's approval. Other artists, while sympathetic to their subjects' points of view, present identity as they ultimately understand it from their vantage points, irrespective of the sitters' judgments. And yet other artists fall, to varying degrees, in between—always attempting to balance their subjects' wishes with their own agendas. Levels of interaction with a sitter are dependent, most of the time, on issues of point of view—it appears that the artists who are more concerned with their subjects' points of view tend to spend more time getting to know them before, during, and after the actual image- making process. A few of *The Jewish Identity Project* artists find it crucial to maintain relationships with their subjects after the images are made. In other words, making the art involves growth and change, affecting them and their sitters as much as the final project.

The Jewish Identity Project provided a special opportunity to uncover the

Fig. 1
Tirtza Even and Brian Karl, *Definition,* 2004–5 (detail)

nature of artist commissions and how commissioning affects the artistic process, the artwork itself, and the nature of the artist's collaboration with the subject. Works of art have been commissioned by institutions for centuries, if not millennia. Historically, however, art has been commissioned either for private purposes (for example, portraiture), for religious purposes (as with church altarpieces), or for political or social purposes (for example, WPA murals or sculptures of Joseph Stalin). In some instances, these commissions included very strict guidelines and parameters: to make a subject appear wealthy or beautiful, to include a donor near a certain saint in an altarpiece, to glorify a certain political leader or concept. In other instances, the artist has had more freedom and leeway in the creative process.

The thirteen artists in *The Jewish Identity Project* were invited by The Jewish Museum in 2000–2002 to create work for the exhibition, and the museum gave the artists the following parameters: to create a photographic or video project that both uncovers and interrogates the varied identities and multiculturalism of Jews in the United States today. The Jewish Museum commissioned these works because very little art tackling this subject matter has been made before. Only in the last century have public institutions devoted to art commissioned artists to make works not to be viewed in the personal, religious, or political arenas, but to be consumed as works of art within the "neutral" confines of an art institution. Exploring museum commissions in this context raises questions about the artist's process and the purpose of the artwork: How much influence does the third-party institution (in this case The Jewish Museum) have on the artwork? How much does the artist take an intended audience of the commissioning institution into consideration? Does the sitter know that the work is commissioned? If so, how does that affect the work?

I sent each of the artists involved a set of written questions about the nature of collaborating and being commissioned with particular emphasis on the projects they made for *The Jewish Identity Project*.[1] In some cases I asked follow-up questions. Below is a sampling of some of the important points that emerged from these responses.

WHOSE POINT OF VIEW IS IN THE IMAGE ANYWAY?

Is the sitter portrayed as he or she wants to be portrayed? How much does the artist impose his or her own opinions onto the representation? How much synergy occurs between the two? Some artists, like Dawoud Bey, feel that while the sitter's point of view is always present, it is the photograph and photographer that have the final say on how someone is depicted. Others, like Chris Verene and Jaime Permuth, privilege the sitters and their points of view while acknowledging the presence of their own vantage points. Yet other artists, such as Rainer Ganahl and Jessica Shokrian, attempt to remove their points of view from the equation. However, is it ever possible to fully remove an artist's perspective, especially in a case like Shokrian, who captures the lives of her own family members, with whom she has intimate relationships? Some of the artists' responses, such as those of the team Tirtza Even and Brian Karl, explain how their works reveal the ways that personal identity in images is always constructed. Other artists, such as Bey, aim to deflect attention from the artificial elements of the photograph.

Yoshua Okon: My role is that of providing the subjects with a context in which their input can acquire meaning. I am not so much interested in my own point of view, I'm interested in creating a platform where other people's points of view (conscious or unconscious) become apparent. But beyond the individual's point of view, through the individuals, I am also interested in providing insight into the bigger structures beyond them. Nevertheless, I'm not into pushing a specific point of view; I'm interested in making works that stimulate thinking and therefore enable people to develop (or reveal) a point of view. . . . The work itself is about the process of getting to know them.

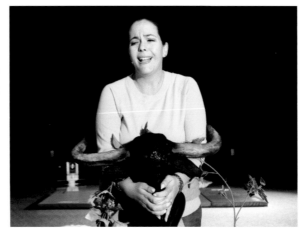

Fig. 2
Yoshua Okon
Casting: Prototype for a Stereotype, 2005. Video still

Dawoud Bey: What emerges, I think, is the point of view of the photographer and the subject, though the photographer is the only one who is aware at the moment the picture is being made just how the subject looks. So in that sense the hierarchy of picture-making—at least for the kind of photographs I do—will usually privilege the photographer. . . . I don't make portraits as a way of verifying or validating the way the subjects see themselves. My interest lies in describing them through the camera, which, as a chemical and optical system, is very different than the subjective human eye. So I expect there to be a difference between the person as they see themselves and the person as I see them through the camera. It can't and in fact shouldn't be the same. If the person doesn't like the picture that results, I try to make them realize that this is a picture, not reality, and it is my own subjective take on them at the moment we made the photograph. While I don't consider myself beholden to the subject's response, it is never my intention to demean them. . . . What I try to do is to make all of the artificiality of the situation—the lights, the camera, and other activity outside the frame of the picture—disappear, so that what we are left with is a photograph that contains a certain level of emotional, psychological, or material information and credibility.

Rainer Ganahl: The nature of words and of pictures is that the world is revealing and hiding something at the same time, i.e., hermeneutically opaque and transparent. None of the interviews are edited since I wouldn't want to prioritize or eliminate anything that is said during a conversation. I try to not reduce the interviews, the personal histories, into sound bites. I prefer the phenomenological impression of a person over the factual condensation to some key data or information. To me, the color of a voice is as important as the things people mention or even don't mention. . . . My voice is unfortunately present though I don't really like it. I never like my voice to be present, but as an interviewer I have no choice but to ask questions and get the conversation going. I try to speak as little as possible, sometimes waiting silently far beyond the usual time of an interview, but it is not always easy not to ask, not to comment. I easily get seduced into too much talking, which I always regret. In some of my previous transcribed interview works—and I have been interviewing people since 1996—I was able to just eliminate my questions and only print the answers. I somehow try to have my voice suppressed by the

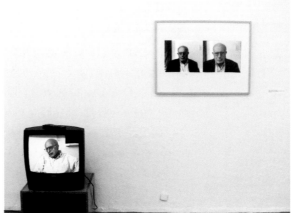

Fig. 3
Ranier Ganahl
Language of Emigration, Ralph Freedman, 1999. Installation view, Kunstverein und Stiftung Sprinhornhof, Neuenkirchen, Germany, 2001

fact that I sit behind the microphone and the quality of my voice is acoustically inferior. . . . Since I'm not doing this as a historian or somebody working for an opinion factory, I always accept happily the self-presentations I encounter and I am allowed to record. For me, it is also not of any significant difference whether a self-presentation is more expressive or not, more reserved or not. Even the completeness or the level of facts presented are not essential.

Shari Rothfarb Mekonen and Avishai Mekonen: We try to balance our vision for the project as directors while nurturing a two-way relationship about the complex subject matter we are tackling—identity—with the people whom we portray. . . . A core element of this film is that it is being presented *from* the points of view (POV) of Jews of color. After seeing various films, for example, those regarding Operation Moses and the Ethiopian Jews—which are like many projects that while at times were/are well-intentioned, come across in ways that are propagandistic, exoticizing, defamatory, and inaccurate—we felt it was personally very important for this story to be told from the POV of people whose identity and lives were actually being discussed. In doing so, we hope that their subjectivity and agency will come through and that their stories will provide key insights into the human experience of having multiple racial, ethnic, cultural, linguistic, etc. identities. . . . As a central character in the film [co-director Avishai Mekonen], an Ethiopian Jew, provides a throughline from his personal POV. Both of our POVs also come through, really, via all aspects of the film, as is the nature of filmmaking—through the editing, framing, accompanying literature, and so on. This is definitely a personal POV project, although we also strive to incorporate as much balance as possible.

Jaime Permuth: One portrays a person as events unfold. A person is portrayed in terms of the photographer's perception of their individuality but also in terms of the role they play in their communities. Again, it is important to stress that a person's trust is reciprocated by a photographer's empathy and compassion. Why speak of compassion? One's scrutiny renders another person vulnerable, a dynamic that can easily lead to exploitation on the part of the photographer. Whereas it is important to remain a critical observer, compassion tempers our gaze and reminds us of the other's humanity.

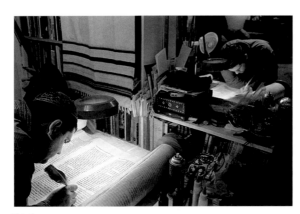

Fig. 4
Jaime Permuth
Scribe, 2002

Chris Verene: My work is about documenting the real story and real lives of my family and friends and their town of Galesburg, Illinois. My role in this is to sincerely describe the life and circumstances of the people and to show reality while preserving the people's honor and dignity. My role is also as interpreter—I explain the story in short form using my handwriting and picture editing. My role or job as artist is understood through the fact that I only make work about people I have known for years or am related to and with whom we have found mutual trust.

My own point of view is obvious in that I tell the story in first-person nonfictional narration. This means that I, the grandson, neighbor, friend, and fellow local Midwesterner, am the one who is telling truths here as I understand them. My goal is that a person in my photograph is seen in a way that he or she believes in, and speaks honestly about their life and situation. I use my handwriting to tell a most whole truth, and to show where

the family lines meet and to explain details that further enhance the meeting of art audience and people and places in the story. My relationship with [the people I portray] is about our connections and the things we share together. Not everybody knows "how they want to be portrayed" and so, if I am going to do the portraying, I pay attention to the person's spirit, and try to capture it on film. Often, the people guide me, by having new pictures made after they see results. Generally, we do not fake or stage anything, but try to make a real portrait out of what happens naturally in life.

Tirtza Even and Brian Karl: [The people portrayed] are never just objects of study. They are crucial partners in a dialogue. However, they don't participate in the decision-making about the final outcome of the piece we make. . . . We want to make images that always eventually reveal themselves to be constructed, but in small ways, subtly, over time. In this specific piece, the images are entirely our projections but the audio is given over to the voices of others. These we try to leave as unmediated as possible given our choice to make thematic connections among excerpts from interviews of different speakers. The choice of topics and the links among individuals inevitably reflect our position and view on these statements.

Fig. 5
Hand gestures such as these provided inspiration for choreographer Melinda Ring, who collaborated on Tirtza Even and Brian Karl's installation *Definition*, 2004–5

Andrea Robbins and Max Becher: In large part whose point of view makes it into the pictures depends on who is viewing them. For the people we photograph, the images will be "professional" representations of themselves and their loved ones. On quite a few occasions we have taken the first photograph of a new family member, or a final representation of a loved one. When we are photographing people, we try to make arrangements in advance or give them time to prepare themselves, otherwise we photograph public events or public displays. People viewing our work in a museum or gallery may come to it with the knowledge of our approach and larger project (we have been doing this for nearly twenty years now), but many people have an interest in the individual subject and they gauge our success through their own professional or personal filters. We treat each project as an introduction to our approach as well as an introduction to the subject. We are aware of the stereotypes that exist regarding a group of people or place that we work in, but we are always trying to introduce new information and a new context, to use irony to dispel past assumptions. Traditional photography is not a static transmitter of either the subject's or the photographer's intent. For this reason we write a text that grounds the images and creates a new context (our own). Photographs contain many levels of personal, cultural, spatial, and formal information and so can operate on many different levels simultaneously and can even shift meanings over time. We are very sensitive to this slippage. Sometimes people want to show us things that they think would be good for us to photograph, or things we may be interested in. People do not show us what they don't want us to see. I think all good photographers grapple with what is going on on both sides of the camera. On one side is the photographer, their interest, intellect, and expertise; and on the other side are people acting out their lives, often for the camera. The photograph simultaneously seals this distance and the connection between the photographer and their subject.

Jessica Shokrian: I want to minimize any influence I may contribute to a situation due to the presence of my camera. But, I do realize more and more that it is my point of view that is apparent in the pieces because of who I am, the experiences I have had, how

I came to this project in the first place, the dynamic of my relationships to the people I am filming, and then, ultimately, what I choose to focus on, how I edit the final pieces, and how they are presented. If I direct at all, it is by encouraging my subjects to be natural and forget about my camera. When things are going well I have become fully immersed in a given situation and most everybody is carrying on just as they would if my camera was not there . . . for as long as I can remember I have been photographing them. I am like an old tribal storyteller, and my stories are photographs and films instead of words. Because it is family and these relations are so close to me, it sometimes feels a bit strange to refer to them as my "subjects." But, I do acknowledge my family's support in agreeing to be filmed, and these pieces are ultimately about my personal regard for my family—as complex as this can be. Suffice to say that for the course of my project I have not sought to distance myself from the dynamics of the relationships involved.

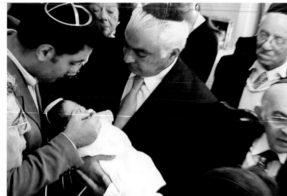

Fig. 6
Jessica Shokrian
Brit Milah, 2004. Video still

Nikki S. Lee: In *Parts,* I set up my personality and [my partner's] personality. There's already a story line in it, that's why I can hire an actor. Let's say I need a "sugar daddy"—he doesn't need to have that personality to play a "sugar daddy." But for *Projects,* I don't hire an actor to play the part of a punk or a Japanese teenager, so their own personal identity needs to come through in the pictures. It's actually not so much their personality, but who they are *socially*—punks are more an identity in society or a social entity, not a personality. In *Projects* they *are* punks, they *are* yuppies. But in *Parts* I set up everything, and then make my friend or the actor I hire become somebody. And then I become somebody too.

WHO IS THE WORK OF ART MADE FOR?

Exploring the issue of point of view necessarily brings up the question: Why does an artist make a work of art, and for whom is the artist making the work? Is the artist making the work for him or herself? To impart a specific message to the viewer? Does the artist make the work so that the sitter might learn through the process of collaborating to make the art? What happens to the sitter in the process of making a work about his or her own identity? Permuth and Verene's responses focus on how the work is shaped by and affects the communities that they engage and know. On the other hand, Even and Karl's responses indicate that their work is primarily made to impart a message to their audiences, and therefore, at times their subjects may not be satisfied with the way they have been represented. Ganahl discusses what he personally gains through the art-making process, and how his life is affected by it.

How does an artist handle negative responses from the sitter? Does it matter? Again, the answers were as varied as the artists. Some, such as Verene and Permuth, actively engage the subject's response through the process of making the art. Other artists, like Shokrian, receive responses but do not incorporate them into the final work.

Verene: Well, I think if you ask the actual people, they would say they are collaborating with me: "Hey, take this picture!! Get one of me on my bike! How about the dog!" "Come

over tomorrow and meet my housekeeper—she's pretty for a picture!!" . . . "Come and make a picture of me and my aunt Edna Levy—she is very old and unwell, and I want to remember her." This is collaboration. . . . I have an earnest, and perhaps old-fashioned belief in art's ability to affirm and ennoble people's experiences. Lots of people don't like cameras, or ask not to be photographed under certain circumstances. Many people have shown me what they like and don't like in their pictures. I am in no hurry to rush out images that would make my people unhappy. I take great care to be an actual friend, and am respectful of people's feelings.

MAX'S BASEMENT

Fig. 7
Chris Verene
Max's Basement, 2002. Type C Archival print, with artist's handwritten text in oil, 30 x 36 in. (76.2 x 91.4 cm). Courtesy of Chris Verene Studio—ChrisVerene.com

Even and Karl: We have had some criticism from people involved in previous projects, where they felt our choices reflected more of the extreme ends of some social continuum while neglecting less radical experiences typical to some mainstream. We thought they were accurate in their observations, but that in order to call attention to actual circumstances in those parts of the world, it was important to highlight problematic phenomena. [Portraying a subject as they want to be portrayed] is something we've been struggling with for years and have no single answer for. Somehow you always end up not doing it perfectly right. Either you betray the people you interview or the piece itself. Or both. . . . It is too easy for even the most well-meaning and thoughtful individual to fall back on habitual ideas (and this applies to us as well!)—especially regarding issues of identity as expressed through ethnic definitions. Part of the aim of our project is to open up conversations that might otherwise be fixed, predictable, or shut down because of such preconceptions, and to enter definitions that would be fresh or revealing because they are more layered, problematic, or even contradictory. We wish to add to the depth of the piece by evoking crucial ethical and political ambiguities.

Shokrian: For the most part the feedback is generally positive, but I have received negative feedback on a few occasions. It is important for me to be able to connect to family members through my work as an artist. Sometimes it feels like there is so little that I have in common with my family. So it hurts when someone is critical or gives me negative feedback and I can see that they just don't understand what I am attempting to express. It is hard at moments like this.

Ganahl: My questioning is mostly informed by my personal curiosity in these individual fates [of the interview partner]. As a child of the generation of perpetrators [of the Holocaust]—my father was drafted into the German army as a minor and spent over a year in that disastrous war—my interest in these stories is very personal and informed by many different emotional and rational layers of involvement. Though I introduce and explain myself and my project offscreen, there are sometimes specific occasions I talk about myself on record. This is the case when I am asked questions, when the subject of discussion invites it, or indirectly through the act of questioning since questions are always telling. . . . Since the final presentation will reflect the complexity and the overwhelming nature of the long, unedited interviews, I don't have exaggerated expectations

of the audience. The volume of the material and the resistance to any quick apprehension will guarantee the original privacy of the interviews, including all my weaknesses and mistakes in interviewing. If some listener or viewer sits through hours of interviews, he or she is not only entitled to understand but also to realize the understanding and caring in handling the stories and all the shortcomings I'm responsible for. . . . Interviewing people is interesting per se. I learn more as a person, a regular human being, than I learn as an artist. The question of what constitutes art is independent of the question of what happens to someone over the course of an interview.

Of course, when I grew up in Austria some decades ago, we weren't really made aware that there are emigrants as a result of the war. Nazi-terror and the war were so horrific that we kids and young students couldn't really imagine it to be diachronically so close to our present. I felt there were two incompatible ways to deal with this aspect of historical distancing. We rationalized it and learned the dates, we studied it and worked on the facts. We were taken to the sites and confronted with historical material. On the other hand, the crimes and horrors were so unimaginable that some irrational temporal distancing took place in myself that pushed it all back into middle age. I couldn't really imagine a connection. So one day when I met a German-Jewish emigrant in an airplane to New York City, I was very moved and became curious. I felt as if somebody took off my blinders and I could see. That marked the beginning of this series of interviews, which I initiated without any institutional support and without the prospect of an exhibition. At that moment, after eight years of living in New York, I was surprised that I hadn't had this moment of awareness and historical apprehension earlier, since some parents of my friends had similar fates. Answering your question simply, I can say that I made this work for me. But I hope it will have similar effects on other people and will also have had some positive impact on the interviewees.

Okon: I have never had anyone complain [about the way I represented them], but on one occasion I could tell that the people portrayed did not understand the work and therefore did not like it, but they were very polite about it. I always invite the participants to the exhibitions, but most of the time they don't come; it is as if they like the experience of performing and being photographed but they are not very interested in the result.

Permuth: In my experience, negative feedback is rare. Mostly, participants tend to suggest additional avenues of exploration that would expand the work I have already completed. Generally speaking, I try to share the work as it progresses. This reassures participants and makes for a deeper process of representation. As the project evolves, informal conversations with the community also become essential. The most important feedback comes when the project nears completion. If the community is not moved emotionally by the images, the work is not successful. And if the project does not inspire people to engage in further dialogue and meditation, it is not successful either. . . . In my artistic practice since being in New York, I have focused on projects that allow me to explore the two main aspects of my identity: Latin American and Jewish cultures. *The Jewish Identity Project* represents the first opportunity that I've had to combine both aspects of my heritage in a single exploration. . . . Coming into this project, the first question that crossed my mind was why would anybody want to be a Jew. The time that I have spent with Torat Emet has provided me with fresh insights into the relevance of the Jewish faith for the twenty-first century.

Rothfarb Mekonen and Mekonen: We have received feedback that, reflecting the highly complex nature of this subject, is likewise complex. There is sometimes hesitancy on the part of people who have been poorly represented—as stereotypes without having their voices heard, etc. As this is a work-in-progress documentary, these concerns are continually addressed through ongoing dialogue.

Fig. 8
Shari Rothfarb Mekonen and Avishai Mekonen
Judaism and Race in America, 2005. Video still

WAS THAT PERFORMANCE REAL?

Responses about collaborating with subjects and the process of working with them raised notions about the performative aspect of being in front of the camera. How does an artist's personal interaction with the participant affect the work of art? Sometimes an artist—purposely or not—provides a context for participants to work through issues of their identities within the process of making a work. For example, Yoshua Okon asked the participants in his video to take on the role of the biblical figure Ruth in order for them to explore their roles as "Jewish mothers." To what extent does the subject "perform" an assumed, expected, or desired identity? As the subject in her own works, Nikki S. Lee takes on certain identities—that of a punk, a preppie, or the wife of a Jewish husband—in order to comment on issues of identity, but also to work through those aspects of herself.

Okon: I did interact with the women I videotaped in the Ken community, and I think that definitely affects their performances. My piece is precisely about conveying a multiplicity of points of views simultaneously, and my intention is to do this as self-reflexively as possible. I'm not looking for any essence, or for any "pure documentary." I'm more interested in how we are constantly being affected by each other.

Bey: I think a portrait is something that results from an implicit agreement between subject and photographer. The subject first consents to the attention of the photographer and the camera. Because the introduction of the camera disrupts the normal social situation, what happens at that point takes on an aspect of personal theater and performance. I, as the photographer, become a kind of director, attempting to provoke a credible performance on the part of the subject, a performance which nominally reads in the photograph as a kind of nonperformance actually, since the role, as such, that the person is "performing" is his or her self. The writer Max Kozloff calls it the "routine deception" of portraiture, since, if the performance is credible, we don't think of it as a performance at all, but instead feel a real sense of engagement with the person in the photograph.

Even and Karl: We attempt to engage in dialogues that are not predetermined but that are challenging both to us and to the people we are interviewing. We begin each interview with the same basic question: What does the word "Jewish" mean to you? We then let the conversation branch out to take its own course.

Ganahl: I cannot tell what effects my interviews might have had on my interview partners, but I left many houses with mixed and shared feelings of compassion, love, understanding, and some sadness. Sadness that it is not possible to keep up visiting and

sadness that life has an inevitable end. Since most interviewees from my *Language of Emigration* series are not only very old but also very lucid and young in spirit, and tended to be somehow lonely—many seemed to have survived their friends—I often felt like an immediate friendship was established that the interviewee and I would like to continue. The impossibility of living up to this undiscussed promise is saddening.

Lee: Personality affects how I work [in the *Parts* series]. If someone is outgoing I work better with him than if he's shy. It affects the process, but it doesn't come out in the pictures, because his face is cut off in the photo. . . . As for my process, in *Projects* I become a yuppie, but in a way I already was a yuppie. It's a part of my identity too—I go shopping, I go to the gym, I go to expensive restaurants. The same goes for any of the other social identities I take on in the *Projects* series—I can say I possess that quality in my identity. It's not that I'm representing something completely as an outsider. In *Projects* the identity issues change from picture to picture and you can see them right away. In *Parts* the identity issues are more hidden, and while it's the same person in every picture, I look slightly different in each one because I'm in a different romantic relationship in each one. That's my setup point—so it's about how my personality gets affected by other personalities. For example, if you hang out with person A, you feel like a gentle, sweet woman, but if you hang out with person B, you feel bossy, and with person C you feel dependent. With one guy you are feminine; with another you are very boyish. You're different in each relationship. They each touch a different part of your identity and it comes through you. So that's what I wanted to review because I think everyone has within them all these different characters, and they emerge through the people they're with.

Fig. 9
Nikki S. Lee
Parts (12), 2002. C-print mounted on aluminum, 30 x 26¼ in. (76.2 x 66.7 cm). Courtesy of Leslie Tonkonow Artworks + Projects, New York

And then for The Jewish Museum project: I used to have a Jewish boyfriend, so I know that this is possible. It's a little bit of *Projects* and *Parts* in one. It's a Jewish wedding, so it's more about social identity issues. And I'm not trying to become a Jewish woman, but an Asian woman who marries a Jewish man. When you marry someone, you enter their culture, and he's going to enter my culture too probably. So, it's more of a mix of cultures, and the cultural issue is more from the *Projects* series. But the context is more like the *Parts* series—how I met this Jewish guy, dating him, how I ended up with him, and now I'm having a wedding—will we be comfortable in the future? I can see similarities between Jewish and Korean cultures as well—because my dealer and my ex-boyfriend are Jewish, I'm familiar with Jewish culture: Jews have suffered from oppression, and in Korean culture there is oppression from the Japanese; Jews eat pickles and we eat pickles too! So perhaps the couple in the image can manage both cultures well if they get married. How does the Jewish man affect the Korean woman's identity and vice versa? Similarly, I live here as a Korean, but I have an identity as a New Yorker as well. When I'm here, my New York identity comes out more, and in Korea my Korean identity comes out more—I hold both inside of me.

Verene: My role as artist is also not finished when the pictures are done. I have always believed that this work is a lifelong commitment. I will be there with the people of Galesburg to discuss the pictures and to continue to be a part of their lives. . . . The art is secondary to the actions of enjoying each other and spending time together. This is

true for happy times and sad. For example, visiting loved ones and friends in a nursing home can be very trying. Making pictures there can be therapeutic and a good participatory game. The time you spend with shut-ins and the elderly is so precious to them, and will not be forgotten. That stuff is the goal of my art. The photographs are a by-product and a document of the real thing that has already happened. This is why I cannot work under strict deadlines or goals—the work has to come naturally.

Permuth: Art is a way of being in the world. In my case, it is the most important avenue I have found for developing and growing as a person. When I undertake a project it is because the work involved represents an aspect of my identity that I wish to explore further. In the case of documentary work per se, I feel a special responsibility toward the participants; their emotional responses are the best indicator of whether the images produced are indeed relevant to their lives. Documentary work functions as a mirror. If participants are not moved by their own reflection in my images, nothing of value has been accomplished.

CAN I GET TO KNOW YOU, PLEASE?

Discussions about collaboration raise the topic of how well an artist gets to know his or her subject before filming or photographing them. This part of the art-making process uncovers how the artist makes the art, and raises issues of how this process affects the final product and how identities are portrayed in that product. To some of the artists, for example Verene and Robbins and Becher, it is important to spend time and get to know the subjects before photographing them. They photograph their subjects over periods of time. To other artists, like Okon and Bey, getting to know the subject beforehand is not necessary, and sometimes even detrimental to making the art. The personal identity of the artist also sometimes plays a role in the ease and extent to which the getting-to-know-you process develops. For example, in Permuth's case, he feels his identity as a Latin Jew has allowed him easier access to the Torat Emet community. In the case of Ganahl, who is a non-Jewish Austrian interviewing German-speaking Holocaust survivors, he feels his personal identity and background do not necessarily affect the interaction with his subjects or the work itself.

Okon: [Q: How much time do you spend getting to know your subjects?] Not so much; I'm very interested in surprises. My work is highly performative, and chance and improvisation play a big role. Therefore I'm very interested in not predetermining the outcome so much; I like the pieces to develop organically, and not knowing the people beforehand helps.

Lee: For my *Projects* series, I didn't spend time with the people beforehand. It was as if I was just seeing them for the first time because the image is supposed to evoke a snapshot. It was kind of like everyday life—you meet a lot of different people. Some people you meet and feel really close to, and other people you meet and you don't feel close. You don't mind if you don't see them again. That's the way people act and react in their everyday lives, and I use the same logic in *Projects*—I meet people, do my project, and some people I really get to know over long periods of time, and some people I never see again, but I don't really think of it as work for me, or that this is part of my work. It's different for my *Parts* series—I usually ask my friends to be in the photographs; it's people I already know, so it's a different process.

Rothfarb Mekenon and Mekonen: For us personally, the best part of this project has been the building of relationships with the individuals and communities represented in the film. A continually growing relationship is critical and central. Based on our own experiences of being represented in manners that are stereotypical, negative, "exotic," etc., we are especially concerned with the politics of representation, and with the representation of politics concerning racially and ethnically diverse Jews. It also ties into [Shari's] ongoing interest in the ways in which Jewish women have been and are represented. We continue to forge relationships of varying kinds with our subjects, and many of these have been growing for years. Trust is a strong theme in any documentary director-subject relationship, especially in one that is as politically charged as this, and of course there is no one right way of representation. We are very concerned about building this trust, and also look forward to various outreach projects associated with the film to continue these relationships.

Even and Karl: We knew many of our subjects in this piece beforehand, sometimes for many years, though we have never discussed the primary theme of "What does Jewish mean?" with most of them in such depth, if at all. We sometimes met others who were recommended to us in advance to discuss the goals and content of the piece and got acquainted with their perspectives. There were still others who, often for logistical reasons, we only met and spoke with at the time of the interview itself. But all of the people we interviewed provided surprising turns of thought that felt both considered and fresh.

Shokrian: I chose to create this body of work about my family partly because I have spent many years developing a relationship to them as the "family" photographer/documentarian. This has not always been easy. As a matter of fact, many of my relatives often question my choices in life, beginning with my obsession to document almost every family gathering. But I have to say that one of the reasons I became a photographer in the first place was to somehow connect with my family, especially my father's generation who preferred to speak Farsi, a

Fig. 10
Jessica Shokrian
The Funeral, 1999. Video still

language still, for the most part, foreign to my ears since my mother is American and we grew up speaking English in our home. I feel I am continually getting to know my family. For me it is in the filming, editing, and then finally the showing of the pieces where I am able to somehow find a sense of connection or communication. If it weren't for this work I feel I might have slowly disappeared from my family's consciousness and perhaps they from mine.

Robbins and Becher: We spent a lot of time reading and researching before our first trip [to Postville]. The Lubavitch group is very rigorous about outreach to lapsed and secular Jews. They have a mandate to reach out to Jews and are very visible and social. Even though we had had contact with them in New York and even in Cuba, they were mysterious figures to us before we began. We had many questions, but we didn't want to waste time having them explain things that we could find elsewhere, and we didn't want to professionalize their dealings with us and tip them into "outreach mode." We felt privileged to be able to spend so much time with them, observing them in relaxed settings, asking questions, but perhaps answering even more, about ourselves, our project, current events, and popular culture.

This project was different because we were working with a group of people who are urban and travel widely but live cloistered lives that separate them from the mainstream. It was very important that we understand, in advance, as much about Hasidism and the Lubavitchers in particular in order not to assert any of our assumptions over their representation, which could have larger implications for them. We explain our project and many of our past works. We generally photograph over time in a series of trips, and so we have a chance to bring images back during subsequent trips as gifts and to show people what we are doing. In this project, on our first trip we met many people and stayed in town a week before taking a photograph. We began by trying to obtain permission to visit the kosher slaughterhouse during this first week, but with each refusal we were introduced to more people and were invited to people's homes as guests, and even to be overnight guests. We did not want to photograph in the slaughterhouse, but we wanted to understand the work the men did and the koshering process. When we finally were permitted to visit the plant, we thought it would be most difficult to see the animals, but our response was the same as Upton Sinclair's in *The Jungle*—we came away more surprised by the loud, cold, fast-paced, monotonous working conditions of the rabbis and workers.

The Hasidim's lives are so ordered by social and dietary restrictions that they appear guarded. This particular group was on guard because a well-known book had been written about them recently, called *Postville: Clash of Cultures,* which by all accounts managed to offend people among both the Hasidim and Postville natives. By explaining that we were not conducting cross interviews with locals and by returning with photographs to show them our progress, we developed a working rapport. We were often interviewed by our subjects in this project about personal things, our backgrounds, our intentions, and our histories. In general we are not forward about these subjects, but we don't mind answering questions. While we were permitted to witness some banal and personal moments, which perhaps gave us more insight than the formal events, our questions were not personal. We like to let people explain themselves and lead discussions about themselves and their group; we like to ask the same questions and wait for new answers.

Bey: Since I don't think the photographs are about "knowing" the person in a literal sense, but are rather about the moment the subject and I come together through the photographic act to make a picture, getting to know the person beforehand is not that important to me. I come to know them through making photographs of them.

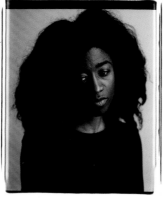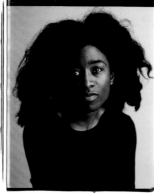

Fig. 11
Dawoud Bey
Alva, 1992. Polacolor ER photographs (diptych), 30¼ x 44 in. (76.8 x 111.8 cm). Museum purchase, Addison Gallery of American Art, Phillips Academy, Andover, Massachusetts

Permuth: In the case of this commission, my role was to document the lives of a particular community. The first part of this process revolves around earning the trust of strangers. If successful, one then enters into an implied social contract; the trust of the community is reciprocated by the empathy, compassion, and openness of the artist. Ultimately, my role as an artist was to create a compelling form for this project and to represent people's lives with integrity. . . . The process of getting to know a community is in itself a negotiation. It is concerned with the issues of trust and mutual benefit. Who

is the photographer, what are his or her aims, and why should the community accept his or her presence in their lives? What value can each party expect to obtain from the process? The first few encounters with the community set the foundation for a future relationship. I prefer to approach this stage without a camera, simply as an observer and new presence in the group.

Ganahl: Before I even got to talk to anybody, the project was somehow explained by the different people who were helping me. For this I am very indebted to Marion R. House, a German Jewish emigrant herself whom I had interviewed before and whom I have been meeting regularly now for many years. The fact that two of the immigrant families interviewed [in this project] are personal friends of hers helped a lot and opened up possibilities. If a person then agrees, I call and explain the project on the phone while arranging an appointment. Before interviewing I again explain the project and answer questions. The interviews are done in one sitting, without interruptions or breaks. Since I prefer to hear as much as possible on tape, I try to start with the recording process right away. Things said over an introductory cup of coffee or tea are often not mentioned again or don't get repeated with the same personal profile as when uttered the first time. . . .

My cultural background is always immediately apparent whenever I speak in any language I know. People apprehend in seconds that I am a native German speaker, but they also apprehend that I was born much after the horrors of the Nazi terrors. So most people I speak to don't hold me directly responsible, since they know that by doing the work I do I try to contribute to fighting such politics. In cases of rejection, the decision not to talk was mostly if not always made independently of me. I felt that many people who were forced out of Austria and Germany when they were young lived with some nostalgic longing for their youth and the places of their childhood. I might have reminded them a bit of this. In fact, I was often astonished why people were not bitter, were not angry anymore, and didn't give me an attitude.

Verene: This means really that we simply spend time together, and go to parties, meals, walks, talks, and visits together. There is no special agenda or process to follow, because I make my work over years and stages of relationships, just the same way that people live in a community and get to know its substance and strength.

COLLABORATING IS AN ORGANIC PROCESS

As much as artists can plan and detail a particular project ahead of time, when they collaborate with subjects, the project is bound to shift because of the unpredictable nature of life. Or, perhaps the project shifts because the sitter is not what the artist expected. In other words, the collaborative process is organic and the artist must be prepared to be flexible and willing to change gears and even plans for the project. In the course of the more than two years that *The Jewish Identity Project* artists worked with their subjects, some of those individuals and groups changed, moved, transitioned. Others did not. For example, both the Ken and Torat Emet communities that Okon and Permuth worked with changed their locations, which also considerably changed the culture and issues of the communities. On a more personal level, Shokrian's relationship with her own family, who are her subjects, changed dramatically through the course of completing her project. I asked the artists about the assumptions and plans they made about the project and how that changed through the process of making the work.

Okon: I am really interested in the unexpected so I try to approach a project with as few expectations as possible. Usually my collaborators go beyond any possible preconceptions I might have, and this was the case in this project as well. I guess if I had to mention a single expectation, then I would say it was that this group would begin to problematize the "essentialist" construction of community. . . . I don't think any of us can have full control of our projections, even if we have a very clear ideal in our mind, what ends up coming out is beyond our control. This can be applied to any of my projects, including *The Jewish Identity Project.*

Even and Karl: As open as we thought we were in approaching others about this topic, our initial anticipation about people's probable responses always proved to be narrower and more stereotypical than the nuanced, complex, and sensitive perspectives each individual actually offered us. . . . We reconfigured the piece to be able to accommodate a much greater quantity of actual interviews—in large part to respond to the range and depth of views we encountered. Initially we imagined a thirty-minute linear piece. We ended up using nearly ten hours of audio that listeners are able to access interactively.

Ganahl: Everyday life can be very exciting if it is accepted. I try not to be judgmental. Of course, a sociologist and scholar of Holocaust-related lives is more eloquent and trained in analysis than somebody who is not. Asking a psychoanalyst about her life again produces a more analytical account than narratives by people who spend their lives in sales or with technology. But it doesn't matter to me, since all storytelling—open or less open, formalized or less formalized, eloquent or less eloquent—is informative for me.

Permuth: When I first approached Torat Emet, I expected to find a reluctant community, defensive and deeply protective of its privacy. However, my first meeting with Rabbi Rigoberto Emmanuel "Manny" Viñas—the spiritual leader of Torat Emet—was a warm and candid encounter. He was responsive to my proposal, and his enthusiasm paved the way for my acceptance among his congregation. About a year into my project, Rabbi Manny was hired to lead the congregation at Lincoln Park Jewish Center. Torat Emet relocated from temporary quarters in Riverdale to a new, permanent home in Yonkers. The transition has been complex at many levels, and is probably the greatest challenge Rabbi Manny has had to face as a leader. I was able to probe into this transition period through my work; specifically, in the last story I shot, which takes place the day of Gila Viñas's Bat Mitzvah. However, the process of change is ongoing, and its outcome is as of yet undecided. Torat Emet was accustomed to the exclusivity of Rabbi Manny's attention and care. Now it has to share him with the larger community of Lincoln Park, whose socioeconomic background and median age is completely different from their own.

Robbins and Becher: We were surprised by how welcomed we were into the community, into homes, the *mikveh,* and even women's etiquette meetings and discussions (Andrea only). The dinners were warm and relaxed with lots of jokes and talking, everyone seemed relaxed, curious, and happy. We make it a point to dress semiformally but comfortably when we work, so as not to offend anyone, and this project was no different, except that I [Andrea] wore long-sleeve shirts at all times and we covered our heads in people's homes. When we broke rules inadvertently (which was often), the people were extremely forgiving and seemed more concerned with not embarrassing us than making us aware of our lapses.

Shokrian: For years I have struggled to pursue my path as an artist and clarify my voice. After embarking on this project with the museum I think I was hoping to become more accepted and understood by my family and by the Persian Jewish community here in Los Angeles. To a certain extent this has been the case, many family members have become very encouraging and supportive. Other people now regard me with a small measure of respect, when once they were suspicious. The most important change though, is that I have grown to spend more time apart from the community and become more interested in my own artistic process and less needy of the communal support. . . . Initially this project was focused on the experience of different individuals surrounding Shabbat. I soon realized that if I was going to depict what was most compelling to me about the community, I needed to cover a whole host of gatherings, rituals, and life's events. The scope of my project has evolved, and I have been experimenting with different ways of editing and presenting footage. This project has become a process of discovery and self-exploration; I have inevitably come to face the truth behind many of my relationships with family members. If at first I was interested in creating a series of straightforward pictures about this community, I am now also engaging the challenge of representing my personal experience in relation to this community. The support of The Jewish Museum has been very encouraging. How does my experience relate to or clarify this community portrait? This is the question I continue to ask myself. My affiliation with the museum has earned me a certain level of respect and acceptance of my work. This project has been a blessing—I have been able to continue to grow more sure of myself and am becoming less dependent on the opinions and approval of others (the community). I want to find the balance in honoring my path and continue to develop the skills as an artist to communicate in a language that, I hope, everyone can understand.

DOES BEING COMMISSIONED MATTER?

The experience of being commissioned to make a work varies from artist to artist and project to project. I was interested in learning how *The Jewish Identity Project* artists felt about being commissioned by The Jewish Museum— would they have executed their project without being prompted by an institution? Did they work differently because it was commissioned? Did they feel limited because of it? Some of the artists feel that being commissioned has no bearing on either their artistic process or their final project. Others feel that the presence of a third party does affect their work. It also struck me that being commissioned specifically by The Jewish Museum, an institution based in a particular culture's history, tradition, and current concerns, may have been a factor for the artists while creating work. For example, did *The Jewish Identity Project* artists assume the museum's audience to be a particular type of person, and if so, did that affect their project at all? Further, did the commission have any bearing on the subjects of the works? Did they know that the artist was commissioned by The Jewish Museum to execute the project? Did this affect their "performance" in front of the camera in any way?

Lee: When I do something for an institution the most important thing is how they understand my work. It also depends on what kind of institution they are, what they want me to do. If the institution understands exactly what I'm doing, understands my work, and appreciates what I'm doing, then that's a comfortable situation, and I don't feel pres-

sured then because I am doing what I want to do and there is support. Then it's great. But if the institution doesn't communicate with me, or they don't get the point of my work, then I probably wouldn't take the commission because it would be a lot of pressure. I think that the commissioned work of art is not the point. The point is how the artist and institution understand each other and how they support each other and work together. That's most important, and then I'm just doing what I do, but with some deadlines. But in other cases, if I had to do something that I didn't want to do, or if there are too many rules, that would make me uncomfortable and I wouldn't be okay with it. But if not, it's a great opportunity.

Fig. 12
Nikki S. Lee
Yuppie Project, 1998.
Duraflex print, 21¼ x 28¼ in. (54 x 71.8 cm).
Courtesy of Leslie Tonkonow Artworks + Projects, New York

Even and Karl: In some ways, The Jewish Museum was like a silent, third partner in the process. And both our assumptions and especially those of our interviewees—about what and whom the museum represented, what it stood for—colored some of the conversations and probably shaped their course. . . . We have been much more crucially aware of the potential audience for this project than for any piece we've worked on before. We chose our interviewees to a large extent as voices that would enter into a challenging and substantial dialogue with that imagined audience. . . . Because the space of the museum is marked explicitly with ethnic connotations, we suspect that the majority of attendees (especially to a show avowedly addressing the issue of identity) would have some degree of personal investment and/or history of intellectual consideration of the very question we were putting to our interviewees (i.e., "What does it mean to be Jewish?"). We were conscious of the diversity of opinions among those we were interviewing and realized that their views might conflict in some cases with individuals in the audience. We were hoping to challenge the very idea of an essential ethnic category by producing such a diverse and at times contradictory array of voices and opinions regarding a definition of Jewishness and the very use of definitions personally, socially, and politically. . . . We made clear to all in advance that this project would be presented at The Jewish Museum in New York. Some of the associations with The Jewish Museum that might have deterred or impacted people's responses were its being an institution dedicated to the exhibition of art (which can seem distanced or divorced from the "real world"), and its being an institution oriented toward the representation or experience of a particular ethnicity (or definition of ethnicity) to the exclusion of others.

Several of those we were interested in interviewing became more responsive to the idea of participating when they learned that The Jewish Museum was the intended public space of presentation, since it meant they would be heard by others who had a strong personal investment in the topic. Others (primarily individuals of Arabic descent, or Jews descended from non-European ancestors) were sometimes reluctant or even refused to be involved once they learned of that fact. The primary reason was their assumption that the museum was biased towards a Euro-centered and/or pro-Israel audience.

Ganahl: I, of course, told everybody about the prominent and well-respected institutional context, The Jewish Museum. But once we started to work on it, this institutional framework was forgotten. Also, I am not necessarily aware of the differences of the audience of The Jewish Museum and audiences of other museums and therefore ignored it. Even if

I imagined every viewer to be Jewish, I wouldn't necessarily know what to ask differently. The differences among my Jewish interviewees are so big and so similar to the differences you find between people in general, ignoring their religious or cultural backgrounds, that I would have difficulties coming up with a specific approach. In some conversations, questions of religious identity come to play a larger role, in others it never surfaced as an issue.

Bey: This project has sent me in search of subjects I would not have sought out otherwise. Once the subjects are in front of the camera, however, the challenge becomes a familiar one: to evoke a sense of presence and engagement between the subject, the photographer, and, I hope, the viewer.

Verene: The museum approached me because I was already making work about Jewish teenagers in my hometown, and Susan Chevlowe asked if I would consider expanding it for a special show at the museum. At first, I thought I would have to seek out strangers in order to meet Jews in the small community. I do not seek out strangers for pictures as a rule, but I thought it might be worth a try in the name of good art. After the first year, I realized the good work [I made] was about Jewish people who were already in my life and the lives of my family members. The work just grew and grew out of the same sources that [inspired] all my twenty years of art in Galesburg—the family, the city, and its history as it relates to my family and friends in Galesburg. I didn't end up courting strangers; I just started finding out who was Jewish, and began with the pictures from those stories. I had been making pictures of my father's best friends since Cub Scouts, and seeing them now as grown men and grandfathers. It turned out that both of his best friends were Jewish! So the work was making me before I was making it.

Okon: I usually work with smaller budgets, and so being commissioned by The Jewish Museum has simplified some logistical issues. Aside from that, as an artist I find it is always interesting to see how I can work within an institution. Finally, in general, when I make a piece, I find something that inspires me and then decide to make it, and in this case the starting point for the piece came from someone else and therefore my process changed, for I had to look for inspiration within certain parameters that were outside of me.

Permuth: It is similar to commissions I have received in the past from other institutions. Once a project is agreed upon, I create the work independently of any other considerations. My only responsibility to the institution is to deliver the highest quality work on time. . . . In the case of Torat Emet, an exhibition at The Jewish Museum represents for the community a measure of interest and validation from mainstream Judaism. The philosophy of inclusion which underpins *The Jewish Identity Project* was a decisive factor in gaining the trust of this community, as was the high regard in which The Jewish Museum is held in Jewish New York. My impression is that being embraced by the institution signifies one more step in Torat Emet's goal of forming part of the mainstream. *Anusim* [*conversos*] have long been treated as outsiders, and their plight is not always—or even frequently—received with sympathy by other Jews. "Crypto-Jews" have often been the object of scorn and misunderstanding, exploited for sensationalist coverage by an unscrupulous media. Even at the research stage of this project—when I was exploring the phenomenon of Anusim in the United States and Latin America—I was met with a reticent and guarded attitude by potential sources of information.

Artist Biographies

DAWOUD BEY

Born in Jamaica, N.Y., 1953
Lives in Chicago

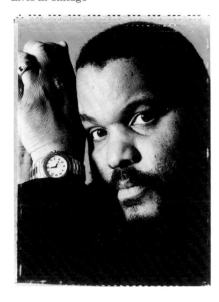

Education

M.A. Yale University School of Art, New Haven, Conn., 1993
B.A. Empire State College, State University of New York, Saratoga Springs, 1990
School of Visual Arts, New York, 1976–78

Selected One-Person Exhibitions

2004

Detroit Institute of Art
Detroit Portraits

Gorney Bravin + Lee, New York
Class Pictures

2003

David and Alfred Smart Museum, University of Chicago
The Chicago Project (catalogue)

2002

Rhona Hoffman Gallery, Chicago
New Photographic Work

2001

Rena Bransten Gallery, San Francisco

1999

Rhona Hoffman Gallery at Gallery 312, Chicago
Recent Work

1998

Queens Museum of Art, N.Y.

1997

Wadsworth Atheneum, Hartford, Conn.
Hartford Portraits

1996

High Museum of Art, Atlanta
Picturing the South: The Commission Project

Wexner Center for the Arts, Columbus, Ohio
Residency Exhibition

1995

Walker Art Center, Minneapolis
Portraits, 1975–1995 (catalogue)

1994

Cleveland Museum of Art
Portraits

1993

Museum of Contemporary Photography, Chicago
Polaroid Portraits

1992

Rotunda Gallery, Brooklyn, N.Y.
Photographs

1991

Fogg Art Museum, Harvard University, Cambridge, Mass.

1990

Ledel Gallery, New York
Recent Photographs (catalogue)

Selected Group Exhibitions

2004

Whitney Museum of American Art, New York
Inside Out: Portrait Photographs from the Permanent Collection (catalogue)

2003

International Center of Photography, New York; Seattle Art Museum (2004)

Only Skin Deep: Changing Visions of the American Self (catalogue)

2002

Museum of Contemporary Art, Chicago
Multiformity: Multiples from the MCA Collection

Whitney Museum of American Art, New York
Visions from America: Photographs from the Whitney Museum of American Art, 1940–2000 (catalogue)

2001

Studio Museum in Harlem, New York
Red, Black, and Green: Loans to and Selections from the Studio Museum Collection

Yale University School of Art, New Haven, Conn.
Alumni Choice: An Exhibition of Works on Paper

2000

Terra Museum of American Art, Chicago
Indivisible: Stories of American Community (catalogue)

Whitney Museum of American Art, New York
2000 Whitney Biennial (catalogue)

1999

The Art Institute of Chicago
Beyond the Photographic Frame

Los Angeles County Museum of Art
Ghosts in the Shell: Photography and the Human Soul, 1850–2000

Wadsworth Atheneum, Hartford, Conn.
Here's Looking at You: Portraits from the Collection

1998

David and Alfred Smart Museum, University of Chicago
Space/Sight/Self

Museum of Contemporary Photography, Chicago
Photography's Multiple Roles: Art, Document, Market, Science

1997

Museum of Fine Arts, Boston
Face and Figure in Contemporary Art

P.S. 1 Contemporary Art Center, Long Island City, N.Y.
Heaven: Public View, Private View

Whitney Museum of American Art, New York
Heart, Body, Mind, Soul: American Art in the 1990s, Selections from the Permanent Collection

1995

DeCordova Museum and Sculpture Park, Lincoln, Mass.
Strokes of Genius

1994

Museum of Contemporary Photography, Chicago
Targeting Images, Objects + Ideas

1992
The Museum of Modern Art, New York
From the Permanent Collection

1991
Gallery 1199, New York
Images of Labor: The Nineties

1990
Studio Museum in Harlem, New York
Home: Contemporary Urban Images by Black Photographers (catalogue)

Selected Bibliography

2004
Beringer, S. K., ed. *Columbia: A Journal of Literature and Art* (spring/summer). New York: Columbia University School of the Arts.

2003
Artner, Alan G. "Dawoud Bey's Latest." *Chicago Tribune,* May 17.

Johnson, Ken. "Dawoud Bey at Gorney Bravin + Lee." *New York Times,* May 10.

Leffingwell, Edward. "Review: Dawoud Bey at Gorney Bravin + Lee." *Art in America* (November).

Weinberg, Adam D., et al. *Treasures of the Addison Gallery of American Art.* New York: Abbeville Press.

2001
Cotter, Holland. "Invoking Marcus Garvey while Looking Ahead." *New York Times,* August 24.

Hall, Stuart, and Mark Sealy. "Contemporary Photographers and Black Identity." *Different.* New York: Phaidon Press.

2000
Galassi, Peter. *Walker Evans and Company.* New York: The Museum of Modern Art; Harry N. Abrams.

Kimmelman, Michael. "A New Whitney Team Makes Its Biennial Pitch." *New York Times,* March 24.

1999
Glueck, Grace. "Art Review: Faces of the Centuries." *New York Times,* September 17.

Johnson, Ken. "Art Review: Seen and Heard: Under the Spell of Childhood and Its Trappings." *New York Times,* August 20.

Vogel, Carol. "Surprises in Whitney Biennial Selections." *New York Times,* December 8.

1998
Johnson, Ken. "Photography Review: Enigmatic Portraits of Teens Free of All Context." *New York Times,* August 21.

Sengupta, Somini. "Portrait of Young People as Artists." *New York Times,* January 18.

1997
Kimmelman, Michael. "Art Review: In New Jersey, Evolution in Retrospectives." *New York Times,* July 18.

Lifson, Ben. "Reviews: Dawoud Bey." *Artforum* (February).

Reid, Calvin. "Review of Exhibitions: Dawoud Bey at David Beitzel." *Art in America* (April).

Schwabsky, Barry. "Photography: Redeeming the Humanism in Portraiture." *New York Times,* April 20.

TIRTZA EVEN AND BRIAN KARL

Born in Jerusalem, 1963; Born in San Fernando, Calif., 1962
Live in New York

Education

Tirtza Even
M.F.A. New York University, Tisch School of the Arts, 1995
B.A. Hebrew University of Jerusalem, 1989

Brian Karl
Ph.D. candidate, Ethnomusicology, Columbia University, New York
B.A. University of California, Los Angeles, 1984

Selected Film Festivals and Installations

2004
The Israel Museum, Jerusalem; Robert Beck Memorial Cinema, Collective Unconscious, New York
Painted Devil/Counterface

The Israel Museum, Jerusalem; Yerba Buena Center for the Arts, San Francisco
Icarus

2003
Pacific Film Archive, San Francisco; The Jewish Museum, New York
Far, Along

2002
Carnegie Art Center, Buffalo, N.Y.; Art Pace, San Antonio, Tex.
Occupied Territory

New York Video Festival; Sixth International Video Festival Videomedeja, Yugoslavia; San Francisco International Film Festival
Far, Along

Whitney Museum of American Art, New York;
Cantor Film Center, New York; Carnegie Art
Center, Buffalo, N.Y.; Santa Monica Museum,
Calif.; Samuel P. Harn Museum of Art, Miami
Kayam Al Hurbano (Existing on Its Ruins)

2001

Postmasters Gallery, New York
Flicker

Postmasters Gallery, New York
Slip

2000

[d]vision 2000 Festival, Vienna
Kayam Al Hurbano (Existing on Its Ruins)

L'immagine Leggera Festival, Palermo, Italy;
Chisenhale Gallery, London; Medi@terra Festival,
Athens, Greece
Optical Poem

1999

Art Focus 99, Jerusalem
Windows

Postmasters Gallery, New York; Kunstwerke,
Berlin; Pratinou, Athens, Greece
Optical Poem

1998

The Haifa Museum of Art, Israel
Blind

Selected Bibliography

2004

Amir, Ayala. "Kayam Al Hurbano." *Liquid
Spaces*. Tel Aviv: Israel Museum Press.

2003

McBee, Richard. "Contemporary Art/Recent
Acquisitions at the Jewish Museum." *The Jewish
Press* (April).

2002

Robinson, George. "Far, Along." *The Jewish
Week* (July).

2000

"Tirtza Even, (Documentary) Gallery 1." *Xcp
Cross-Cultural Poetics* (May).

1999

Bijerano, Maya. "Kayam Al Hurbano." *Iton 77*
(April).

"Introducing Art Focus." *Kol Haiir* (October).

"Mary Kelly/Tirtza Even." *The New Yorker*,
April 23.

Nachshon, Ilan. "Open Wound." *Yediot
Acharonot*, January 18.

1998

Nachmias, Joseph. "*Pan* and *Zoom* at the Haifa
Museum." *Studio Art Magazine* (November).

RAINER GANAHL

Born in Bludenz, Austria
Lives in New York City

Education

Whitney Museum Independent Study Program,
New York, 1991
M.Phil. University of Innsbruck, Austria, 1991
B.A. Academie Düsseldorf, 1986

Selected One-Person Exhibitions

2005

Baumgartner Gallery, New York

Museum of Modern Art, Vienna (catalogue)

Wallach Art Gallery, Columbia University, New
York (catalogue)

2004

Paul Petro Contemporary Art, Toronto
Bicycle

2003

Gesellschaft für Aktuelle Kunst, Bremen,
Germany (catalogue)

2002

Base, Florence

Baumgartner Gallery, New York

2001

Galeria Massimo de Carlo, Milan

2000

Centre de Photographie, Geneva
Rainer Ganahl: From 10 Seconds to 500 Hours

Paul Petro Contemporary Art, Toronto
Basic Canadian

1999

Max Protetch, New York

1997

Generali Foundation, Vienna

1996

Galerie Roger Pailhas, Paris

Thomas Solomon Garage, Los Angeles

1995

Blum & Poe, Los Angeles

Sandra Gering, New York

1994

Galerie Roger Pailhas, Paris

1992

Dallas Museum of Art

Nordanstad-Skarstedt, New York

1991

White Columns, New York

Selected Group Exhibitions

2005

Palais de Beaux-Arts, Brussels
Beliques Visionaires

White Columns, New York
Trade

2004

Cuchifritos, New York
Market Value

White Box, New York
When Democracy Was Fun

2003

Häusler Contemporary, Munich
Private/Public

Spazio Alcatraz, Florence
Contested Space

University Art Museum, Santa Barbara
Social Strategies: Redefining Social Realism

2002

Baumgartner Gallery, New York
re: "la chinoise"

Kunsthalle Wein, Vienna
How to Do Things with Words

2001

Apex Curatorial Program, New York
In/SITE/Out

Renaissance Society at the University of Chicago
Detourism

2000

Contemporary Museum, Baltimore
Snapshot

National Museum of Contemporary Art, Oslo
Illuminations

1999

Venice Biennale
Austrian Pavilion

Selected Bibliography

2004
Fusco, Maria. "Rainer Ganahl, The Angry
Optimist." *Afterart News* (January).

Siegel, Katy, and Paul Mattick. *Money*. New
York: Thames & Hudson.

2003

Cotter, Holland. "Southfirst: Art." *New York Times,* February 21.

Manacorda, Francesco. "Homeland Security—l'arte come strumento di riflessione politica." *Flash Art,* Italian edition (November).

Said, Edward. "Imperiale Sichtweisen." *Springerin* (winter).

Schwendener, Martha. "Rainer Ganahl at Base." *Artforum* (February).

2002

Baldon, Diana. "Rainer Ganahl, Tema Celeste." *Contemporary Art* (May/June).

Leffingwell, Edward. "Rainer Ganahl at Baumgartner." *Art in America* (September).

2001

Verwoert, Jan. "Rainer Ganahl." *Frieze* (November).

Williams, Gregory. "Rainer Ganahl: Baumgartner Gallery." *Artforum* (summer).

2000

Costantino, Roberto. "Broken Language." *Flash Art,* Italian edition (summer).

1999

Baker, George. "Rainer Ganahl: Max Protetch Gallery." *Artforum* (April).

Ganahl, Rainer, and George Baker. "Letters to the Editor." *Artforum* (September).

Princenthal, Nancy. "Rainer Ganahl at Max Protetch." *Art in America* (May).

Wulffen, Thomas. "Ortssprache—Local Language." *Kunstforum International* (February)

1998

Schwabsky, Barry. "Rainer Ganahl: Windows on the Word." *The Widening Circle: Consequences of Modernism in Contemporary Art.* Cambridge, U.K: Cambridge University Press.

Tupper, Martin. "Imported—Rainer Ganahl." *Interview* (summer).

Volk, Gregory. "Kwangju Biennale." *World Art* (April).

1996

Ipolito, John. "Where Has All the Uncertainty Gone?" *Flash Art* (summer).

Kandel, Susan. "A Bare-Bones Look at Cyberspace Totems." *Los Angeles Times,* March 7.

1995

Gorden, Janine. "Rainer Ganahl, Matthew McCaslin at Sandra Gering New York." *Flash Art* (November).

1993

Heartney, Eleanor. "Rainer Ganahl, Nordanstad-Skarstedt, New York." *Art in America* (March).

NIKKI S. LEE

Born in South Korea, 1970
Lives in New York City

Education

M.F.A. in Photography, New York University, 1999
A.A.S. Fashion Institute of Technology, New York, 1996
B.F.A. Chung-Ang, College of Arts, University of Korea, 1993

Selected One-Person Exhibitions

2004

Numark Gallery, Washington, D.C.

2003

Cleveland Museum of Art

Leslie Tonkonow Artworks + Projects, New York

2002

Clough-Hanson Gallery, Rhodes College, Memphis

Galeria Senda, Barcelona

2001

Institute of Contemporary Art, Boston

Leslie Tonkonow Artworks + Projects, New York

Museum of Contemporary Photography, Chicago

Yerba Buena Center for the Arts, San Francisco

2000

Gallery Gan, Tokyo

Stephen Friedman Gallery, London

1999

Leslie Tonkonow Artworks + Projects, New York

Selected Group Exhibitions

2004

Bronx Museum of the Arts, New York
Portraits and Places: Recent Acquisitions to the Permanent Collection

Center for Art and Visual Culture, Baltimore; International Center of Photography, New York (2005)
White: Whiteness and Race in Contemporary Art (catalogue)

Des Moines Art Center, Iowa
Contested Fields

Herbert F. Johnson Museum of Art, Cornell University, Ithaca, N.Y.
Double Takes: Transformations through the Lens

San Francisco Museum of Modern Art
Picturing Modernity: Photographs from the Permanent Collection

Sheldon Art Galleries, Saint Louis, Mo.
Will Boys Be

2003

International Center of Photography, New York; Seattle Art Museum (2004)
Only Skin Deep: Changing Visions of the American Self (catalogue)

Istanbul Biennial

Ronald Feldman Fine Art, New York
American Dream

2002

Albright-Knox Art Gallery, Buffalo, N.Y.
Fresh: Recent Acquisitions

Carnegie Museum of Art, Pittsburgh
Hello My Name Is . . .

Greene Naftali, New York
Pictures

Hammer Museum of Art, University of California, Los Angeles
Mirror Image

Japan Society, New York
Character and Choice: Nikki S. Lee, Yasumasa Morimura, and Tomoko Sawada

Museo de Bellas Artes de Bilbao, Spain
Open City: Street Photographs 1950–2000

The Photographers Gallery, London
The Brixton Studio

2000

DC Moore Gallery, New York
The Likeness of Being: Contemporary Self-Portraits by Fifty Women Artists

Teseco Fondazione per l'Arte, Pisa, Italy
Who's That Girl?

1999

Center for Curatorial Studies, Bard College, Annandale-on-Hudson, N.Y.
The Calendar Project

P.S. 1 Contemporary Art Center, Long Island City, N.Y.
Generation Z

303 Gallery, New York
No Place Rather than Here

1998

Leslie Tonkonow Artworks + Projects, New York
The Cultured Tourist

Selected Bibliography

2004

Dawson, Jessica. "The Artist's Pare of Lovers." *Washington Post,* July 8.

Johnson, Ken. "The Game Show." *New York Times,* February 6.

O' Sullivan, Michael. "Nikki S. Lee: New Guises, New Gazes." *Washington Post Weekend,* July 16.

Rexer, Lyle. "Only Skin Deep." *Art on Paper* (March/April).

Waltener, Shane. "The Real Nikki." *Modern Painters* (spring).

2003

Boxer, Sarah. "The Street Game Is to Be Distinctive Without Seeming to Work at It." *New York Times*, July 5.

Clifford, Katie. "Nikki S. Lee." *ARTnews* (March).

Doherty, Claire. "Liverpool Biennal." *Art Monthly* (November).

Garulli, Lavinia, "Nikki S. Lee." *Flash Art* (December).

Gopnik, Blake. "Art and Race, Making a Memorable Appearance." *Washington Post*, April 6.

Gopnik, Blake. "Just Point and Shoot (But Plan First!)." *Washington Post,* June 23.

Harris, Jane. "When in Rome." *Artext* (Summer).

Honigman, Ana. "Nikki S. Lee." *Flash Art* (January/February).

Kerr, Merrily. "Breaking Up Is Hard to Do." *Flash Art* (November).

Smith, Roberta. "In the Orbit of Funk and Hip-Hop." *New York Times,* January 18.

Triming, Lee. "The Liverpool Biennial." *Flash Art* (November/December).

Valdez, Sarah. "Nikki S. Lee at Leslie Tonkonow." *Art in America* (April).

Van Gelder, Lawrence. "Through a Lens." *New York Times,* May 30.

Ward, Ossian. "Who's That Girl." *Art Review* (October).

Yablonsky, Linda. "To Thine Own Selves Be True." *ARTnews* (November).

2001

Berger, Maurice. "Picturing Whiteness: Nikki S. Lee's Yuppie Project." *Art Journal* (winter).

Falconer, Morgan. "Street Life." *Art Review* (June).

Ferguson, Russell. "Let's Be Nikki." *Nikki S. Lee: Projects.* Ostfildern-Ruit, Germany: Hatje Cantz.

Glueck, Grace. "A Universe of Art, Spanning the Centuries and Centered in Boston." *New York Times,* August 17.

Hamilton, William. "Dressing the Part Is Her Art." *New York Times,* Sunday Styles, December 2.

Kerr, Merrily. "Lil Nikki 'n' Friendz." *New York Arts Magazine* (October).

Lawson, Whitney. "Nikki S. Lee." *The New Yorker*, November 5.

Robinson, Lisa. "Under 21, the Young and Cultural." *Boston Globe,* August 2.

Rosenfeld, Kathryn. "Nikki S. Lee." *New Art Examiner* (November/December).

2000

Cruz, Amada. "Nikki S. Lee." *Fresh Cream.* London: Phaidon.

Damian, Carol. "Art Miami 2000." *Art Nexus* (May–July).

Fujimori, Manami. "Nikki S. Lee." *Very New Art: One-Hundred Artists of the Year 2000.* Tokyo: Bijutsu Shuppan-sha.

Gilman-Sevcik, Frantiska, and Tim Gilman-Sevcik. "New York's Mega-Shows." *Flash Art* (May/June).

Godfrey, Mark. "Nikki S. Lee." *Frieze* (May).

Hoffmann, Frank. "Report from Kwangju: Monoculture and Its Discontents." *Art in America* (November).

Homes, A. M. "Hot Shots." *Harpers Bazaar* (February).

Kino, Carol. "Surveying the Scene II, the Emergent Factor." *Art in America* (July).

Pollack, Barbara. "Nikki S. Lee." *Flash Art* (January/February).

1999

Camhi, Leslie. "A Forgotten Gender Bender." *ARTnews* (November).

Cotter, Holland. "Nikki S. Lee." *New York Times,* September 10.

Exley, Roy. "Nikki Lee." *Creative Camera* (December).

Schwabsky, Barry. "Openings: Nikki S. Lee." *Artforum* (September).

Smith, Roberta. "More Space for Young Artists." *New York Times,* February 19.

Stamets, Bill. "The Cultured Tourist." *New Art Examiner* (April).

1998

Schutz, Heinz. "Filme und Identitäten." *Kunstforum International* (April–June).

SHARI ROTHFARB MEKONEN AND AVISHAI MEKONEN

Shari Rothfarb Mekonen
Born in Miami
Lives in New York City

Education
M.F.A. Columbia University, New York, 1999
Whitney Independent Study Program, Studio Art, New York, 1992
B.F.A. The Cooper Union, School of Art, New York, 1990

Selected One-Person Exhibitions

1999

The Jewish Museum, New York
Water Rites

1990

Frame by Frame Gallery, Tampa, Fla.

Selected Group Exhibitions

2003

Onisaburo Gallery, New York
Immersion

2002

Oberosterreichisches Landesmuseum, Linz, Austria
Aquaria

2001

Yeshiva University Museum, New York
Jewish Artists on the Edge

1993

Whitney Museum of American Art, New York
The Subject of Rape

1992

Pat Hearn Gallery, New York

1991

Houghton Gallery, New York

1990

Alternative Museum, New York

Selected Film Festivals

2003

Calgary Jewish Film Festival, Canada

2002

Vancouver Jewish Film Festival

2001

Contra Costa International Jewish Film Festival, Calif.

IFP—Buzz Cuts, Independent Feature Project, Pioneer Theater, New York

NYJCC/Manhattan Short Film Festival, New York

Washington, D.C., Jewish Film Festival Repertory Film Series, *The Screening Room*

2000

Alcala Short Film Festival, Madrid, Spain

Athens International Film and Video Festival, Ohio

Atlanta Jewish Film Festival

Los Angeles Independent Film Festival

Palm Beach Jewish Film Festival, Fla.

Palm Springs International Short Film Festival, Calif.

The Santa Fe Film Festival

1999

Boston Jewish Film Festival

The Jewish Museum, Contemporary Artists Series, New York

Maine Jewish Film Festival, Portland

Avishai Mekonen
Born in Gondar, Ethiopia
Lives in New York City

Education
B.F.A. Tel Chai College of Haifa University/Hebrew University, Israel, 1997

Selected Films

2005

In Every Tongue

Judaism and Race in America (working title)

2001

Video Flour

1998

Anchor

1997

Hothouse

1996

On the Way Home

Selected Film Festivals

2004

Sheba Film Festival, New York

2002

AFO 2002 International Competition Documentary Festival, Czech Republic

International Festival of Documentary Films and Multimedia Programmes, Czech Republic

Maine Jewish Film Festival, Portland

Washington, D.C., Jewish Film Festival

2001

Haifa Jewish Film Festival, Israel

Tel Aviv Cinemateque

YOSHUA OKON

Born in Mexico City, 1970
Lives in Mexico City and Los Angeles

Education

M.F.A. University of California, Los Angeles, 2002
B.F.A. Concordia University, Montreal, 1994

Selected One-Person Exhibitions

2004

The Project, Los Angeles
Shoot

2003

Galleria Francesca Kaufmann, Milan
Cockfight

2002

Art & Public, Geneva
Oríllese a la Orilla

Black Dragon Society, Los Angeles

Galería Enrique Guerrero, Mexico City

2000

La Panadería, Mexico City
Lo Mejor de lo Mejor

Modern Culture, New York
Cockfight

1998

Brasilica, Vienna
Rise & Fall

1997

La Panadería, Mexico City
A Propósito

Selected Group Exhibitions

2003

International Center of Photography, New York
Strangers: The First ICP Triennial of Photography and Video (catalogue)

Istanbul Biennial

2002

Americas Society, New York
Pictures of You

Orange County Museum of Art, Irvine, Calif.
California Biennial

Vedanta Gallery, Chicago
Use Your Illusion

2001

Mercer Union, Toronto
City of Fictions

The Project, New York
ZONING

2000

Artists Space, New York
Action Videos by Latin American Artists

1999

Museo Carrillo Gil, Mexico City
Paradas Continuas

Passage de Retz, Paris; Capella de l'Antic
Hospital de la Santa Creu, Barcelona
Sous la grisaille de Mexico

1998

Galerie Philomene Magers, Cologne, Germany
Okon, Calderon, Ocampo

Musée d'art Contemporain de Lyon, France
Vidéos d'art du Mexique et des Etats-Unis

Yerba Buena Center for the Arts, San Francisco
Mexelente

Selected Bibliography

2004

Welchman, John. "Crying Wolf." *Flash Art*
(January–February).

2003

Beith, Malcolm. "Mexico's New Wave." *Newsweek,*
May 26.

Reynolds, Christopher. "Head over Heels." *Los
Angeles Times,* October 20.

2002

Cotter, Holland. "Pictures of You." *New York
Times,* May 10.

Echeverria, Pamela. "Focus Mexico." *Flash Art*
(July–September).

Pagel, David. "California Biennial Is on the Right
Laugh Track." *Los Angeles Times,* July 17.

2001

De la Torre, Mónica. "Pull Over! The Art of
Yoshua Okon." *BOMB Magazine* (winter).

Helguera, Pablo. "Mexico City: Unmasked
Contexts." *Tema Celeste Contemporary Art
Magazine* (May/June).

Schneider Enriquez, Mary. "Beyond the Border."
ARTnews (January).

JAIME PERMUTH

Born in Guatemala City, 1968
Lives in Brooklyn, N.Y.

Education

M.F.A. School of Visual Arts, New York, 1994
B.A. Hebrew University of Jerusalem, 1990

Selected One-Person Exhibitions

2005

Instituto Guatemalteco Americano, Guatemala
City
Triptico de familia (catalogue)

Yeshiva University Museum, New York (2004)
Manhattan Mincha Map

2004

Cooperación Española, Antigua, Guatemala
Re-trato de familia

2003

Museum of the City of New York
*Manhattan Mincha Map: Photographs by Jaime
Permuth*

Casa del Lago, Festival Fotoseptiembre, Mexico
City
Cascadas de luz

National Institute of Fine Arts, San Miguel de
Allende, Mexico
The Rose of Xido

Selected Group Exhibitions

2005

Irving Arts Center, Dallas
Family Triptych

2004

Galeria Mozart, Antigua, Guatemala
III-P

2002

The Museum of Modern Art, New York
Life of the City

2001

Contemporary Museum, Baltimore
Snapshot

Queens Museum of Art, New York
Crossing the Line (catalogue)

2000

Bronx Museum of the Arts, New York
*Good Business Is the Best Art: Twenty Years of
the Artist in the Marketplace*

1999

El Museo del Barrio, New York
Selected from the Files

1998

Museo Nacional de Arte Moderno, Guatemala
City
Colloquia

1997

Mary Barone Gallery, New York
Jaime Permuth and Marina Berio

Selected Bibliography

2005

Escobar, Luis. "La triple arista de un retrato
familiar." *Siglo Veintiuno,* January 12.

Leibovitz, Liel. "Prayer as Art, Art as Prayer: Two
Exhibits at Yeshiva University Museum Explore
the Intersection of the Spiritual and the
Aesthetic." *The Jewish Week,* February 9.

Sagone, Itziar. "Critica vs. Critica." *Revista
Magna Terra* (September).

Sicha, Choire. "Praying in Manhattan." *New
York Times,* February 27.

2004

de Prera, Lucrecia C. "A posteriori: Archivo para
una ciudad imaginaria." *El Periódico,* July 12.

Méndez de la Vega, Luz. "Tríptico Fotográfico."
Diario La Hora, July 31.

Siekavizza, Edwin. "Plegarias Atendidas." *El
Periódico,* September 10.

2003

Goldman, Julia. "Manhattan's Other Sacred
Spaces." *The Jewish Week,* December 5.

2002

Banai, Nuit. "Shifting Sites, the Brewster Project
and the Plight of Place." *PAJ: A Journal of
Performance and Art* (September).

2001

Elan, Susan. "Brewster Art Show Invites
Participation." *The Journal News,* July 29.

1999

Garcia, Mayra. "Cara a Cara con: el fotografo
Jaime Permuth." *Noticias de Arte* (winter).

1998

Gomez, Elsa. "*La Rosa de Xido,* carta de presen-
tacion de un pueblo." *El Nacional,* August 8.

ANDREA ROBBINS AND MAX BECHER

Born in Boston, 1963; Born in Düsseldorf, Germany, 1964
Live in New York City and Gainesville, Fla.

Education

Andrea Robbins
M.F.A. Hunter College School of Art, New York, 1989
B.F.A. The Cooper Union, School of Art, New York, 1986

Max Becher
M.F.A. Mason Gross School of the Arts, Rutgers University, New Brunswick, N.J., 1989
B.F.A. The Cooper Union, School of Art, New York, 1986

Selected One-Person Exhibitions

2005

Photographische Sammlung, Cologne, Germany
Andrea Robbins und Max Becher

2004

Sonnabend Gallery, New York
Where Do You Think You Are?

Museum of Contemporary Photography, Chicago
The Transportation of Place

Sonnabend Gallery, New York
Portraits

2002

Sonnabend Gallery, New York
Figures . . .

2001

Sonnabend Gallery, New York
A Survey 1991–2000

Yerba Buena Center for the Arts, San Francisco
Andrea Robbins and Max Becher

1999

Leslie Tonkonow Artworks + Projects, New York
German Indians

1998

Robert B. Menschel Photography Gallery, Syracuse University, N.Y.
Bavarian by Law and *German Indians*

1997

Basilico Fine Arts, New York
Dachau

1996

Basilico Fine Arts, New York
Shrinking People, Exiled Cigars, and Galloping Dinosaurs

1995

Basilico Fine Arts, New York
Holland

1994

Kunstverein Hamburg, Germany
Holland/Colonial Remains

1992

Berland Hall Gallery, New York
Colonial Remains

Selected Group Exhibitions

2005

Museum of Contemporary Art, Chicago
Universal Experience: Art, Life, and the Tourist's Eye

2004

Center for Art and Visual Culture, Baltimore; International Center of Photography, New York (2005).
White: Whiteness and Race in Contemporary Art (catalogue)

2003

International Center of Photography, New York
How Human: Life in the Postgenome Era

International Center of Photography, New York; Seattle Art Museum (2004)
Only Skin Deep: Changing Visions of the American Self (catalogue)

Whitney Museum of American Art, New York
The American Effect (catalogue)

2001

The Museum of Modern Art, New York
Documentary Fortnight

2000

Halle Tony Garnier, Lyon, France
Biennale de Lyon d'art contemporain

1999

Solomon R. Guggenheim Museum, Bilbao, Spain
Photography: An Expanded View

Thread Waxing Space, New York
Conceptual Art as Neurobiological Praxis (Andrea Robbins only)

1998

Leslie Tonkonow Artworks + Projects, New York
The Cottingley Fairies and Other Apparitions

1996

The Jewish Museum, New York
Culture and Continuity: The Jewish Journey

1994

The New Museum of Contemporary Art, New York
Trade Routes

Selected Bibliography

2004

"Andrea Robbins and Max Becher at Sonnabend Gallery." *New York* (February).

Diaz, Eva. "Andrea Robbins and Max Becher at Sonnabend." *Art in America* (October).

Jefferson, Margo. "Playing on Black and White: Racial Messages Through a Camera Lens." *New York Times,* January 10.

Johnson, Ken. "Andrea Robbins and Max Becher." *New York Times,* March 12.

2002

Grundberg, Andy. "Global Breach: The Photos of Andrea Robbins and Max Becher." *Art on Paper* (May/June).

2001

Schwendener, Martha. "Critics' Picks: Andrea Robbins and Max Becher." Artforum.com (September).

Smith, Roberta. "Andrea Robbins and Max Becher." *New York Times,* October 5.

2000

Newhall, Edith. "Andrea Robbins and Max Becher." *New York,* January 3.

1999

Glueck, Grace. "Andrea Robbins and Max Becher." *New York Times,* December 31.

1998

Boxer, Sarah. "The Guggenheim Sounds the Alarm: It Ain't Necessarily So." *New York Times,* March 19.

Cullum, Jerry. "Andrea Robbins and Max Becher at Vaknin Schwartz." *Art in America* (July).

Goldberg, Vicki. "Eliminating the Distance between Two Points." *New York Times,* November 17.

1997

Baker, George. "Andrea Robbins and Max Becher." *Artforum* (September).

1996

Karmel, Pepe. "Andrea Robbins and Max Becher: 'Shrinking People, Exiled Cigars and Galloping Dinosaurs.'" *New York Times,* February 2.

Van de Wall, Mark. "Andrea Robbins and Max Becher." *Artforum* (May).

1995

Mariño, Melanie. "Andrea Robbins and Max Becher at Basilico Fine Arts." *Art in America* (November).

1994

Kandel, Susan. "Land Ahoy." *Los Angeles Times,* November 17.

JESSICA SHOKRIAN

Born in Los Angeles, 1968
Lives in Los Angeles

Education

B.F.A. Art Center College of Design, Pasadena, Calif.

Selected Group Exhibitions

2004
Gallery of Functional Art, Santa Monica, Calif.
Group Show

2002
Stephen Cohen Gallery, Los Angeles

2000
Contemporary Museum, Baltimore
Snapshots

1998
Gallery 825, Los Angeles

1997
Paul Kopeikin Gallery, Los Angeles
The Las Vegas Show

State Capitol, Sacramento

1996
Xibit Gallery, Los Angeles

1995
The Eye Gallery, San Francisco

1993
Louis Stern Fine Arts, Los Angeles
Body Parts

Selected Film Festivals

2004
Videozone, Tel Aviv and Jerusalem

2002
Beyond Baroque, Los Angeles

Darklight, Dublin

2001
Digidance, Park City, Utah

Selected Bibliography

2002
Sarshar, Houman. *Esther's Children: A Portrait of Iranian Jews.* New York: Jewish Publication Society of America.

2001
Sunshine, Linda. *Waiting for My Baby: A Celebration of Pregnancy.* Kansas City, Mo.: Andrews McMeel Publishing.

1998
Picture L.A.: Landmarks of a New Generation. Los Angeles: Getty Conservation Institute.

Rome, Loretta, ed. *Mendhi: The Timeless Art of Henna Painting.* New York: St Martin's Press.

1994
Sunshine, Linda, ed. *Our Grandmothers: Loving Portraits by Seventy-Four Granddaughters.* New York: Welcome Enterprises.

CHRIS VERENE

Born in Galesburg, Ill., 1969
Lives in Brooklyn, N.Y.

Education

M.F.A. Georgia State University, Atlanta, 1996
B.A. Emory University, Atlanta, 1991

Selected One-Person Exhibitions

2005
Chelsea YMCA, New York
The Self-Esteem Salon, The Frisbee Series

Peres Project, Los Angeles
The Self-Esteem Salon, The Baptism Series

2004
Contemporary Art Center, Atlanta
Chris Verene: From Galesburg to Atlanta, 1986–2004

P.S.1 Contemporary Art Center, Long Island City, N.Y.
The Big Umbrella, The New York Series

2003
Photographs Do Not Bend, Dallas
Galesburg

2002
Deitch Projects, New York
The Self-Esteem Salon, The Baptism Series

Fay Gold Gallery, Atlanta
The Baptism Series

Wendy Cooper Gallery, Madison, Wisc.
Galesburg

2001
Fay Gold Gallery, Atlanta
Galesburg

2000
Colin De Land Fine Art, New York

Paul Morris Gallery and American Fine Art Company, New York

Vaknin Schwartz, Atlanta
Self-Esteem

1999

Galerie Rabouen Moussion, Paris

Vaknin Schwartz, Atlanta
Galesburg

1998

Paul Morris Gallery, New York
Camera Club

Selected Group Exhibitions

2005

NurtureArt & Naked Duck Gallery, New York
Cracker

2004

Deitch Projects, New York
k-48 Klubhouse

Yossi Milo Gallery, New York
Pool Party

2003

Daniel Reich Gallery, New York
Gallery Artists

Museum of Contemporary Photography, Chicago
The Furtive Gaze

Ronald Feldman Gallery, New York
American Dreams

2002

Whitney Museum of American Art, New York
*Visions from America: Photographs from the
Whitney Museum of American Art*

2001

Paul Morris Gallery, New York
It's a Wild Party and We're Having a Great Time

Whitney Museum of American Art, New York
Text in Art

2000

Nikolai Fine Art Gallery, New York
Because Sex Sells

Paul Morris Gallery, New York
Do You Hear What We Hear?

Whitney Museum of American Art, New York
2000 Whitney Biennial (catalogue)

1999

New Jersey Center for the Visual Arts, Summit
Full Exposure: Contemporary Photography

San Diego University Art Museum
Emerging Artists

1998

Paul Morris Gallery, New York
Portraits

Serge Sorokko Gallery, New York
Backstage

Vaknin Schwartz Gallery, Atlanta
*Peepshow: John Waters, Cheri Nevers, Ken
Probst, Chris Verene*

1997

Lenox Square Gallery, Atlanta
Collectors Collecting

Marcia Wood Gallery, Atlanta
Contemporary American Landscape

Nexus Contemporary Art Center, Atlanta
*Look Back and Get Down: A Celebration of
Athens and Atlanta Music 1977–1997*

Thread Waxing Space, New York
You Should Know Better

Vaknin Schwartz, Atlanta
Post-Construction

1996

Bathhouse Show, Piedmont Park Arts Festival,
Atlanta
*Olympic Experience, or What I Did in Summer
1996*

1995

City Hall East Gallery, Atlanta
National Association of People with AIDS

1994

High Museum of Art, Atlanta
Electric Blanket (AIDS Projection Project)

Nexus Art Center, Atlanta
Sex, Love, and Death

Selected Performances

2001

Christie's Auction House, New York
The Self-Esteem Salon

The Schoolhouse Center, Provincetown, Mass.
Chris Verene and Vereni the Great

2000

The Fifth International Gallery, New York
Home Shopping One with Gentle Heights

Thread Waxing Space, New York
Vereni The Great

Whitney Museum of American Art, New York
*The Self-Esteem Salon: Whitney Museum of Art—
A Corollary to Camera Club*

1999

Gavin Brown Enterprise, New York
Bach on a Hook and M.I.M.E.

Selected Bibliography

2004

"Chris Verene: From Galesburg to Atlanta."
Artforum (November).

2002

"A Different Kind of Family." *Los Angles Times,*
July 5.

"Art Review." *New York Times,* June 25.

2001

Baxter, Joell. "Reviews." *New Art Examiner*
(February).

Doonan, Simon. "Simon Says." *New York
Observer,* April 30.

Harris, Jane. "Art Review." *Art in America*
(April).

Kushner, Rachel. "Openings: Chris Verene."
Artforum (March).

Yablonsky, Linda. "Chris Verene: Camera Club."
Time Out New York, May 28–June 4.

2000

Dimling Cochran, Rebecca. "Chris Verene." *Flash
Art* (fall).

Grundberg, Andy. "Photography Books Review."
New York Times Book Review, December 3.

Homes, A. M. "American Pie." *Vanity Fair*
(March).

Johnson, Ken. "Art Guide." *New York Times,*
October 20.

Korotkin, Joyce B. "Chris Verene." *New York
Arts Magazine,* (October).

Newhall, Edith. "The Human Factor." *New York,*
October 23.

Prose, Francine. "Till Death Do Us Part."
Aperture (spring).

Turner, Grady T. "Sexually Explicit Art." *Flash
Art* (May–June).

Verene, Chris. *Chris Verene.* Santa Fe: Twin
Palms Publishers.

1998

Cullum, Jerry. "Chris Verene at Vaknin
Schwartz." *ARTnews,* December 1.

Feaster, Felicia. "Chris Verene." *Art in America*
(October).

1997

Smith, Roberta. "The Celluloid Cave." *New York
Times,* June 27.

1996

Todd-Raque, Susan. "Galesburg and Camera
Club." *Art Papers* (April).

Exhibition Checklist

DAWOUD BEY

With audio interviews by Dan Collison and
Elizabeth Meister
All works courtesy of the artist and
Rhona Hoffman Gallery, Chicago

Samantha, 2004
Pigment print
50 x 40 in. (127 x 101.6 cm)

Claire, 2004
Pigment print
50 x 40 in. (127 x 101.6 cm)

Zenebesh, 2005
Pigment print
50 x 40 in. (127 x 101.6 cm)

Sahai, 2005
Pigment print
50 x 40 in. (127 x 101.6 cm)

Jacob, 2005
Pigment print
50 x 40 in. (127 x 101.6 cm)

TIRTZA EVEN AND BRIAN KARL

With Melinda Ring, choreographer, and Todd
Holoubek and Scott Fitzgerald, programmers

Definition, 2004–5
An interactive, audio-graphic physical computing
installation (two motorized pendulums and
graphics display projected on the ground),
accessing a database of 15–20 hours of audio;
and two single-channel video projection loops, 20
minutes and 7 minutes each

RAINER GANAHL

Language of Emigration, 2003–5
All works courtesy of the artist and
Baumgartner Gallery, New York

*Language of Emigration/Lederer Family/Gerda
Lederer,* 2003
Six chromogenic prints, 16 x 20 in.
(40.6 x 50.8 cm) each, and video, 90 min.

*Language of Emigration/Lederer Family/
Catherine Lederer-Plaskett/Rodney Lederer-
Plaskett/Aliza Lederer-Plaskett/Lucas Lederer-
Plaskett,* 2003

Six chromogenic prints, 16 x 20 in.
(40.6 x 50.8 cm) each, and four video segments,
87, 16, 16, and 19 min. each

*Language of Emigration/Indenbaum Family/
Gisa Indenbaum,* 2003
Six chromogenic prints, 16 x 20 in.
(40.6 x 50.8 cm) each, and video, 82 min.

*Language of Emigration/Indenbaum Family/
Miriam Indenbaum/Wilfredo Rodriguez/Michael
Rodriguez,* 2004
Six chromogenic prints, 16 x 20 in.
(40.6 x 50.8 cm) each, and three video segments,
53, 55, and 25 min. each

*Language of Emigration/Schlanger Family/
Lizza Schlanger/Sam Schlanger,* 2004
Six chromogenic prints, 16 x 20 in.
(40.6 x 50.8 cm) each, and two video segments,
60 and 20 min. each

*Language of Emigration/Schlanger Family/
Debby Schlanger,* 2005
Six digital color prints, 16 x 20 in.
(40.6 x 50.8 cm) each, and video, 49 min.

NIKKI S. LEE

The Wedding, 2005
from the *Parts* series
All works courtesy of Leslie Tonkonow Artworks
+ Projects

The Wedding (2), 2005
C-print mounted on aluminum
40 x 24 in. (101.6 x 61 cm)

The Wedding (8), 2005
C-print mounted on aluminum
30 x 22½ in. (76.2 x 57.2 cm)

The Wedding (3), 2005
C-print mounted on aluminum
30 x 31 in. (76.2 x 78.7 cm)

The Wedding (5), 2005
C-print mounted on aluminum
30 x 34 in. (76.2 x 86.4 cm)

The Wedding (6), 2005
C-print mounted on aluminum
30 x 22½ in. (76.2 x 57.2 cm)

SHARI ROTHFARB MEKONEN AND AVISHAI MEKONEN

Judaism and Race in America, 2005
Excerpt of work-in-progress feature documentary
Shooting format: mixed (DVCAM, miniDV, film)

YOSHUA OKON

Casting: Prototype for a Stereotype, 2005
Two-channel video installation, variable dimensions

JAIME PERMUTH

La Conversión de Carmen (Carmen's Conversion),
2003
20 black-and-white digital prints
8 x 10 in. (20.3 x 25.4 cm) each

*Kashrut en la casa Liker (Kashrut in the Liker
Home),* 2003*
18 black-and-white digital prints
8 x 10 in. (20.3 x 25.4 cm) each

*La Bat Mitzvah de Gila Viñas (Gila Viñas's Bat
Mitzvah),* 2003*
23 black-and-white digital prints
8 x 10 in. (20.3 x 25.4 cm) each

ANDREA ROBBINS AND MAX BECHER

Brooklyn Abroad, 2004–5
All works courtesy of the artists and Sonnabend
Gallery, New York

Postville

Yeshiva Students and Teacher, 2004
Archival ink-jet print
20 x 24 in. (50.8 x 61 cm)

Boy's Camp, 2004
Archival ink-jet print
20 x 24 in. (50.8 x 61 cm)

Triplets, 2004
Archival ink-jet print
20 x 24 in. (50.8 x 61 cm)

Three Girls, 2004
Archival ink-jet print
20 x 24 in. (50.8 x 61 cm)

Boy Biking, 2004
Archival ink-jet print
20 x 24 in. (50.8 x 61 cm)

Fishing Scene, 2004
Archival ink-jet print
20 x 24 in. (50.8 x 61 cm)

Lawn Mowing, 2004
Archival ink-jet print
20 x 24 in. (50.8 x 61 cm)

770

770 Eastern Parkway, Brooklyn, 2005
Archival ink-jet print
18⅛ x 42½ in. (46 x 108 cm)

Kfar Chabad, near Tel Aviv, Israel, 2005
Archival ink-jet print
18⅛ x 42½ in. (46 x 108 cm)

Ramat Shlomo, Jerusalem, Israel, 2005
Archival ink-jet print
18⅛ x 42½ in. (46 x 108 cm)

Kiryat Ata, near Haifa, Israel, 2005
Archival ink-jet print
18⅛ x 42½ in. (46 x 108 cm)

New Brunswick, New Jersey, USA, 2005
Archival ink-jet print
18⅛ x 42½ in. (46 x 108 cm)

Pico Avenue, Los Angeles, USA, 2005
Archival ink-jet print
18⅛ x 42½ in. (46 x 108 cm)

Gayley Avenue, Los Angeles, USA, 2005
Archival ink-jet print
18⅛ x 42½ in. (46 x 108 cm)

São Paulo Far Shot, 2005
Archival ink-jet print
18⅛ x 22¾ in. (46 x 57.8 cm)

Ramat Shlomo Far Shot, 2005
Archival ink-jet print
18⅛ x 22¾ in. (46 x 57.8 cm)

JESSICA SHOKRIAN

Simchah Torah, 2004
Digital video, 2 min., 50 sec.

Brit Milah, 2004
Digital video, 2 min.

The Funeral, 1999
Digital video, 4 min., 30 sec.

Ameh Jhan (Dear Aunt), 2001
Digital video, 11 min.

The Engagement, 2003
Digital video, 1 min., 45 sec.

Turning It Around, 2005
Digital video, 6 min., 20 sec.

CHRIS VERENE

Prairie Jews, 1997–2005
from the series *Galesburg*
All works courtesy of Chris Verene Studio—
ChrisVerene.com

Max's Kitchen, 2002
Type C Archival print, with artist's handwritten
text in oil
30 x 36 in. (76.2 x 91.4 cm)

Max on Exercise Bike, 2002
Type C Archival print, with artist's handwritten
text in oil
30 x 36 in. (76.2 x 91.4 cm)

Max and Marlene, 2004
Type C Archival print, with artist's handwritten
text in oil
30 x 36 in. (76.2 x 91.4 cm)

Sabbath, 2004
Type C Archival print, with artist's handwritten
text in oil
30 x 36 in. (76.2 x 91.4 cm)

Junkyard, 2002
Type C Archival print, with artist's handwritten
text in oil
30 x 36 in. (76.2 x 91.4 cm)

Max's Basement, 2002
Type C Archival print, with artist's handwritten
text in oil
30 x 36 in. (76.2 x 91.4 cm)

Brenda, 2003*
Type C Archival print, with artist's handwritten
text in oil
30 x 36 in. (76.2 x 91.4 cm)

Brenda Toasting the Flowers, 2003
Type C Archival print, with artist's handwritten
text in oil
30 x 36 in. (76.2 x 91.4 cm)

Donny and Barry on the Porch, 2001
Type C Archival print, with artist's handwritten
text in oil
30 x 36 in. (76.2 x 91.4 cm)

Harry in the Engineer's Seat, 2003
Type C Archival print, with artist's handwritten
text in oil
30 x 36 in. (76.2 x 91.4 cm)

Harry and Tornado N Scale Model, 2003
Type C Archival print, with artist's handwritten
text in oil
30 x 36 in. (76.2 x 91.4 cm)

Jewish Witches, 1997
Type C Archival print, with artist's handwritten
text in oil
30 x 36 in. (76.2 x 91.4 cm)

Jewish Witches Return, 2001
Type C Archival print, with artist's handwritten
text in oil
30 x 36 in. (76.2 x 91.4 cm)

Crystal at Eighteen, 2003
Type C Archival print, with artist's handwritten
text in oil
30 x 36 in. (76.2 x 91.4 cm)

*In exhibition only, not reproduced in catalogue

Notes

SUSAN CHEVLOWE, FRAMING JEWISHNESS

Epigraph 1. Shaye Cohen, *The Beginnings of Jewishness: Boundaries, Varieties, Uncertainties* (Berkeley and Los Angeles: University of California Press, 1999), 5.

Epigraph 2. Daniel Itzkovitz, "Secret Temples," in *Jews and Other Differences: The New Jewish Cultural Studies,* ed. Jonathan Boyarin and Daniel Boyarin (Minneapolis: University of Minnesota Press, 1997), 180.

1. Laurence J. Silberstein, ed., *Mapping Jewish Identities* (New York: New York University Press, 2000), 13. A survey by The Institute for Jewish and Community Research headed by San Francisco demographer Gary A. Tobin recently determined that there are 400,000 Jews of color in the United States. This number excluded Sephardi Jews, but included converts, adoptees, multiracial children of white Jews and persons of color, "and those who are themselves the generational descendants of Jews of color." In addition, according to Tobin, who was one of the initial advisors for The Jewish Museum's exhibition, "[a]nother 600,000 people are 'connected non-Jews.' These are individuals who might be practicing another religion as well as Judaism, people who are living with Jews (and sometimes as Jews), but who have not yet converted. There are yet another 700,000 people of color who are not currently Jewish but have a Jewish grandparent or great-grandparent. In other words, about 1.7 million people of color in the United States are currently Jews, have a familial or ethnic connection to Judaism, or an ancestral connection. At least 400,000 of these would be defined as currently Jewish, even by the most conservative sociologists, demographers, or other social scientists" ("Ethnic and Racial Diversity," http://www.jewishresearch.org/projects.htm [accessed November 19, 2004]).

2. Steve Pile and Nigel Thrift, "Mapping the Subject," in *Mapping the Subject: Geographies of Cultural Transformation,* ed. Steve Pile and Nigel Thrift (New York: Routledge, 1995), 47–48; cited in Silberstein, *Mapping Jewish Identities,* 5.

3. Cohen, *Beginnings of Jewishness,* 10.

4. Ibid., 3.

5. Ibid.

6. Itzkovitz, "Secret Temples," 180.

7. Silberstein, *Mapping Jewish Identities,* 31 n. 14: "In the 1950s, it was common for sociologists to speak of Jews as a religious group. By the 1970s, partly in response to the changes in American society and partly in response to the existence of large numbers of American Jews who self-identified as secular, sociologists increasing spoke of Jews as an ethnic group."

8. Jack Kugelmass, "Jewish Icons: Envisioning the Self in Images of the Other," in Boyarin and Boyarin, *Jews and Other Differences,* 44.

9. Chaim Potok, "Introduction," in David Cohen, *The Jews in America* (New York: Collins, 1989), 11; cited in Kugelmass, "Jewish Icons," 48–49.

10. Kugelmass, "Jewish Icons," 49.

11. For discussions, see Laura S. Levitt, "Photographing American Jews: Identifying American Jewish Life," in Silberstein, *Mapping Jewish Identities,* 65–96. The subject also emerged in Deborah Dash Moore, "Seeing Ourselves: Looking into a Photographic Mirror," a talk presented at "Imagining the American Jewish Community" conference, Jewish Theological Seminary of America, New York, March 21, 2004.

12. Sharon Strassfeld and Arthur Kurzweil, eds., *Behold a Great Image: The Contemporary Jewish Experience in Photographs* (Philadelphia: Jewish Publication Society of America, 1978), 6.

13. Roland Barthes, "The Great Family of Man," in *Mythologies,* trans. Annette Lavers (New York: Hill and Wang, 1997), 100–102. Steichen's exhibition has received intense critical attention in the last decade. Among other investigations, it has been the subject of a book-length study by Eric Sandeen, *Picturing an Exhibition: "The Family of Man" and 1950s America* (Albuquerque: University of New Mexico Press, 1995).

14. The book was the product of an amateur photography contest sponsored by a group of American Jewish *havurot* (religious fellowships). Its editors were members of a New York City–based *tzedakah* collective, a grassroots communal effort that independently raised funds and contributed to Jewish causes in the fields of culture, education, and the arts that it felt were neglected by more mainstream Jewish philanthropies, in particular the Jewish federations. Such collectives were founded in most other major United States cities with substantial Jewish populations, including Philadelphia, Boston, Washington, Los Angeles, and Cleveland. They were in most cases outgrowths of other counterculture movements of the period. See Strassfeld and Kurzweil, *Behold a Great Image,* 6.

15. See Kugelmass, "Jewish Icons," 31. Kugelmass discusses the assimilation of photographs of Hasidim into the visual iconography of American Jewish life. His essay is useful in looking at the work of Robbins and Becher discussed herein.

16. Katya Gibel Azoulay, *Black, Jewish, and Interracial: It's Not the Color of Your Skin But the Race of Your Kin, and Other Myths of Identity* (Durham, N.C.: Duke University Press, 1997), 79–80. Azoulay, for example, discusses both attitudes in the 1960s toward intermarriage and United States Jews' internalization of American racism.

17. See the following by Gary A. Tobin: *Opening the Gates: How Proactive Conversion Can Revitalize the Jewish Community* (San Francisco: Jossey-Bass, 1999); "The Case for Proactive Conversion," *Sh'ma* (October 1999): http://www.shma.com/oct99/1099art2.htm (accessed November 19, 2004); and "Do We Want to Be Who We Really Are?" *Interfaithfamily.com* (July 2003): http://interfaithfamily.com/article/issue114/tobin.phtml (accessed November 19, 2004).

18. See Azoulay, *Black, Jewish, and Interracial.* Also see Rebecca Walker, *Black, White, and Jewish: Autobiography of a Shifting Self* (New York: Riverhead Books, 2001); James McBride, *The Color of Water: A Black Man's Tribute to His White Mother* (New York: Riverhead Books, 1996); Jennifer Chau, "'Purina Dog Chow' and 'Chow Mein,'" in *What Are You? Voices of Mixed-Race Young People,* ed. Pearl Fuyo Gaskins (New York: Henry Holt, 1999), 152–56; and Patricia Lin, "Race, Culture, and Gender and the Asian American Jewish Experience," paper presented at the Asian Pacific Americans and Religion Research Initiative annual conference, April 2004. See also the important articles in the special "Writing and Art by Jewish Women of Color" issue of *Bridges* 9, no. 1 (summer 2001).

19. Jane Lazarre, *Beyond the Whiteness of Whiteness: Memoir of a White Mother of Black Sons* (Durham, N.C.: Duke University Press, 1996), 49.

20. Ibid., 25, 57.

21. Katya Gibel Azoulay, "Jewishness after Mount Sinai: Jews, Blacks, and the (Multi)racial Category," *Bridges* 9, no. 1 (summer 2001): 31. See also Karen Brodkin, *How Jews Became White Folks and What That Says about Race in America* (New Brunswick, N.J.: Rutgers University Press, 1998).

22. Ilan Stavans, *On Borrowed Words: A Memoir of Language* (New York: Viking, 2001), 22–23.

23. For historical discussions of this model of physical adaptability of Jews in different cultures, and particularly in the United States, see Sander L. Gilman, "The Jew's Body: Thoughts on Jewish Physical Difference," in *Too Jewish? Challenging Traditional Identities,* ed. Norman

L. Kleeblatt (New York: The Jewish Museum; New Brunswick, N.J.: Rutgers University Press, 1996), 69; see also Azoulay, *Black, Jewish, and Interracial,* 67.

24. Sephardi-Ashkenazi marriages in colonial America—as well as in countries south of the border in our own time—were considered interracial and frowned upon. See Howard M. Sachar, *A History of the Jews in America* (New York: Vintage Books, 1993), 33; and Stavans, *On Borrowed Words,* 117.

25. Levitt, "Photographing American Jews," 77.

26. Ibid., 78. Levitt quotes Janet Jakobsen, *Working Alliances and the Politics of Difference* (Bloomington: Indiana University Press, 1997), 9–10.

27. There are a number of Hebrew Israelite (also known as Ethiopian Hebrew) congregations in the United States. For detailed accounts of the histories and current activities of two of these, see http://members.aol.com/Blackjews/beth1.html and http://www.bethshalombz.org/bs_history.html (accessed November 19, 2004), Websites of the Beth Elohim Hebrew Congregation in St. Albans, Queens, N.Y., and Beth Shalom B'nai Zaken Ethiopian Hebrew Congregation (Beth Shalom) in Chicago, respectively. The history of the relationship of the Hebrew Israelite community to the mainstream American Jewish community is complex and beyond the scope of this essay. For additional background, also see Yvonne Chireau and Nathaniel Deutsch, eds., *Black Zion: African American Religious Encounters with Judaism* (New York: Oxford University Press, 2000).

28. The exhibition originated at the McKissick Museum at the University of South Carolina (January 13–May 19, 2002) and traveled to Yeshiva University Museum in New York (February 6–July 20, 2003). Aron's image was also published in a collection of his photographs, *Shalom Y'All* (Chapel Hill: Algonquin Books of Chapel Hill, 2002).

29. Greenberg was attracted to Judaism in the early 1960s when he was involved in the civil rights movement in San Francisco. See Bernard J. Wolfson, "African American Jews: Dispelling Myths, Bridging the Divide," in Chireau and Deutsch, *Black Zion,* 38. See also Reuben Greenberg, *Let's Take Back Our Streets* (Chicago: Contemporary Books, 1989).

30. Kugelmass, "Jewish Icons," 37.

31. Mark Seliger and Lenny Kravitz, *Lenny Kravitz* (Santa Fe, N.M.: Arena Editions, 2001).

32. Kravitz's father, who is white and Jewish, was a television producer. Kravitz's late mother—to whom the book is dedicated—was Roxie Roker, who played Helen Willis, a black woman married to a white man in the television series *The Jeffersons.* Her photograph graces the dedication page. Kravitz is reportedly at work on an autobiographical film in which he will also star, *Barbecues and Bar Mitzvahs.* "It's about someone in my particular position growing up between two cultures. It's like *Annie Hall* or *Manhattan,*" he told Music Television Network (MTV) News. What other narrative could we possibly expect? See "Lenny Kravitz to Star in *Barbecue and Bar Mitzvahs,*" *MTVNews.com* (April 21, 2004):

http://www.mtv.com/news/articles/1486476/04202004/kravitz_lenny.jhtml (accessed November 19, 2004).

33. Ibid.

34. Seliger and Kravitz, *Lenny Kravitz,* unpaginated.

35. Paul Gilroy, "Diasporas and the Detours of Identity," in *Identity and Difference,* ed. Kathryn Woodward (Thousand Oaks, Calif.: Sage, 1997), 301; cited in Silberstein, *Mapping Jewish Identities,* 1.

36. Stuart Hall, "Cultural Identity and Diaspora," in *Identity: Community, Culture, Difference,* ed. J. Rutherford (London: Lawrence and Wishart, 1990), 221; cited in Silberstein, *Mapping Jewish Identities,* 3.

37. Silberstein, *Mapping Jewish Identities,* 3. Silberstein also cites Stuart Hall, "Who Needs Identity?" in *Questions of Cultural Identity,* ed. Stuart Hall and Paul du Gay (Thousand Oaks, Calif.: Sage, 1996), 4.

38. I would like to acknowledge the thoughtful input of Joanne Rizzi and Nicholas Mirzoeff in formulating these questions during a meeting at The Jewish Museum, December 10, 2003.

39. For further discussion of Jews and racial identities in the United States, see the following in *Bridges* 9, no. 1 (summer 2001): Shahanna McKinney, "Writing and Art by Jewish Women of Color: Introduction," 4–7; and Azoulay, "Jewishness after Mount Sinai," 31–45. McKinney's essay also addresses how the use of the term *Jews of color* can give people a chance "to think critically with other people about white identity among Jews in the United States and in other places" (5). A government directive in 1997 allowing for "multiple checkoffs on government forms that ask for racial/ethnic information," most notably the United States Census, has been understood as putting an end to the "one-drop rule" that had effectively "prevented the acknowledgement of people of multiracial parentage" ("Census 2000," http://www.ameasite.org/census [accessed November 19, 2004]). However, such categories as "European Jewish" or "Sephardi Jewish" are not available as racial or ethnic categories. Unlike in Canada, Jews in the United States cannot choose Jewish as an ethnic category (Azoulay, "Jewishness after Mount Sinai," 39).

40. The phrase is from Brodkin, *How Jews Became White Folks.* See also Maurice Berger, *White Lies: Race and the Myths of Whiteness* (New York: Farrar, Straus, and Giroux, 1999); Maurice Berger, *White: Whiteness and Race in Contemporary Art* (Baltimore: University of Maryland, Baltimore County, Center for Art and Visual Culture, 2003); Matthew Frye Jacobson, *Whiteness of a Different Color: European Immigrants and the Alchemy of Race and Culture* (Cambridge, Mass.: Harvard University Press, 1998); Jon Stratton, *Coming Out Jewish: Constructing Ambivalent Identities* (New York: Routledge, 2000); and the following essays in *Names We Call Home: Autobiography on Racial Identity,* ed. Becky Thompson and Sangeeta Tyagi (New York: Routledge, 1996): Ruth Frankenberg, "'When We Are Capable of Stopping, We Begin to See': Being White, Seeing Whiteness," 3–17; David Wellman, "Red and

Black in White America: Discovering Cross-Border Identities and Other Subversive Activities," 29–41; Melanie Kaye/Kantrowitz, "Jews in the U.S.: The Rising Costs of Whiteness," 121–37; and Pam Mitchell, "My Dear Niece," 155–69.

41. Gilman, "The Jew's Body"; see also Brodkin, *How Jews Became White Folks,* chapter 1.

42. When there is discussion of "microdiversity" vis-à-vis American Jews it is usually limited to the subject of religious diversity on a scale ranging from secular to Orthodox. See also Laurie Shrage, "Ethnic Transgressions: Confessions of an Assimilated Jew," in *American Mixed Race: The Culture of Microdiversity,* ed. Naomi Zack (Lanham, Md.: Rowman and Littlefield, 1995), 287–307.

43. Dawoud Bey, cited in Kellie Jones, "Dawoud Bey: Portraits in the Theater of Desire," in *Dawoud Bey: Portraits 1975–1995* (Minneapolis: Walker Art Center, 1995), 48.

44. Chris Verene, proposal to The Jewish Museum, February 2002, museum files.

45. *American Gothic,* American Art, Collections, Art Institute of Chicago, http://www.artic.edu/aic/collections/amer/73pc_wood.html (accessed November 19, 2004).

46. E-mail to the author, summer 2004.

47. A wide array of scholars and community leaders from diverse backgrounds were interviewed for the film, although they may not all appear in the final edited cut. Among them: Gary A. Tobin, of white European descent, who is President of The Institute for Jewish and Community Research and the adoptive father of an African American son; Lewis Gordon, a Jamaican who is Jewish through his mother—a Solomon whose ancestors emigrated from Jerusalem to the West Indies in the nineteenth century—and professor and chair of the Department of Africana Studies at Brown University; Rabbi Capers Funnye of Chicago, spiritual leader of Beth Shalom B'nai Zaken Ethiopian Hebrew Congregation, who works to fight racism within the Jewish community and black anti-Semitism without; Shahanna McKinney of Milwaukee, a biracial Jew of East European, Native American, and African American descent, raised Orthodox, and an educator and curator who focuses largely on Jewish multicultural coalition building in the Midwest; Rabbi Rigoberto Emmanuel Viñas, founder of El Centro de Estudios Judíos Torat Emet, whose efforts to bring together two diverse communities—Latino Jews mainly from the Bronx and Ashkenazi Jews in Yonkers—into a united congregation is the subject of Jaime Permuth's photographic project in the last section of this exhibition; Rabbi and Cantor Angela Warnick Buchdahl, the first Asian American to be ordained as a rabbi (May 2001) or invested as a cantor (May 1999) by Hebrew Union College; and Davi Cheng, a convert and president of the Los Angeles Beth Chayim Chadashim Synagogue, who speaks about how her community sees her as a role model for the wave of families who have adopted girls from China.

48. Shari Rothfarb Mekonen and Avishai Mekonen, "Beyond Blood: Judaism and Race in America—

A Documentary," undated proposal submitted to The Jewish Museum, December 2004, p. 2, museum files.

49. Ibid., 1.

50. Silberstein, *Mapping Jewish Identities*, 18.

51. David Biale, Michael Galchinsky, and Susannah Heschel, eds., *Insider/Outsider: American Jews and Multiculturalism* (Berkeley and Los Angeles: University of California Press, 1998), 9. They also cite Arnold Eisen, *Galut: Modern Jewish Reflection on Homelessness and Homecoming* (Bloomington: Indiana University Press, 1986), as well as Paul Gilroy, *The Black Atlantic: Modernity and Double Consciousness* (Cambridge, Mass.: Harvard University Press, 1993), the latter for its discussion of issues of home and homeland for African Americans and its comparison between African Americans and Jews (13 nn. 20, 21). See also Stratton, *Coming Out Jewish.*

52. For more on this notion of American Jewish intellectuals' assertion of American exceptionalism, as well as its relationship to postcolonial discourse of diaspora, see Michael Galchinsky, "Scattered Seeds: A Dialogue of Diasporas," in Biale, Galchinsky, and Heschel, *Insider/Outsider,* 185–211.

53. Kerry P. Steinberg, for example, explores the subject in "Photography, Philanthropy and the Politics of American Jewish Identity," Ph.D. diss., University of California, Los Angeles, 1998.

54. One important goal of the Jewish Multicultural Curriculum Project has been to teach children about the diversity of Jewish communities around the world and throughout history. This is considered the underpinning of understanding the origins of today's multicultural American Jews. In this regard one should be cautious about not fixing such Diaspora communities in time and space and acknowledging the ongoing migrations that constantly shape and reshape Jewish communities.

55. See also note 41, above. The work of numerous nonprofit and grassroots organizations in providing support networks and advocating and educating both Jews and non-Jews about Jews of color should also be acknowledged, among them: Ayecha Resource Organization, Be'chol Lashon, *Bridges: A Journal for Jewish Feminists and Our Friends,* Interfaith Family, Jewish Family and Life, Jewish Multicultural Curriculum Project, Jewish Multiracial Network, Kulanu, Moreshet Network, Swirl, Inc., Yachad b'Shalom, and others. Multicultural programming has also been offered by the Jewish Community Center Manhattan and the Makor/Steinhardt Center in New York City.

56. David Theo Goldberg and Michael Krausz, "Introduction: The Culture of Identity," in *Jewish Identity,* ed. David Theo Goldberg and Michael Krausz (Philadelphia: Temple University Press, 1993), 12; and Gabriel Josipovici, "Going and Resting," in Goldberg and Krausz, *Jewish Identity,* 309–21.

57. See Silberstein, *Mapping Jewish Identities, 25.* Alcalay "suggests the need for new discourses if we are to grasp the complexities of contemporary individual and collective identity construction. . . . Traversing spaces and transgressing bound-

aries and 'natural' divisions, Alcalay suggests that a new discourse of identity is required, one that privileges multiplicity, spaces, and becoming over unity, time, and being." See also Amiel Alcalay, "Weighing the Losses, Like Stones in Your Hand," in Silberstein, *Mapping Jewish Identities,* 250–65.

58. Other artists have incorporated Holocaust testimony into their works in a variety of ways, though Ganahl's position as an Austrian interviewing a Jew distinguishes his work from most of these. See Dora Apel, "Appropriating the Testimonial Form," in *Memory Effects: The Holocaust and the Art of Secondary Witnessing* (New Brunswick, N.J.: Rutgers University Press, 2002), 92–107. See also Lawrence Langer, *Holocaust Testimonies: The Ruins of Memory* (New Haven, Conn.: Yale University Press, 1991); Geoffrey Hartman, "Tele-Suffering and Testimony in the Dot Com Era," in *Visual Culture and the Holocaust,* ed. Barbie Zelizer (New Brunswick, N.J.: Rutgers University Press, 2001), 111–24; and James E. Young, "Holocaust Video and Cinemagraphic Testimony: Documenting the Witness," in *Writing and Rewriting the Holocaust: Narrative and the Consequences of Interpretation* (Bloomington and Indianapolis: Indiana University Press, 1990), 157–71.

59. Nikolas Rose, *Inventing Ourselves: Psychology, Power, and Personhood* (New York: Cambridge University Press, 1996), 180; cited in Silberstein, *Mapping Jewish Identities,* 4.

60. Mihaly Csikszentmihalyi and Eugene Rochberg-Halton, *The Meaning of Things: Domestic Symbols and the Self* (New York: Cambridge University Press, 1989), 94; cited in Kugelmass, "Jewish Icons," 45–46.

61. Irit Rogoff, "Daughters of Sunshine: Diasporic Impulses and Gendered Identities," in *With Other Eyes: Looking at Race and Gender in Visual Culture,* ed. Lisa Bloom (Minneapolis: University of Minnesota Press, 1999), 157. Rogoff writes about European Israeli feminine identity and its visual representations. In Zionist photography, "the images of European women are equally conscripted into the fervor to produce and represent that elusive concept of belonging, mapped onto modern European bodies. At the same time they also act out a certain diasporic dissonance, a diasporic desire for a much hankered-after, yet unachievable state of belonging that is written in their bodies and gestures, in the veiling and performing of their sexuality, in their physically embodied challenge to the indigenous bodies around them" (158). See also Irit Rogoff, *Terra Infirma: Geography's Visual Culture* (New York: Routledge, 2000).

62. Rogoff, "Daughters of Sunshine," 163.

63. E-mail from Jessica Shokrian to Joanna Lindenbaum, December 9, 2004, The Jewish Museum files.

64. Ibid.

65. The plant was originally opened by Aaron Rubashkin and is operated by his sons. It employs both Jews and non-Jews.

66. See Kugelmass, "Jewish Icons," 50, for more on the idea of the Hasids as "others" in opposition to whom mainstream Jews define themselves and as "a bulwark against the seemingly relentless

process of assimilation and cultural attenuation." Robbins and Becher have themselves pondered the idea that "after three generations of secularism, perhaps Hasids will be the majority Jewish population in the United States by the time our children are adults, and perhaps middle American towns like Postville will not conjure up old-time farmer types, but Hasidic families and businesses, like those whose images are now nearly synonymous with Williamsburg, Brooklyn" (proposal to The Jewish Museum, March 2004, museum files).

67. Kugelmass, "Jewish Icons," 41.

68. Patricia C. Albers and William R. James, "Travel Photography: A Methodological Approach," *Annals of Tourism Research* 15 (1988): 134–58, as discussed ibid., 39–40.

69. Anthony D. Smith, *The Ethnic Revival* (Cambridge, U.K.: Cambridge University Press, 1981), 66; cited in Cohen, *Beginnings of Jewishness,* 7.

70. Cohen, *Beginnings of Jewishness,* 7–8.

71. *Ger,* "stranger" in Hebrew, is also the word used for a convert. The conversion ceremony has ancient roots in rabbinic literature, specifically, as depicted in the Babylonian Talmud and later, in the post-Talmudic tractate, *Gerim.* See Cohen, "The Rabbinic Conversion Ceremony," ibid., 198–238. As Cohen states in his introduction: "The point of the ceremony is to provide a means for society to verify that the formal requirements for conversion (as established by the rabbis) have been met. By accepting the people of Israel and the commandments of the Torah a gentile could become a Jew ('Israelite' in rabbinic terminology). The precision that the rabbis introduced, or attempted to introduce, into the definition of conversion contrasted with the social reality of the preceding centuries, and perhaps of their own period as well."

72. For example, a painting of the *Brit Milah* ceremony (with the title *The Child Enters the Covenant*) is the first of the life-cycle events depicted in Moritz Oppenheim's nineteenth-century *Bilder aus dem altjüdischen Familienleben* (*Scenes from Traditional Jewish Family Life*), a number of which are in the collection of The Jewish Museum. In fact, Oppenheim's painting cycle may be the urtext of depictions of Jews by Jews that focus on holiday and life-cycle events. Begun in the 1830s, Oppenheim's anachronistic renderings fixed German Jewish cultural and religious identity on the cusp of Emancipation. His nostalgic renderings became the site of an essential, idealized, and timeless Jewish identity, although one in tension with the new challenges of modernity. Instead of seeing Jewishness as a process of becoming, Oppenheim's cycle fixed Jewish identity as a state of being. Yet as we know, Oppenheim's frozen moments (perhaps even pastiches of moments) are historically and locally determined, particular to German Jews of c. 1800. See Ismar Schorsch, "Art as Social History: Oppenheim and the German Jewish Vision of Emancipation," in *Moritz Oppenheim: The First Jewish Painter* (Jerusalem: The Israel Museum, 1983); and Georg Heuberger and Anton Merk, eds., *Moritz Daniel Oppenheim: Jewish Identity in Nineteenth-Century Art* (Cologne, Germany: Wienand Verlag and the Frankfurt Jewish Museum, 2000).

73. According to the artist, the group's "multi-layered hyphenated identity can be clearly seen in their journal called 'CommuniKEN,' a word constructed with 3 different languages (Spanish, English, and Hebrew). This title refers to: 'Comuniquen' which is the imperative form of the verb 'to communicate' in Spanish; to 'community' in English and 'Ken' which in Hebrew means 'nest.' This hybridity/pastiche of languages and cultures can also be seen in the contents of the journal itself. The cover has writing in Spanish, in English and in Hebrew (both in Hebrew and roman alphabets) and most articles are written in a combination of these three languages" (Yoshua Okon, proposal to The Jewish Museum, November 2004, museum files).

74. Ibid.

75. Tirtza Even and Brian Karl, proposal to The Jewish Museum, May 2004, museum files.

76. See, for example, David Efron, "Gesture, Race, and Culture: A Tentative Study of the Spatiotemporal and 'Linguistic' Aspects of the Gestural Behavior of Eastern Jews and Southern Italians in New York City, Living under Similar as Well as Different Environmental Conditions," in Approaches to Semiotics 9 (The Hague: Mouton, 1972; originally published 1941). This particular work was a defensive response to the racist and anti-Semitic "pseudoscientific" studies published throughout the early twentieth century by German anthropologists who negatively linked the propensity for gesture to inferior character and "race."

77. "'Anti-Semitism Is Anti-Me' Campaign Hits the Streets," press release, July 12, 2004, http://adl.org/PresRele/DiRaB_41/4532_41.htm (accessed November 19, 2004). According to their Website: "The Anti-Defamation League, founded in 1913, is the world's leading organization fighting anti-Semitism through programs and services that counteract hatred, prejudice and bigotry." Its slogan is "To stop the defamation of the Jewish people . . . to secure justice and fair treatment to all." I am indebted to Fred Wasserman for drawing my attention to one of these posters on 93rd Street and Madison Avenue during the summer of 2004.

78. Cohen, Beginnings of Jewishness, 10.

79. Silberstein, Mapping Jewish Identities, 1–2.

80. Egon Mayer, Barry Kosmin, and Ariela Keysar, "American Jewish Identity Survey" (New York: Graduate Center, City University of New York, 2001; reprinted by the Center for Cultural Judaism, New York, 2003), 32. The quotation continues: "Recent studies by Bethamie Horowitz (Connections and Journeys) and by Steven Cohen and Arnie Eisen (The Jew Within) have begun to come to grips with the growing anomalies of the concept. These studies have had to make sense of increasingly lumpy data, which suggest that people lay claim to Jewish ideas, images, experiences and even institutional affiliation and participation in often highly idiosyncratic patterns that defy the kind of linear or holistic interpretation that the concept of 'Jewish identity' would imply."

ILAN STAVANS, OY, ARE WE A *PLURIBUS*?

1. Philip Levine, "The Sweetness of Bobby Hefka," in What Work Is (New York: Alfred A. Knopf, 1991), 56.

2. Adrienne Rich, "Yom Kippur 1984," in Your Native Land, Your Life (New York: W. W. Norton, 1986), 34.

3. See Sander L. Gilman, The Jew's Body (New York: Routledge, 1991), and Jewish Frontiers: Essays on Bodies, Histories, and Identities (New York: Palgrave Macmillan, 2003). See also his Creating Beauty to Cure the Soul: Race and Psychology in the Shaping of Aesthetic Surgery (Durham, N.C.: Duke University Press, 1998).

4. Some useful sources on Jews and multiculturalism are Laurence J. Silberstein, ed., Mapping Jewish Identities (New York: New York University Press, 2000); Jon Stratton, Coming Out Jewish: Constructing Ambivalent Identities (New York: Routledge, 2000), which contains an entire chapter on Seinfeld; Daniel Biale, Michael Galchinsky, and Susannah Heschel, eds., Insider/Outsider: American Jews and Multiculturalism (Berkeley and Los Angeles: University of California Press, 1998); Jonathan Boyarin and Daniel Boyarin, eds., Jews and Other Differences: The New Jewish Cultural Studies (Minneapolis: University of Minnesota Press, 1997); Marla Brettschneider, ed., The Narrow Bridge: Jewish Views on Multiculturalism (New Brunswick, N.J.: Rutgers University Press, 1996); David Theo Goldberg, ed., Multiculturalism: A Critical Reader (Oxford: Blackwell, 1994); Norman L. Kleeblatt, ed., Too Jewish? Challenging Traditional Identities (New York: The Jewish Museum; New Brunswick, N.J.: Rutgers University Press, 1996); Naomi Zack, ed., American Mixed Race: The Culture of Microdiversity (Lanham, Md.: Rowman and Littlefield, 1995); Laurence J. Silberstein and Robert L. Cohn, eds., The Other in Jewish Thought and History: Constructions of Jewish Culture and Identity (New York: New York University Press, 1994); and David Theo Goldberg and Michael Krausz, eds., Jewish Identity (Philadelphia: Temple University Press, 1993).

5. See Joseph L. Blau and Salo W. Baron, eds., The Jews of the United States: A Documentary History, 1790–1840 (New York: Columbia University Press, 1963).

6. See Isaiah Berlin, Three Critics of the Enlightenment: Vico, Hamann, Herder, ed. Henry Hardy (Princeton, N.J.: Princeton University Press, 2000). Especially important is Berlin's posthumous anthology The Proper Study of Mankind, ed. Henry Hardy and Roger Hausheer (New York: Farrar, Straus, and Giroux, 1998). On a less political, more philosophical plane, I also recommend Emmanuel Levinas's Difficult Freedom, trans. Seán Hand (Baltimore: Johns Hopkins University Press, 1990).

7. See Jack J. Diamond, "A Reader in Demography," American Jewish Year Book 77 (1977): 251–319; 91 (1991): 209; 92 (1992): 143; 102 (2002): 255 and 615. The 5.34 million "core" Jewish population includes those "who regard themselves as Jewish by religion or say they are of Jewish parentage or upbringing but have no religion." The 7.7 number includes those "who are either currently Jewish or of Jewish origins." Data from Egon Mayer, Barry Kosmin, and Ariela Keysar, American Jewish Identity Survey 2001, AJIS Report: An Exploration in the Demography and Outlook of a People (New York: Center for Cultural Judaism, 2003), 6. See also Gary A. Tobin and Sid Groeneman, Surveying the Jewish Population in the United States (Part 1: Population Estimate; Part 2: Methodological Issues and Challenges) (San Francisco: Institute for Jewish and Community Research, 2004).

8. Jonathan D. Sarna, American Judaism: A History (New Haven, Conn.: Yale University Press, 2004).

9. Reprinted in Ilan Stavans, ed., The Schocken Book of Modern Sephardic Literature (New York: Schocken Books, 2005), 27–28.

10. Jules Chametzky et al., eds., Jewish American Literature (New York: W. W. Norton, 2001), 194.

11. I've meditated on the topic, from an autobiographical perspective, in On Borrowed Words: A Memoir of Language (New York: Viking, 2001).

12. See Adina Cimet, Ashkenazi Jews in Mexico: Ideologies in the Structuring of a Community (Albany: State University of New York Press, 1997).

13. The demographic information in this paragraph and the one above comes from American Jewish Year Book (2002), quoted by Sarna, American Judaism, 358–59.

14. Martin A. Cohen, The Martyr: Luis de Carvajal, A Secret Jew in Seventeenth-Century Mexico (Albuquerque: University of New Mexico Press, 2003). See also Ilan Stavans, ed., The Cross and the Scroll: One Thousand Years of Jewish-Hispanic Literature (New York: Routledge, 2003).

15. An impressionistic study on this topic is Harriet and Fred Rochlin's Pioneer Jews: A New Life in the Far West (Boston: Houghton Mifflin, 2000).

16. All three jokes from Chametzky, Jewish American Literature, 323–24.

17. Leo Rosten, The Joys of Yiddish (New York: Penguin Books, 1968), 19–20.

18. The National Jewish Population Survey, 2000–2001 (A United Jewish Communities Report in Cooperation with the Mandell L. Berman Institute-North American Jewish Data Bank) (September 2003), 16.

19. See, for instance, Larry Tye's Home Lands: Portraits of the New Jewish Diaspora (New York: Henry Holt, 2001), as well as Frédéric Brenner's Diaspora: Homelands in Exile (New York: HarperCollins, 2003).

20. Some provocative readings on Jewish identity are to be found in Names We Call Home: Autobiography on Racial Identity, ed. Becky Thompson and Sangeeta Tyagi (New York: Routledge, 1996). In particular, see Ruth Frankenberg, "'When We Are Capable of Stopping, We Begin to See': Being White, Seeing Whiteness," 3–17; David Wellman, "Red and Black in White America: Discovering Cross-Border Identities and Other Subversive

Activities," 29–41; Melanie Kaye/Kantrowitz, "Jews in the U.S.: The Rising Costs of Whiteness," 121–37; and Pam Mitchell, "My Dear Niece," 155–69.

21. Betty Friedan, *The Feminine Mystique* (New York: W. W. Norton, 1963), 96.

22. Aside from the standard works by Betty Friedan and Germane Greer, see Andrea Dworkin, *Scapegoat: The Jews, Israel, and Women's Liberation* (New York: Free Press, 2000).

23. See Daniel Boyarin, Daniel Itzkovitz, and Ann Pellegrini, eds., *Queer Theory and the Jewish Question* (New York: Columbia University Press, 2003). See also Lev Raphael, *Journeys and Arrivals: On Being Gay and Jewish* (Boston: Faber and Faber, 1996).

24. Although it almost exclusively focuses on religion, a valuable panoramic view of the sociological changes affecting the American Jewish community for 350 years is Sarna, *American Judaism*.

25. The threat to the power of the white majority has generated much debate. Samuel Huntington's *Who Are We? The Challenges to America's Identity* (New York: Simon and Schuster, 2004) takes a xenophobic perspective, decrying the end of the United States as we know it, in large part thanks to the explosive growth of the Mexican American community and its resistance to assimilating. Also see the schematically argued volume by Michael Barone, *The New Americans: How the Melting Pot Can Work Again* (New York: Regnery, 2001). A more thoughtful, incisive meditation is Michael Walzer's *On Toleration* (New Haven, Conn.: Yale University Press, 1997).

26. See http://www.hiflenberg.com/kesher (accessed December 14, 2004).

27. See Jonathan Kaufman, *Broken Alliance: The Turbulent Times between Blacks and Jews in America* (New York: Scribner, 1988); and Paul Berman, ed., *Blacks and Jews: Alliances and Arguments* (New York: Delacorte, 1994).

28. See James E. Young, *The Texture of Memory: Holocaust Memorials and Meaning* (New Haven, Conn.: Yale University Press, 1993). See also David Biale, ed., *Cultures of the Jews: A New History* (New York: Schocken Books, 2002).

JOANNA LINDENBAUM, COMMISSIONS AND COLLABORATION

1. I interviewed each of the artists via e-mail, except for Nikki S. Lee, whom I interviewed in person. Shari Rothfarb Mekonen and Avishai Mekonen were already at work on their documentary when they were asked to edit a segment of it for inclusion in the museum's exhibition.

Selected Bibliography

BOOKS AND DISSERTATIONS

Aciman, André, ed. *Letters of Transit: Reflections on Exile, Identity, Language, and Loss.* New York: The New Press, 2000.

Anderson, Benedict. *Imagined Communities: Reflections on the Origin and Spread of Nationalism.* Revised Edition. London: Verso, 1991.

Azoulay, Katya Gibel. *Black, Jewish, and Interracial: It's Not the Color of Your Skin, but the Race of Your Kin, and Other Myths of Identity.* Durham, N.C.: Duke University Press, 1997.

Bal, Mieke. *Double Exposures: The Subject of Cultural Analysis.* New York: Routledge, 1996.

Bal, Mieke, and Leo Spitzer, eds. *Acts of Memory.* Hanover, N.H.: Dartmouth College; University Press of New England, 1999.

Behar, Ruth. *The Vulnerable Observer: Anthropology That Breaks Your Heart.* Boston: Beacon Press, 1996.

Bennett, David. *Multicultural States: Rethinking Difference and Identity.* New York: Routledge, 1998.

Ben-Ur, Aviva. *Where Diasporas Met: Sephardic and Ashkenazic Jews in the City of New York: A Study in Intra-Ethnic Relations, 1880–1950.* Ph.D. dissertation, Brandeis University, 1998.

Berger, Maurice. *White Lies: Race and the Myths of Whiteness.* New York: Farrar, Straus, and Giroux, 1999.

Biale, David, ed. *Cultures of the Jews: A New History.* New York: Schocken Books, 2002.

Biale, David, Michael Galchinsky, and Susannah Heschel, eds. *Insider/Outsider: American Jews and Multiculturalism.* Berkeley and Los Angeles: University of California Press, 1998.

Boyarin, Daniel, Daniel Itzkovitz, and Ann Pellegrini, eds. *Queer Theory and the Jewish Question.* New York: Columbia University Press, 2003.

Boyarin, Jonathan, and Daniel Boyarin, eds. *Jews and Other Differences: The New Jewish Cultural Studies.* Minneapolis: University of Minnesota Press, 1997.

Brenner, Frédéric. *Diaspora: Homelands in Exile.* New York: HarperCollins, 2003.

———. *Jews, America: A Representation.* New York: Harry N. Abrams, 1996.

Brettschneider, Marla, ed. *The Narrow Bridge: Jewish Views on Multiculturalism.* New Brunswick, N.J.: Rutgers University Press, 1996.

Bridwell-Bowles, Lillian. *Identity Matters: Rhetorics of Difference.* Upper Saddle River, N.J.: Prentice-Hall, 1998.

Brodkin, Karen. *How Jews Became White Folks and What That Says about Race in America.* New Brunswick, N.J.: Rutgers University Press, 1998.

Chen, Kuan-Hsing. *Stuart Hall: Critical Dialogues.* New York: Routledge, 1996.

Chireau, Yvonne, and Nathaniel Deutsch, eds. *Black Zion: African American Religious Encounters with Judaism.* New York: Oxford University Press, 2000.

Cimet, Adina. *Ashkenazi Jews in Mexico: Ideologies in the Structuring of a Community.* Albany: State University of New York Press, 1997.

Cohen, David. *The Jews in America.* New York: Collins, 1989.

Cohen, Shaye. *The Beginnings of Jewishness: Boundaries, Varieties, Uncertainties.* Berkeley and Los Angeles: University of California Press, 1999.

Cohen, Steven M., and Arnold M. Eisen. *The Jew Within: Self, Family, and Community in America.* Bloomington: Indiana University Press, 2000.

Dubner, Stephen J. *Turbulent Souls: A Catholic Son's Return to His Jewish Family.* New York: Avon Books, 1998.

Eisen, Arnold. *Galut: Modern Jewish Reflections on Homelessness and Homecoming.* Bloomington: Indiana University Press, 1986.

Essed, Philomena, and David Theo Goldberg, eds. *Race Critical Theories: Text and Context.* Malden, Mass.: Blackwell, 2002.

Evans, Jessica, and Stuart Hall, eds. *Visual Culture: The Reader.* Thousand Oaks, Calif.: Sage, 2000.

Gilman, Sander L. *Jewish Frontiers: Essays on Bodies, Histories, and Identities.* New York: Palgrave Macmillan, 2003.

———. *The Jew's Body.* New York: Routledge, 1991.

Gilroy, Paul. *The Black Atlantic: Modernity and Double Consciousness.* Cambridge, Mass.: Harvard University Press, 1993.

Goldberg, David Theo. *The Anatomy of Racism.* Minneapolis: University of Minnesota Press, 1990.

———. *The Racial State.* Malden, Mass.: Blackwell, 2002.

———. *Racial Subjects: Writing on Race in America.* New York: Routledge, 1997.

———. *Racist Culture: Philosophy and the Politics of Meaning.* Oxford: Blackwell, 1993.

———, ed. *Multiculturalism: A Critical Reader.* Oxford: Blackwell, 1994.

Goldberg, David Theo, and Ato Quayson. *Relocating Postcolonialism: A Critical Reader.* Oxford: Blackwell, 2002.

Goldberg, David Theo, and Michael Krausz, eds. *Jewish Identity.* Philadelphia: Temple University Press, 1993.

Gordon, Avery F., and Christopher Newfield, eds. *Mapping Multiculturalism.* Minneapolis: University of Minnesota Press, 1996.

Greenberg, Reuben. *Let's Take Back Our Streets.* Chicago: Contemporary Books, 1989.

Hall, Stuart, and Paul du Gay, eds. *Questions of Cultural Identity.* Thousand Oaks, Calif.: Sage, 1996.

Hirsch, Marianne. *Family Frames: Photography, Narrative, and Postmemory.* Cambridge, Mass.: Harvard University Press, 1997.

———, ed. *The Familial Gaze.* Hanover, N.H.: University Press of New England, 1999.

Jacobson, Matthew Frye. *Whiteness of a Different Color: European Immigrants and the Alchemy of Race and Culture.* Cambridge, Mass.: Harvard University Press, 1998.

Jacoby, Susan. *Half-Jew: A Daughter's Search for Her Family's Buried Past.* New York: Scribner, 2000.

Karp, Ivan. *Exhibiting Cultures.* Washington, D.C.: Smithsonian Institution Press, 1991.

Kaye/Kantrowitz, Melanie. *The Issue Is Power: Essays on Women, Jews, Violence, and Resistance.* San Francisco: Aunt Lute Books, 1992.

Khazzoom, Loolwa. *The Flying Camel: Essays on Identity by Women of North African and Middle Eastern Jewish Heritage.* New York: Seal Press, 2003.

Landing, James E. *Black Judaism: Story of an American Movement.* Durham, N.C.: Carolina Academic Press, 2002.

Lazarre, Jane. *Beyond the Whiteness of Whiteness: Memoir of a White Mother of Black Sons.* Durham, N.C.: Duke University Press, 1996.

Lester, Julius. *Lovesong: Becoming a Jew*. New York: Arcade, 1988.

Mayer, Egon, Barry Kosmin, and Ariela Keysar. *American Jewish Identity Survey* (2001). Reprint. New York: Center for Cultural Judaism, 2003.

McBride, James. *The Color of Water: A Black Man's Tribute to His White Mother*. New York: Riverhead Books, 1996.

McClintock, Anne A., Amir Mufti, and Ella Shohat, eds. *Dangerous Liaisons: Gender, Nation, and Postcolonial Perspectives*. Minneapolis: University of Minnesota Press, 1997.

Mirzoeff, Nicholas. *Diaspora and Visual Culture: Representing Africans and Jews*. New York: Routledge, 1999.

———. *Introduction to Visual Culture*. New York: Routledge, 1999.

———. *The Visual Culture Reader*. New York: Routledge, 1998.

Montagu, Ashley. *Man's Most Dangerous Myth: The Fallacy of Race*. Sixth Edition. Abridged student edition. Walnut Creek, Calif.: AltaMira Press, 1997.

The National Jewish Population Survey, 2000–2001 (A United Jewish Communities Report in Cooperation with the Mandell L. Berman Institute–North American Jewish Data Bank) (September 2003).

Pile, Steve, and Nigel Thrift, eds. *Mapping the Subject: Geographies of Cultural Transformation*. New York: Routledge, 1995.

Primack, Karen, ed. *Under One Canopy: Readings on Jewish Diversity*. Silver Spring, Md.: Kulanu, 2003.

Raphael, Lev. *Journeys and Arrivals: On Being Gay and Jewish*. Boston: Faber and Faber, 1996.

Rogoff, Irit. *Terra Infirma: Geography's Visual Culture*. New York: Routledge, 2000.

Rose, Nikolas. *Inventing Ourselves: Psychology, Power, and Personhood*. New York: Cambridge University Press, 1996.

Ross, James R. *Fragile Branches: Travels through the Jewish Diaspora*. New York: Riverhead Books, 2000.

Rutherford, Jonathan, ed. *Identity: Community, Culture, Difference*. London: Lawrence and Wishart, 1990.

Sachar, Howard M. *A History of the Jews in America*. New York: Vintage Books, 1993.

Sandeen, Eric. *Picturing an Exhibition: "The Family of Man" and 1950s America*. Albuquerque: University of New Mexico Press, 1995.

Sarna, Jonathan D., ed. *The American Jewish Experience*. New York: Holmes and Meier, 1997.

———. *American Judaism: A History*. New Haven, Conn.: Yale University Press, 2004.

Setton, Ruth Knafo. *The Road to Fez*. Washington, D.C.: Counterpoint Press, 2001.

Shohat, Ella, ed. *Talking Visions: Multicultural Feminism in a Transnational Age*. New York: The New Museum of Contemporary Art; Cambridge, Mass.: The MIT Press, 1998.

Silberstein, Laurence J., ed. *Mapping Jewish Identities*. New York: New York University Press, 2000.

Silberstein, Laurence J., and Robert L. Cohn, eds. *The Other in Jewish Thought and History: Constructions of Jewish Culture and Identity*. New York: New York University Press, 1994.

Smith, Anthony D. *The Ethnic Revival*. Cambridge, U.K.: Cambridge University Press, 1981.

Stavans, Ilan. *The Essential Ilan Stavans*. New York: Routledge, 2000.

———. *The Hispanic Condition: Reflections on Culture and Identity in America*. New York: HarperCollins, 1995.

———. *On Borrowed Words: A Memoir of Language*. New York: Viking, 2001.

———, ed. *The Schocken Book of Modern Sephardic Literature*. New York: Schocken Books, 2005.

Steinberg, Kerry P. "Photography, Philanthropy, and the Politics of American Jewish Identity." Ph.D. dissertation. University of California, Los Angeles, 1998.

Sternfeld, Joseph. *Stranger Passing*. Boston: Bulfinch Press/Little, Brown, 2001.

Stratton, Jon. *Coming Out Jewish: Constructing Ambivalent Identities*. New York: Routledge, 2000.

Thompson, Becky, and Sangeeta Tyagi, eds. *Names We Call Home: Autobiography on Racial Identity*. New York: Routledge, 1996.

Tobin, Gary A. *Opening the Gates: How Proactive Conversion Can Revitalize the Jewish Community*. San Francisco: Jossey-Bass, 1999.

Tobin, Gary A., and Sid Groeneman. *Surveying the Jewish Population in the United States (Part 1: Population Estimate; Part 2: Methodological Issues and Challenges)*. San Francisco: Institute for Jewish and Community Research, 2004.

Tobin, Gary A., Diane K. Tobin, and Scott Rubin. *In Every Tongue: Ethnic and Racial Diversity in the Jewish Community*. San Francisco: Institute for Jewish and Community Research. Forthcoming 2005.

Tye, Larry. *Home Lands: Portraits of the New Jewish Diaspora*. New York: Henry Holt, 2001.

Walker, Rebecca. *Black, White, and Jewish: Autobiography of a Shifting Self*. New York: Riverhead Books, 2001.

Walzer, Michael. *On Toleration*. New Haven, Conn.: Yale University Press, 1997.

Wertheimer, Jack. *A People Divided: Judaism in Contemporary America*. New York: Basic Books, 1993.

Willis, Deborah. *Imagining Families: Images and Voices*. Washington, D.C.: Smithsonian Institution Press, 1995.

———. *Picturing Us: African American Identity in Photography*. New York: The New Press, 1996.

Woodward, Kathryn, ed. *Identity and Difference*. Thousand Oaks, Calif.: Sage, 1997.

Zack, Naomi, ed. *American Mixed Race: The Culture of Microdiversity*. Lanham, Md.: Rowman and Littlefield, 1995.

EXHIBITION CATALOGUES

Ansel Adams Center for Photography. Beyond Boundaries: Contemporary Photography in California. San Francisco: Friends of Photography, 2000.

Berger, Maurice. *White: Whiteness and Race in Contemporary Art*. Baltimore: University of Maryland, Baltimore County, Center for Art and Visual Culture, 2003.

Cole, Carolyn Kozo, and Kathy Kobayashi. *Shades of L.A.: Pictures from Ethnic Family Albums*. New York: The New Press, 1996.

Fusco, Coco, and Brian Wallis, eds. *Only Skin Deep: Changing Visions of the American Self*. New York: Harry N. Abrams, 2003.

Kleeblatt, Norman L., ed. *Too Jewish? Challenging Traditional Identities*. New York: The Jewish Museum; New Brunswick, N.J.: Rutgers University Press, 1996.

Millstein, Barbara Head. *Committed to the Image: Contemporary Black Photographers*. New York: Brooklyn Museum of Art in association with Merrell, 2001.

Roodenburg, Linda. *Photowork(s) in Progress/ Constructing Identity: Rineke Dijkstra, Wendy Ewald, Paul Seawright*. Rotterdam: Netherlands Photo Institute, 1997.

ARTICLES

Albers, Patricia C., and William R. James. "Travel Photography: A Methodological Approach." *Annals of Tourism Research* 15 (1988): 134–58.

Azoulay, Katya Gibel. "Jewishness after Mount Sinai: Jews, Blacks, and the (Multi)racial Category." *Bridges* 9 (summer 2001): 30–45.

Azoulay, Katya Gibel, Siona Benjamin, Carolivia Herron, Shahanna McKinney, Aurora Levins Morales, and Rosa Maria Pegueros, eds. "Writing and Art by Jewish Women of Color." *Bridges* 9 (summer 2001).

Buchdahl, Angela Warnick. "Kimchee on the Seder Plate." *Sh'ma* (June 2003): http://www.shma.com/june03/Angela.htm.

Chau, Jennifer. "'Purina Dog Chow' and 'Chow Mein.'" In *What Are You? Voices of Mixed-Race Young People*, 152–56. Edited by Pearl Fuyo Gaskins. New York: Henry Holt, 1999.

Cline, Scott. "Jewish-Ethnic Interactions: A Bibliographical Essay." *American Jewish History* 77, no. 1 (September 1987): 135–54.

Gilman, Sander L. "The Jew's Body: Thoughts on Jewish Physical Difference." In *Too Jewish? Challenging Traditional Identities*, 60–73. Ed. Norman L. Kleeblatt. New York: The Jewish Museum; New Brunswick, N.J.: Rutgers University Press, 1996.

Goldstein, Eric L. "'Different Blood Flows in Our Veins': Race and Jewish Self-Definition in Late-Nineteenth-Century America." *American Jewish History* 85, no. 1 (1997): 29–55.

Hall, Stuart. "Cultural Identity and Diaspora." In *Identity: Community, Culture, Difference*, 222–37. Ed. Jonathan Rutherford. London: Lawrence and Wishart, 1990.

"Jewish Identity." Special issue. *The Reconstructionist* 66, no. 1 (fall 2001).

McCoy, Yavilah. "The Changing Face of Jewish Identity: Inside, Outside, and Other." *Sh'ma* (June 2003): http//www.shma.com/june03/Yavilah.htm.

McKinney, Shahanna. "Writing and Art by Jewish Women of Color: Introduction." *Bridges* 9, no. 1 (summer 2001): 4–7.

Rogoff, Irit. "Daughters of Sunshine: Diasporic Impulses and Gendered Identities." In *With Other Eyes: Looking at Race and Gender in Visual Culture,* 157–83. Ed. Lisa Bloom. Minneapolis: University of Minnesota Press, 1999.

Sarna, Jonathan D. "American Anti-Semitism." In *History and Hate: The Dimensions of Anti-Semitism,* 115–28. Ed. David Berger. Philadelphia: Jewish Publication Society of America, 1986.

———. "From Immigrants to Ethnics: Toward a New Theory of 'Ethnicization.'" *Ethnicity* 5 (1978): 370–78.

Shrage, Laurie. "Ethnic Transgressions: Confessions of an Assimilated Jew." In *American Mixed Race: The Culture of Microdiversity,* 287–307. Ed. Naomi Zack. Latham, Md.: Rowman and Littlefield, 1995.

Tobin, Gary A. "The Case for Proactive Conversion." *Sh'ma* (October 1999): http://www.shma.com/oct99/1099art2.htm.

———. "Do We Want to Be Who We Really Are," *Interfaithfamily.com* (July 2003): http://interfaithfamily.com/article/issue114/tobin.phtml.

Waters, Mary C. "Flux and Choice in American Ethnicity." In *Ethnic Options: Choosing Identities in America,* 16–51, 169. Berkeley and Los Angeles: University of California Press, 1990.

ONLINE RESOURCES ON ISSUES OF JEWISH DIVERSITY

(All are on http://)

Alliance of Black Jews, www.aobj.org

Association for Multiethnic Americas, www.ameasite.org

Ayecha Resource Organization, www.ayecha.org

Be'chol Lashon, www.jewishresearch.org

Beth Elohim Hebrew Congregation, St. Albans, Queens, N.Y., members.aol.com/Blackjews/beth1.html

Beth Shalom B'nai Zaken Ethiopian Hebrew Congregation (Beth Shalom), Chicago, www.bethshalombz.org/bs_history.html

Institute for Jewish and Community Research, San Francisco, www.jewishresearch.org

Interfaith Family, www.interfaithfamily.com

Jewish Family and Life, www.jewishfamily.com

Jewish Multicultural Curriculum Project, www.loolwa.com/multiculturalism/curriculum.html

Jewish Multiracial Network, www.isabellafreedman.org/jmn/jmn_intro.shtml

Kulanu, www.kulanu.org

Moreshet Network, www.moreshetnetwork.com

Reboot: A Network for Jewish Innovation, www.rebooters.net

Swirl, Inc., www.swirlinc.org

Contributors

Susan Chevlowe, formerly associate curator of fine arts at The Jewish Museum, holds a Ph.D. in art history from the Graduate Center of the City University of New York and is adjunct assistant professor in the program in Jewish art and material culture at the Jewish Theological Seminary of America. She is the author of *Common Man, Mythic Vision: The Paintings of Ben Shahn* (1998) and the editor, with Norman L. Kleeblatt, of *Painting a Place in America: Jewish Artists in New York, 1900–1945* (1991), winner of the National Jewish Book Award. During her tenure at the museum she coordinated or curated more than a dozen exhibitions including *Ben Katchor: Picture Stories* (2001), *Anni Albers: A Retrospective* (2000), and *Paris in New York: French Jewish Artists in Private Collections* (2000).

Joanna Lindenbaum, formerly curatorial assistant at The Jewish Museum, received an M.A. in art history from Hunter College and served as assistant curator for *Mirroring Evil: Nazi Imagery/Recent Art* (2002). She also coordinated the Jewish Museum exhibitions *Innovator, Activist, Healer: The Art of Friedl Dicker-Brandeis* (2004), *Erwartung/Expectancy: A Video Installation by Dara Birnbaum* (2003), *Arnold Dreyblatt: The Re-Collection Mechanism* (2001), and *Doug and Mike Starn: Ramparts Café* (2001). She is cofounder and director of WomanVision, an organization dedicated to empowering women of all backgrounds by helping them to connect to their authentic selves.

Ilan Stavans is Lewis-Sebring Professor in Latin American and Latino Culture and Five-College 40th Anniversary Distinguished Professor at Amherst College. Among his many books are *Dictionary Days: A Defining Passion* (2005), *The Schocken Book of Modern Sephardic Literature* (2005), *Spanglish: The Making of a New American Language* (2003), *On Borrowed Words: A Memoir of Language* (2001), *The Oxford Book of Jewish Stories* (1998), and *The Hispanic Condition: Reflections on Culture and Identity in America* (1995). He is the general editor of the forthcoming *Norton Anthology of Latino Literature* and the editor of the three-volume *Isaac Bashevis Singer: Collected Stories* (2004) for The Library of America. His work has been translated into a dozen languages.

Index

Illustration Credits

Susan Chevlowe, *Framing Jewishness*

© 2004 Anti-Defamation League (figs. 18–20)

© Bill Aron (figs. 2, 7)

Photography © The Art Institute of Chicago (fig. 12)

© Frédéric Brenner (fig. 4)

Reprinted with permission of Chabad of California (fig. 9)

© Beth Hatefutsoth, The Nahum Goldmann Museum of the Jewish Diaspora, Tel Aviv (fig. 10)

Chester Higgins Jr. (fig. 5)

© Stuart E. Karu (fig. 15)

Thomas Roma (fig. 13)

Ezra Stoller © Esto (fig. 1)

Ilan Stavans, *Oy, Are We a* Pluribus?

© 1985 Joyce Culver (fig. 12)

© Abe Frajndlich (fig. 2)

Courtesy of Hip Hop Hoodíos (fig. 7)

© John T. Hopf (fig. 9)

Photofest (figs. 1, 3, 4)

© Stan Sherer (fig. 5)

Artist Biographies

Portrait of Dawoud Bey © 2005 Mnemone Manzoni

Portrait of Jessica Shokrian by Brandy Eve Allen

Photograph of Chris Verene: Courtesy of Chris Verene Studio—ChrisVerene.com